HOW TO DRAW
COMICS

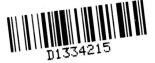

Michael O'Mara Books Limited

FIRST PUBLISHED IN GREAT BRITAIN IN 2016 BY LOM ART,
AN IMPRINT OF MICHAEL O'MARA BOOKS LIMITED
9 LION YARD
TREMADOC ROAD
LONDON SW4 7NQ

A CIP CATALOGUE RECORD FOR THIS BOOK IS
AVAILABLE FROM THE BRITISH LIBRARY.

PAPERS USED BY MICHAEL O'MARA BOOKS LIMITED ARE NATURAL,
RECYCLABLE PRODUCTS MADE FROM WOOD GROWN IN SUSTAINABLE
FORESTS. THE MANUFACTURING PROCESSES CONFORM TO THE
ENVIRONMENTAL REGULATIONS OF THE COUNTRY OF ORIGIN.

ISBN: 978-1-910552-29-2 IN PAPERBACK PRINT FORMAT

1 3 5 7 9 10 8 6 4 2

COVER DESIGN BY DAN MOGFORD
ASHCAN BB FONT © 2007 NATE PIEKOS

PRINTED IN CHINA

WWW.MOMBOOKS.COM

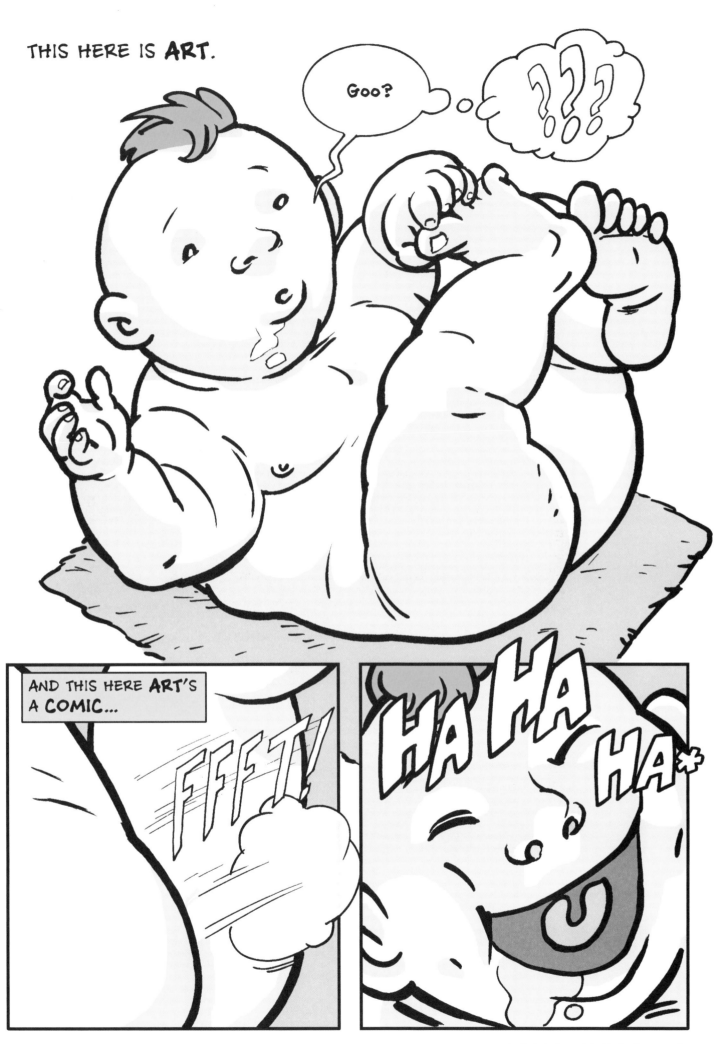

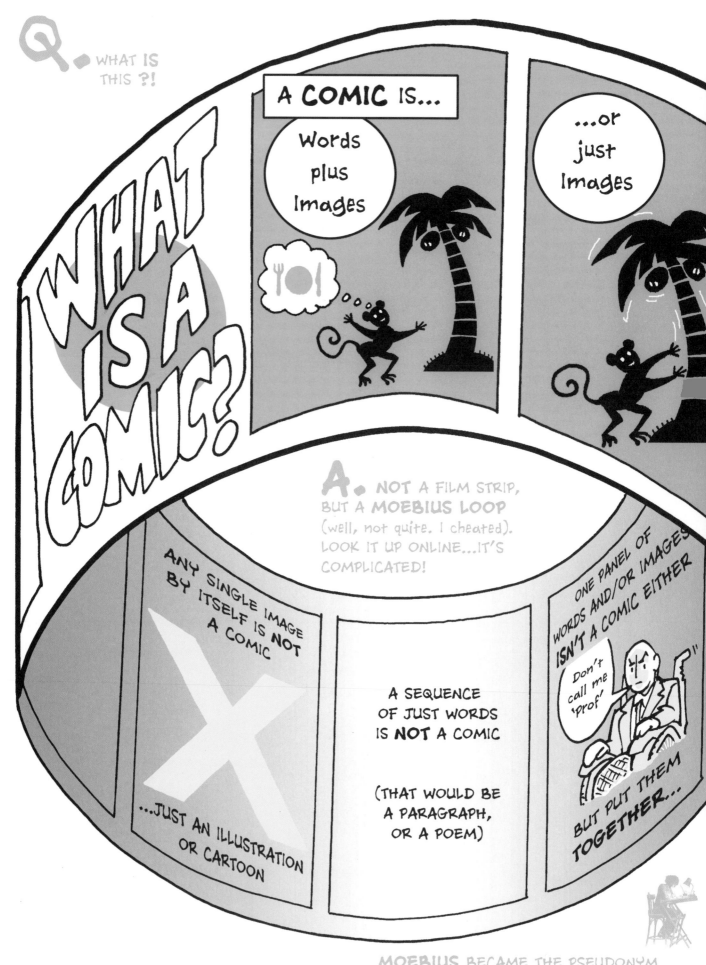

WHAT IS A COMIC?

A **COMIC** IS...

Words plus Images

...or just Images

A. NOT A FILM STRIP, BUT A **MOEBIUS LOOP** (well, not quite. I cheated). LOOK IT UP ONLINE...IT'S COMPLICATED!

ANY SINGLE IMAGE BY ITSELF IS **NOT** A COMIC

...JUST AN ILLUSTRATION OR CARTOON

A SEQUENCE OF JUST WORDS IS **NOT** A COMIC

(THAT WOULD BE A PARAGRAPH, OR A POEM)

ONE PANEL OF WORDS AND/OR IMAGES ISN'T A COMIC EITHER

Don't call me 'Prof'

BUT PUT THEM **TOGETHER**...

MOEBIUS BECAME THE PSEUDONYM (AN ADAPTED 'ART NAME', LIKE...ILYA!) OF FRENCH COMICS MASTER JEAN GIRAUD (1938-2012). MORE ABOUT HIM...LATER!

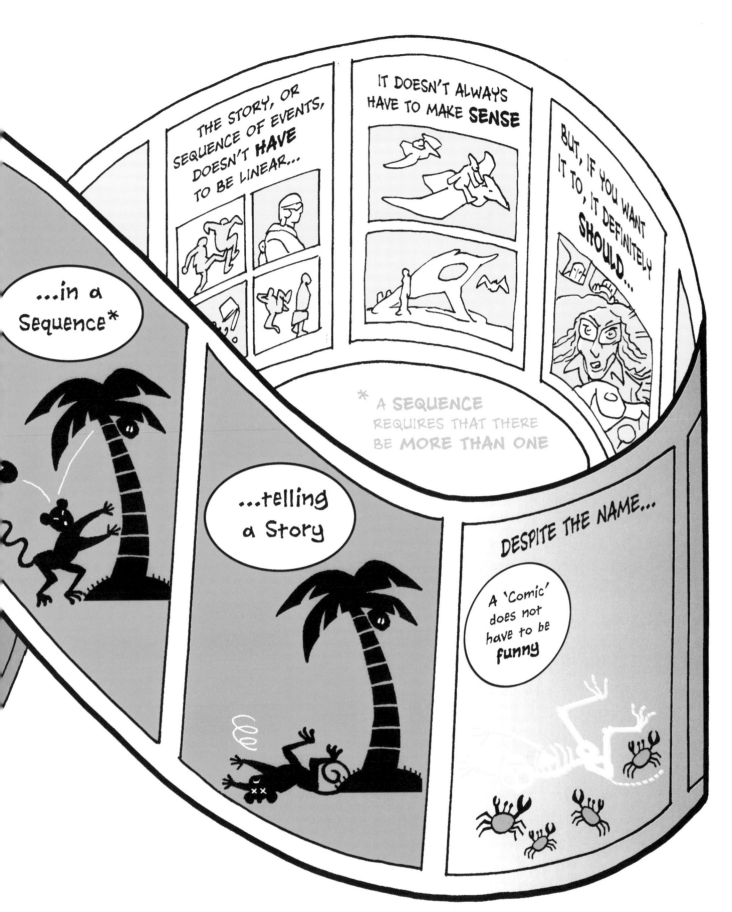

THE POSSIBILITIES
...ARE INFINITE!

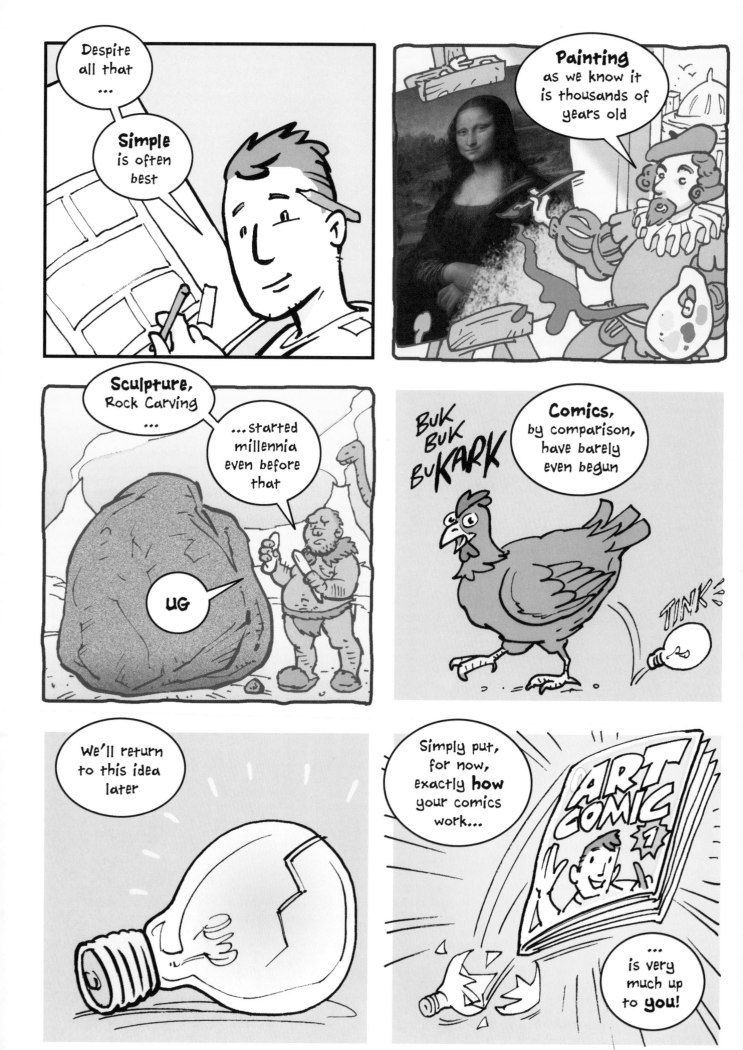

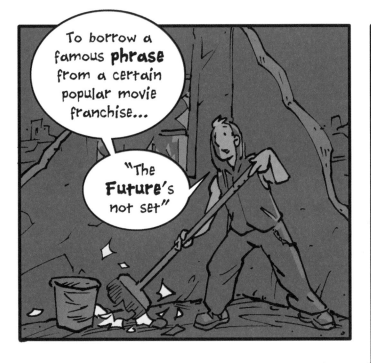

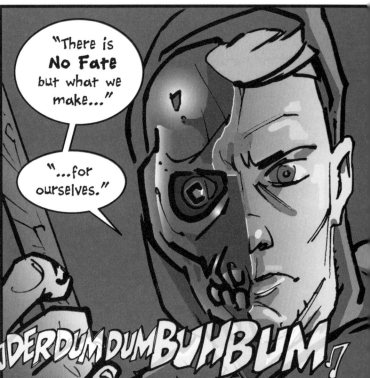

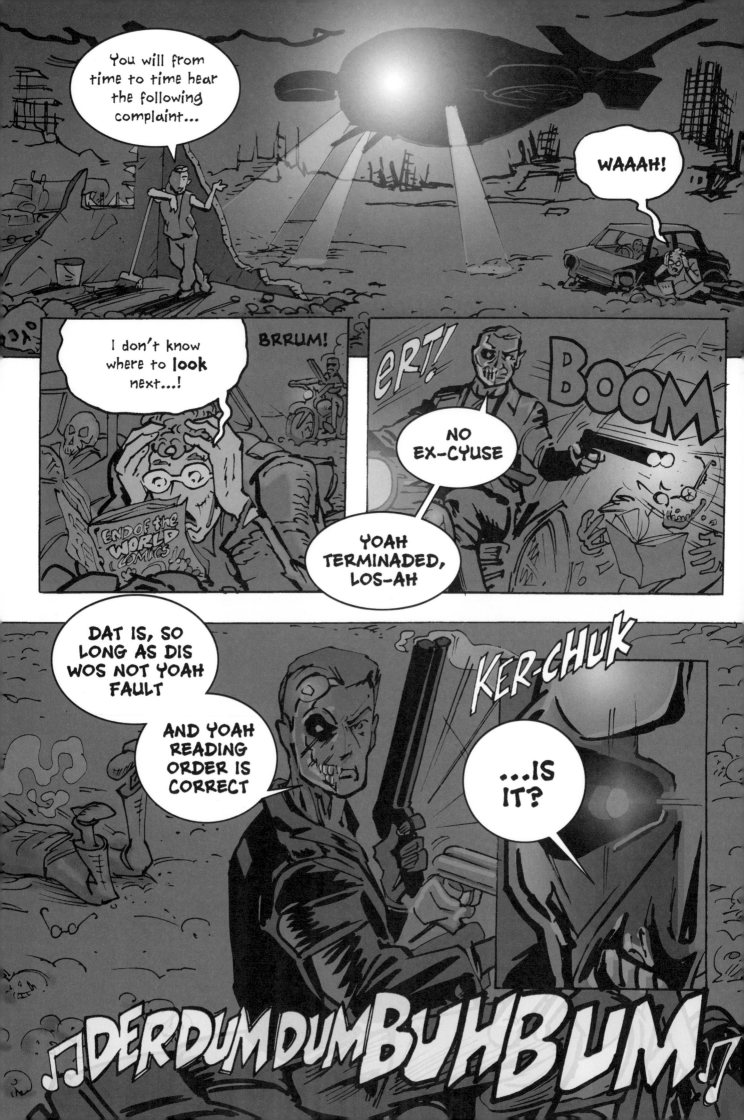

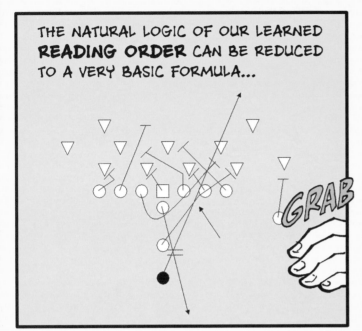

THE NATURAL LOGIC OF OUR LEARNED **READING ORDER** CAN BE REDUCED TO A VERY BASIC FORMULA...

GRAB

Think about it and it is **simple**

TOSS

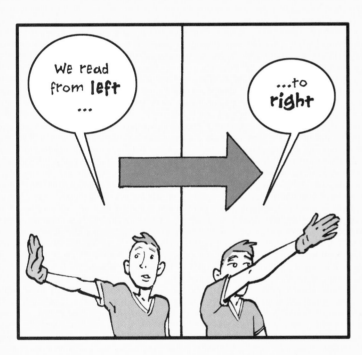

We read from **left** ...

...to **right**

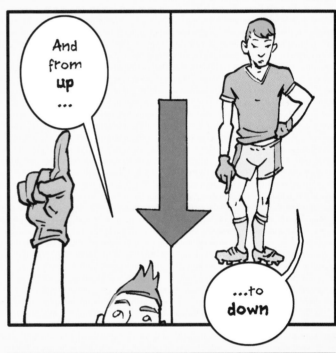

And from **up** ...

...to **down**

Simple

Right?

IT MAY **SEEM** OBVIOUS, BUT EVEN THE MOST EXPERIENCED COMICS PROS CAN TAKE THEIR EYE OFF THE BALL AND...

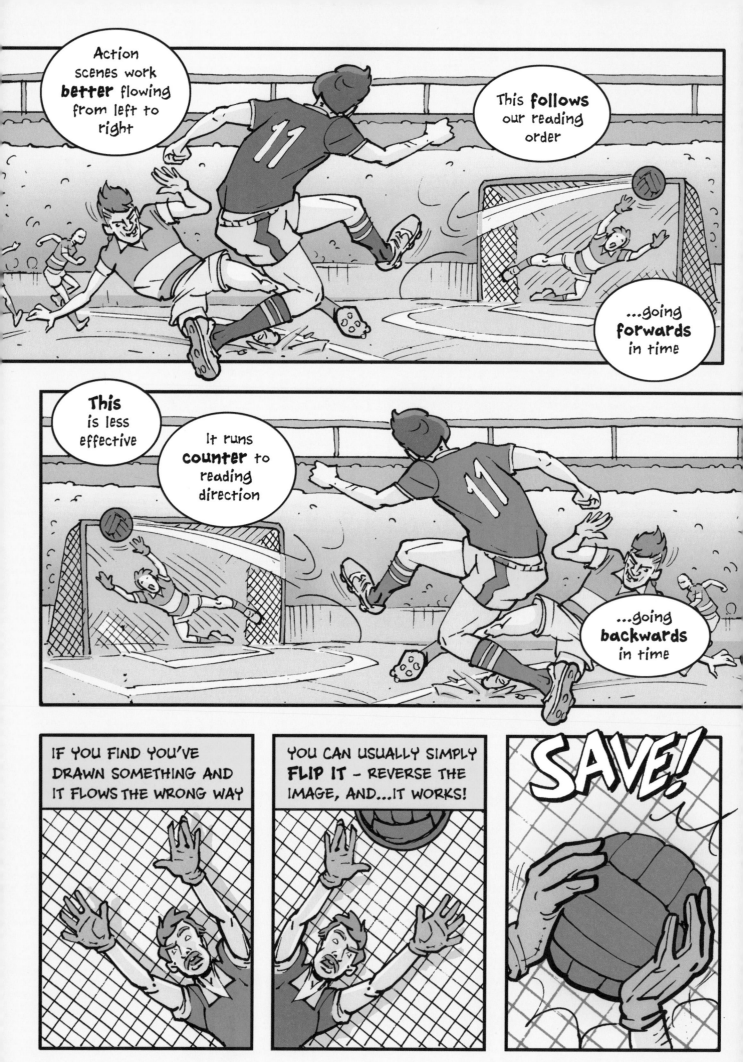

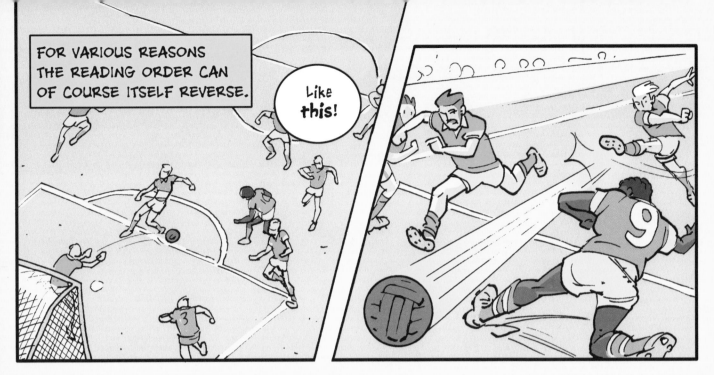

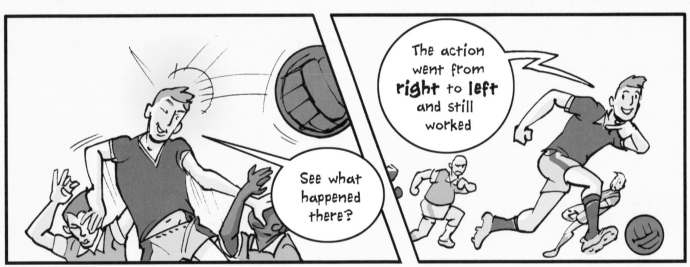

THE **GOAL** IS TO INVITE READERS, NOT TO CONFUSE OR REPEL THEM.

COMPOSE YOUR PANELS TO **LEAD** THE EYE WHERE YOU WANT IT TO GO, AND IN THE ORDER YOU SET, ACROSS EACH PAGE.

LEFT TO RIGHT, TOP TO BOTTOM, LIKE LETTER **Z**'s.

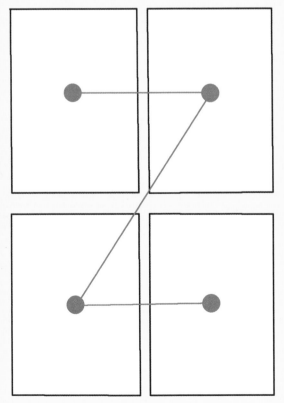

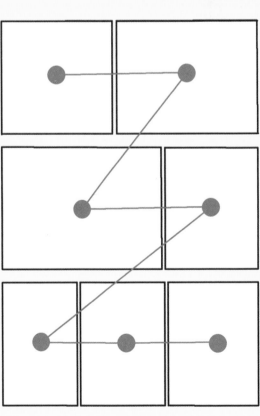

This principle works much the same way...

...when it comes to **speech balloons**

Gasp

BaWOONS!

Write (or type) the **words** in first

Then create a balloon around them

Keep it **spacious**

Big balloons make for **easier reading**

A crowded balloon is ugly and **hard** to read

The **tail** points to whoever is speaking

We tend to read the balloon first

Then look at the picture

Yo, BUD

Yo, BUD

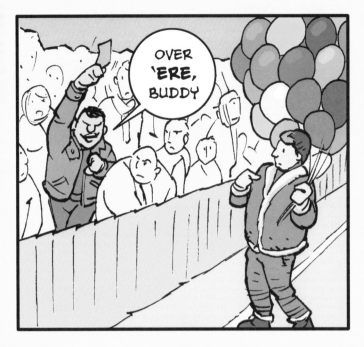

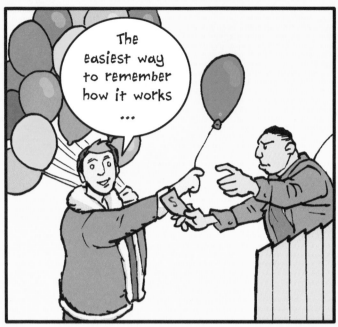

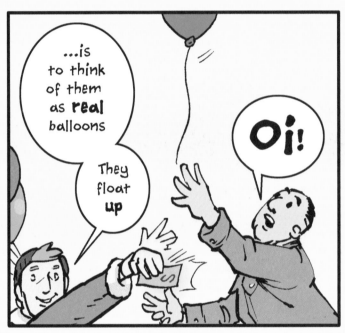

AS A GENERAL RULE OF THUMB, RESERVE THE **TOP THIRD** OR SO OF ANY PANEL THAT INCLUDES SPEECH. YOUR BALLOONS WILL TEND TO **FILL** THIS SPACE.

MORE, WHERE MORE THAN ONE CHARACTER SPEAKS, OR IF THEY HAVE A LOT TO SAY!

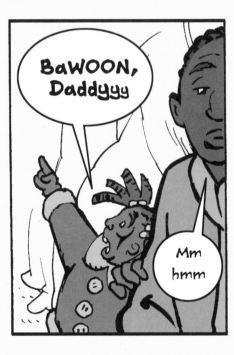

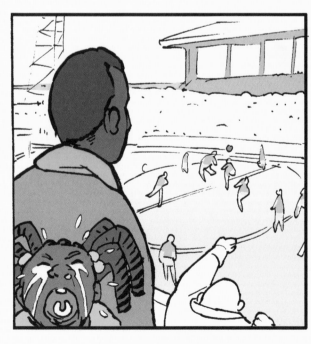

OFTEN YOU CAN HAVE MORE THAN ONE BALLOON, OR MORE THAN ONE SPEAKER.

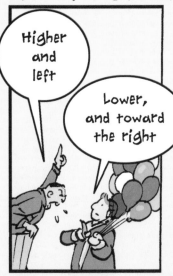

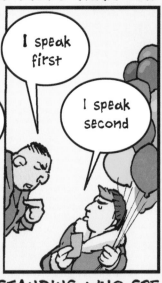

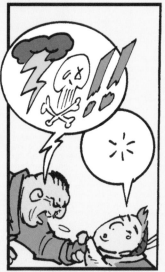

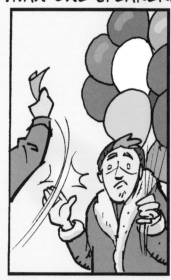

THE READER UNDERSTANDING WHO SPEAKS, AND IN WHAT ORDER, IS IMPORTANT.

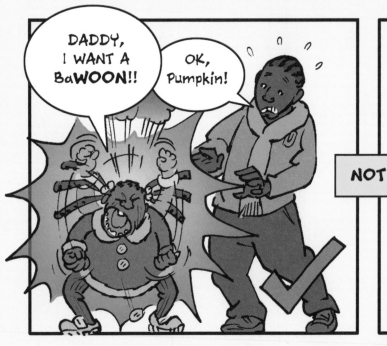

NOT

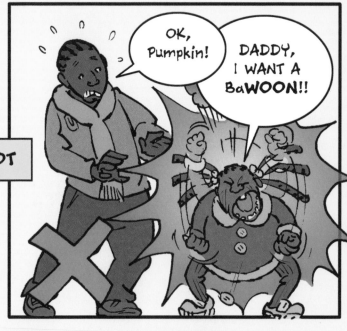

WHEREVER POSSIBLE, PLACE ANY FIGURES IN YOUR PANELS ACCORDING TO THE READING ORDER.

THAT IS, TRY TO MAKE SURE THAT THEY APPEAR IN THE **SAME** ORDER IN WHICH THEY SPEAK.

OR ELSE CHANGE THE **P.O.V.** - THE **POINT OF VIEW** - THAT YOU TAKE, TO MAKE **CERTAIN** OF THAT.

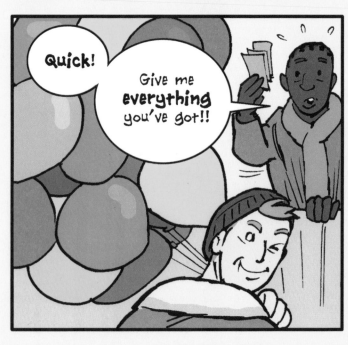

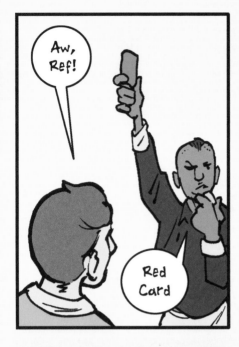

DID THEY SEEM TO SPEAK OUT OF ORDER? **NO.**

THIS TIME, IT'S OK...READING THE IMAGE, THE PLAYER MIGHT HAVE SEEN THE CARD **BEFORE** THE REFEREE SPEAKS.

OR, YOU CAN ALWAYS PLAY IF **SAFE**...

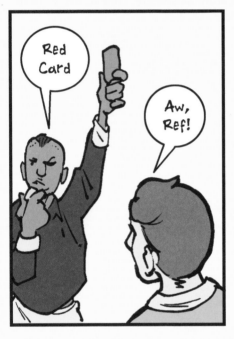

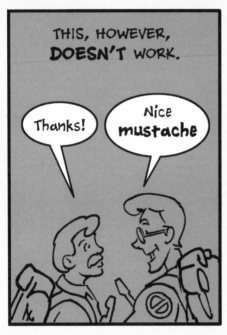

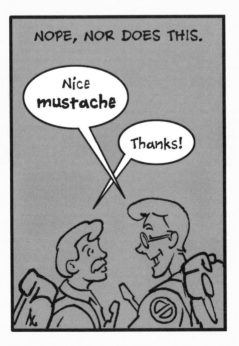

AS EVERY GHOSTBUSTER WORTH THEIR PROTON DRIVE KNOWS, CROSSING THE STREAMS (OR BALLOON TAILS) IS **BAD.** STRICTLY A NO-NO.

THE END OF ALL LIFE AS WE KNOW IT, EVERY MOLECULE IN OUR BODIES EXPLODING INSTANTANEOUSLY.

DOGS, POSSIBLY LIVING WITH CATS.

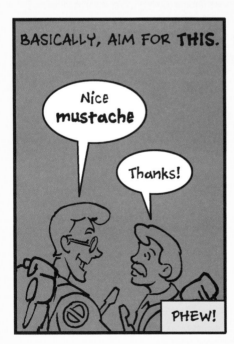

USE THESE BLANK TEMPLATES
TO HAVE A GO YOURSELF –
MAKE UP A SHORT SCENE AND
APPLY SOME OF WHAT WE'VE
EXPLORED SO FAR.

DON'T BE AFRAID TO EXPERIMENT.

SHOULD YOU FEEL YOU **FAIL**, KNOW
THAT FAILURE IS THE BEST – AND
OFTEN THE ONLY – WAY TO LEARN.
WHEN YOU FAIL, YOU'RE LEARNING!

IF YOU WANT TO BE ABLE TO USE
THESE TEMPLATES MORE THAN JUST
ONCE, **PHOTOCOPY** THEM FIRST,
IN BLACK AND WHITE – THEN
WORK ON THE PHOTOCOPIES!

(THIS LETTERING WON'T SHOW)

YOU CAN CLIP AND COMBINE
THE 6- AND 9-PANEL GRIDS TO
VARY YOUR PAGES AS YOU LIKE.

18 BLANK TEMPLATES

BLANK TEMPLATES 19

THE GREAT THING ABOUT COMICS IS THAT YOU DON'T NEED TONS OF **SPECIALIST EQUIPMENT**...

oh

NO MORE THAN **PAPER**...

...PLUS...A **PENCIL**!

PENCILS GO **BLUNT** AND WE ALL MAKE **MISTAKES**...

SO, A **SHARPENER** OF SOME SORT, AND AN **ERASER**.

SHOULD YOU CHOOSE TO... **INK**!

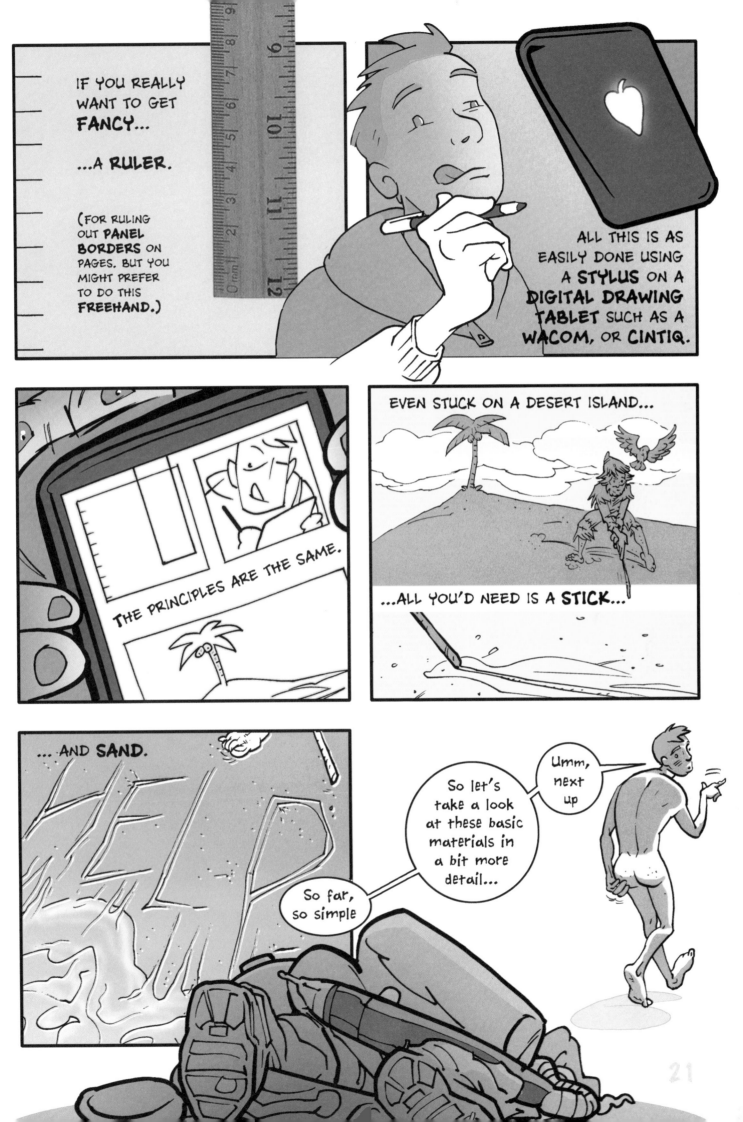

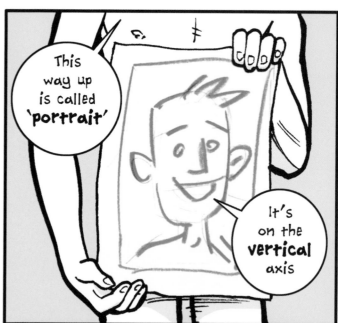

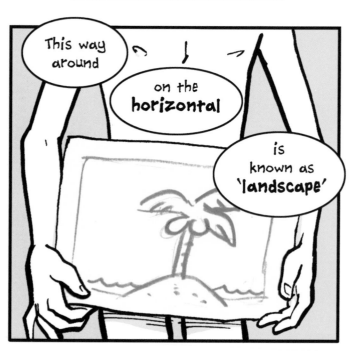

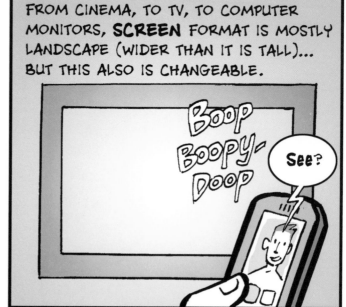

FROM CINEMA, TO TV, TO COMPUTER MONITORS, **SCREEN** FORMAT IS MOSTLY LANDSCAPE (WIDER THAN IT IS TALL)... BUT THIS ALSO IS CHANGEABLE.

THE ADVENT AND SPREAD OF THE **INTERNET** MEANS **ONLINE COMICS** COME IN ALMOST ANY FORMAT POSSIBLE...WORTH EXPLORING...

MEANWHILE, MOST **PRINT** ARTEFACTS, BE THEY BOOKS, NEWSPAPERS, MAGAZINES OR COMICS, STICK TO **PORTRAIT** FORMAT...

THE EARLIEST WRITING AND DRAWING WAS DONE IN CHALK AND POWDER ON **ROCK**...PROGRESSING TO A STYLUS INSCRIBING MARKS ON A **CLAY TABLET**.

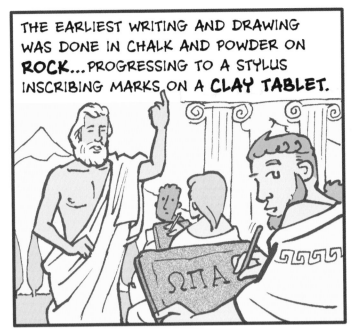

MANY ARTISTS COMING INTO THE COMICS INDUSTRY NOWADAYS WORK PURELY **DIGITALLY**, NOT USING PAPER AT ALL.

IRONICALLY ENOUGH, THEY'VE GONE BACK TO USING A STYLUS ON A DRAWING TABLET.

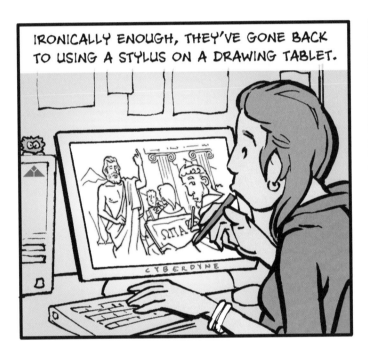

YOU MAY NOT HAVE ACCESS TO THESE SAME ELECTRONIC RESOURCES, MAYBE YOU NEVER WILL. PERHAPS, YOU WOULD PREFER NOT TO.

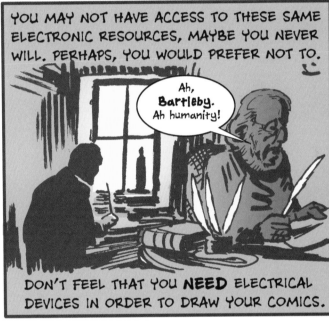

DON'T FEEL THAT YOU **NEED** ELECTRICAL DEVICES IN ORDER TO DRAW YOUR COMICS.

IN OUR DESTROYED FUTURE, **NONE** OF THAT'S GOING TO WORK ANYWAY...

SAVE AND USE ANY OLD **SCRAP** TO SKETCH OUT IDEAS THAT COME TO YOU.

OR, IF YOU ARE MORE DISCIPLINED, KEEP A **SKETCHBOOK** FILLED WITH SAME...

OR EVEN, TO ASSEMBLE A **SCRAPBOOK**.

YOU NEVER KNOW WHEN OR WHERE INSPIRATION MIGHT STRIKE, SO YOU'LL PROBABLY END UP WITH ANY NUMBER OF SKETCHBOOKS ON THE GO...

Me too!

IT'S ALL GOOD.

I GET A LOT OF MY IDEAS IN MY **SLEEP.**

...HALF-AWAKE, OR IN **DREAMS**...

SO, I TRY TO KEEP A **PAD** HANDY BY THE BED TO NOTE STUFF DOWN...

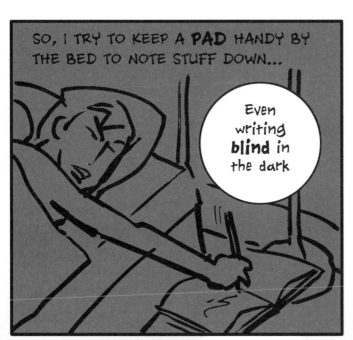

Even writing **blind** in the dark

In the mornings

I can't always work out what it means

or even **says**

but often enough

it's **Gold**

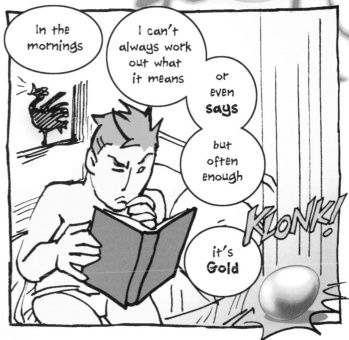

RESTING, RELAXING, WHEN TRAVELLING, WALKING – **ALL** THESE GENERATE IDEAS.

QUIET TIME, DOWN TIME, AWAY FROM NOISE AND DISTRACTION.

IT THEREFORE HELPS TO **ALWAYS** HAVE SOMETHING TO SKETCH ON TO HAND...

YES, EVEN **HERE.**

WHEN IT COMES TO CREATING ARTWORK FOR YOUR COMICS, THAT'S A WHOLE DIFFERENT STORY.

I'VE MENTIONED THE GROWING PRACTICE OF **DIGITAL** DRAWING. IF YOU WANT TO KNOW MORE ABOUT THAT SPECIFICALLY, THEN THERE ARE MANY PUBLICATIONS GOING INTO GREATER DEPTH ABOUT IT (BOTH IN PRINT AND ONLINE).

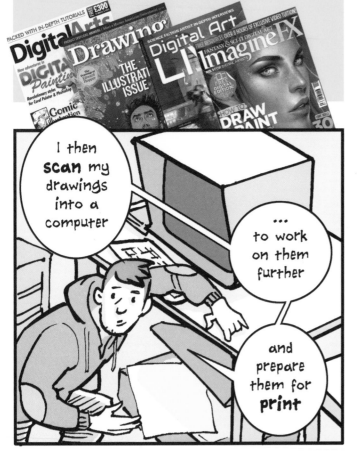

I'VE TRIAL-TESTED DRAWING TABLETS AND FOUND THEM VERY RESPONSIVE.

WITHIN AN HOUR OR TWO, ADJUSTING SETTINGS TO SUIT, IT AMOUNTS TO MUCH THE SAME THING AND CAN PRODUCE VERY SIMILAR-SEEMING ARTWORK – YOUR DRAWINGS AS IF YOU **HAD** SKETCHED THEM ON TO PAPER, AND NOT A SCREEN. THE DIGITAL TOOLS CAN MIMIC ANY STYLE OF PEN OR BRUSH EFFECT THAT YOU'D LIKE, LENDING YOU A GREATER DEGREE OF **CONTROL** OVER THEM.

BUT HERE'S MY **STICKING POINT...**

THE **PAPER** (PROPERLY, CARD) **STOCK** THAT MOST COMICS PROFESSIONALS USE IS CALLED **BRISTOL BOARD**.

(WHEN YOU WORK FOR THE BIGGER COMPANIES LIKE **MARVEL** OR **DC**, THEY HAVE THEIR OWN PRINTED SUPPLIES)

As with any **art supplies**

...you tend to get the **quality** you pay for

And it **doesn't** come cheap

PLEASE HELP ME TO BUY PAPER

A GOOD, BUDGET **SUBSTITUTE** I'VE FOUND – LESS EXPENSIVE, ESPECIALLY BOUGHT IN BULK (100 SHEETS A TIME) IS **EXCELDA IVORY** (AKA PURE DUTCH).

MORE WIDELY AVAILABLE, GOOD BRANDS OF HEAVY **CARTRIDGE PAPER** WILL DO.

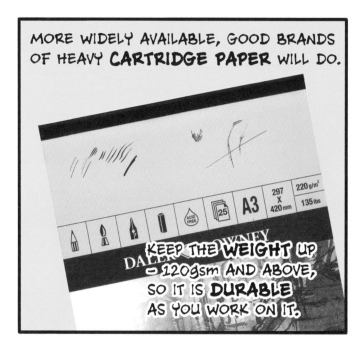

KEEP THE **WEIGHT** UP – 120gsm AND ABOVE, SO IT IS **DURABLE** AS YOU WORK ON IT.

PAPERS COME IN A VARIETY OF STYLES. YOU'RE USUALLY BETTER OFF WITH A **SMOOTH** FINISH, OR SURFACE. SOME FOLKS THO' PREFER A LITTLE 'TOOTH'...

A SLIGHTLY ROUGH TEXTURE, A BIT LIKE THE RASP OF A CAT'S TONGUE...

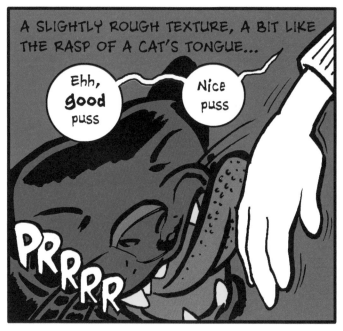

Ehh, **good** puss

Nice puss

PRRRR

TOOLS OF THE TRADE

OBVIOUS ONES THAT YOU MIGHT OVERLOOK.

BUT ALSO...

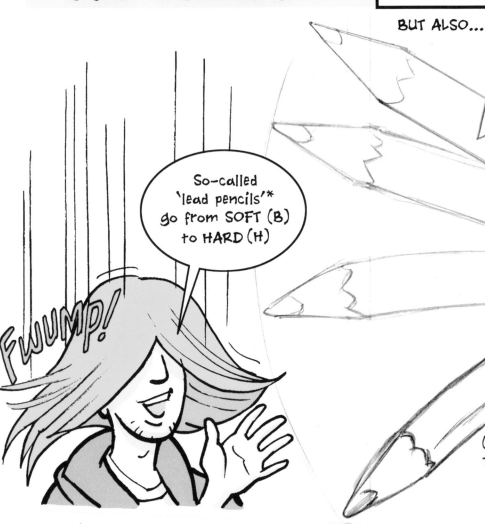

So-called 'lead pencils'* go from SOFT (B) to HARD (H)

Pencils

FWUMP!

* PROPERLY, **GRAPHITE** (PLUS CLAY MIXED WITH WATER). THE 'H' STANDS FOR HARDNESS, AND 'B', BLACKNESS, HENCE, 'HB' EQUALS **HARD BLACK**!

'H' PENCILS MAKE FOR A **LIGHTER** LINE – 9H IS SO HARD IT BARELY LEAVES A MARK.

Too faint

THE 'B' RANGE GIVES A **DARKER** LINE, WHICH IS ALSO WAXY AND MAY SMUDGE.

Too greasy

DRAWN WITH A 4H

DRAWN WITH AN 8B

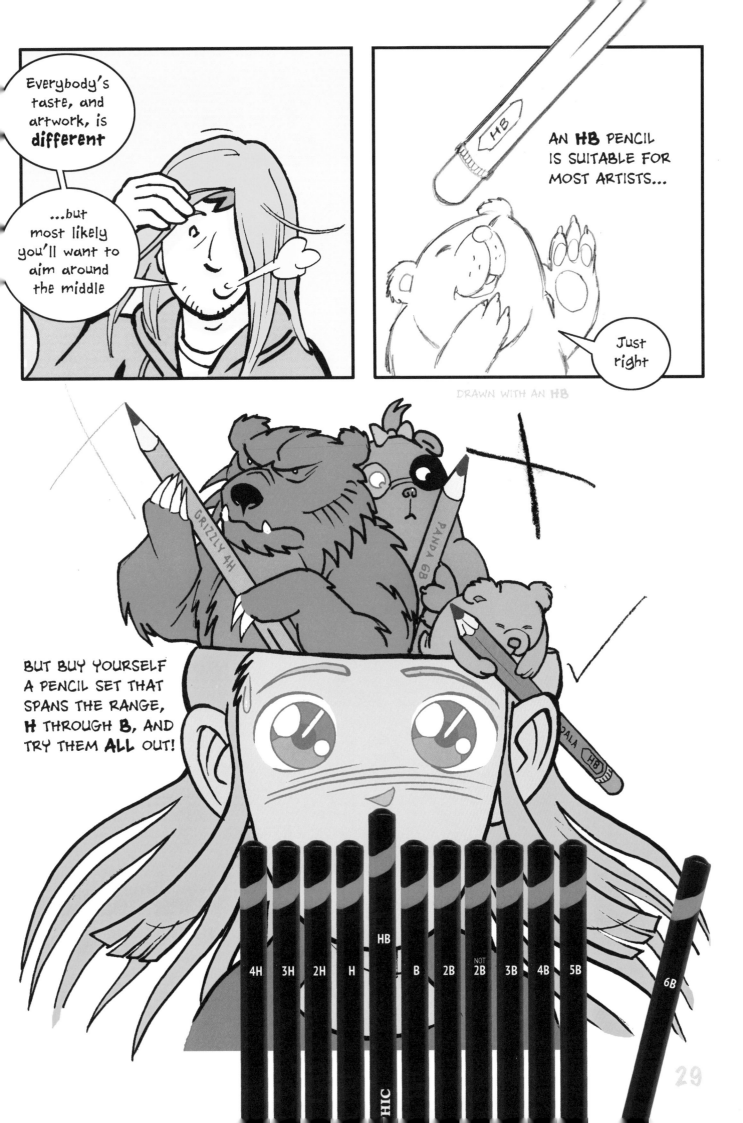

Like many comics artists I don't even draw with a lead pencil anymore

Instead, sketching out my panels in **blue** pencil

WHY **BLUE**?!

Because, according to how you set your scanner or photo-copier

the blue can be made **non-repro**

It doesn't **come out**

IT USED TO BE THE CASE THAT DRAWINGS IN PENCIL HAD TO BE INKED TO REPRODUCE. (**NOT ANY MORE**, THANKS TO IMPROVED SCANNING TECHNOLOGY.) TAKING MY INKED PENCILS, ORDINARILY I WOULD HAVE TO **ERASE** THE PENCIL DRAWINGS ANYWHERE THEY SHOWED UNDERNEATH, OR ELSE RISK A SCRAPPY, 'DOUBLE-EXPOSED' IMAGE.

...THAT'S AN AWFUL LOT OF RUBBING OUT!

LET'S SAY I'VE DRAWN 100 PAGES...

AAH!

YOU DON'T NEED ANYTHING **SPECIALIZED**. ANY ORDINARY LIGHT BLUE PENCIL WILL DO. AS WITH ANY PENCIL, JUST KEEP IT **SHARP** IF AND WHEN YOU WANT ACCURATE LINES.

FOR **FINE LINE** STYLES AND SKETCHING YOU CAN GET **TECHNICAL** OR **PUSH PENCILS**. WITH REFILLABLE LEADS*, THEY DON'T EVEN NEED SHARPENING...YAY!

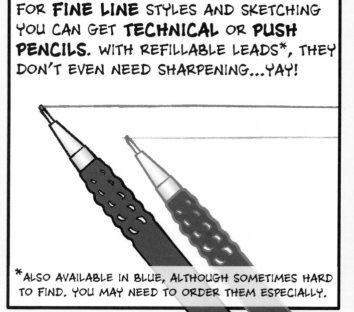

*ALSO AVAILABLE IN BLUE, ALTHOUGH SOMETIMES HARD TO FIND. YOU MAY NEED TO ORDER THEM ESPECIALLY.

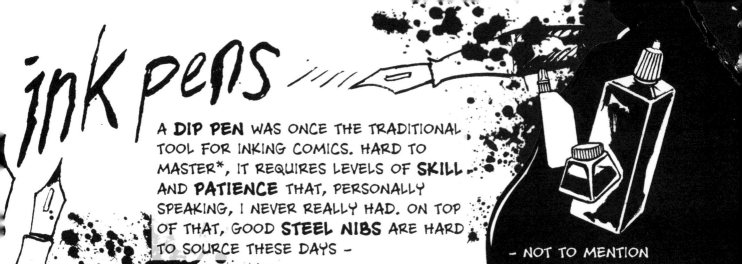

ink pens

A **DIP PEN** WAS ONCE THE TRADITIONAL TOOL FOR INKING COMICS. HARD TO MASTER*, IT REQUIRES LEVELS OF **SKILL** AND **PATIENCE** THAT, PERSONALLY SPEAKING, I NEVER REALLY HAD. ON TOP OF THAT, GOOD **STEEL NIBS** ARE HARD TO SOURCE THESE DAYS –

– NOT TO MENTION THE EVER-PRESENT RISK OF **SPILLAGE!**

*CHECK OUT THE COMICS AND ILLUSTRATION OF **JOSE MUNOZ** TO WITNESS A DIP-PEN MASTER.

WHEN YOU WANT LINES OF **CONSTANT WIDTH**, NOT MUCH BEATS THE STEEL-NIB **TECHNICAL PEN** – AN **ISOGRAPH** OR **RAPIDOGRAPH** (W/CARTRIDGES).

DOWNSIDES ARE THEIR HUGE EXPENSE, EXTREME HIGH MAINTENANCE (LOTS OF CLEANING EVERY TIME THEY BLOCK UP), AND THE THINNER NIBS (0.25) SNAPPING.

AT THE OTHER EXTREME, A **BRUSH** GIVES A VERY **VERSATILE** LINE...

...DEPENDING ON THE DEGREE OF PRESSURE APPLIED, AND HOW LOADED IT IS WITH INK.

BEST FOR HAIR, CREASES IN CLOTHING, THICKER OUTLINES – ALL SORTS OF EFFECTS.

LOOSE AND LYRICAL IN THE RIGHT HANDS, CONTROLLED BRUSHWORK TAKES LOADS OF PRACTICE.

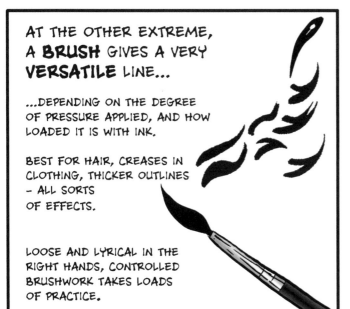

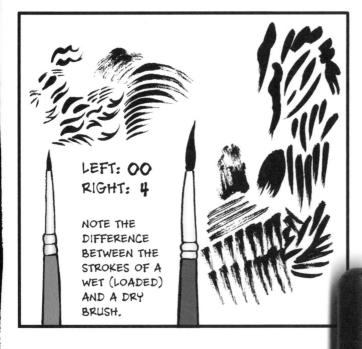

LEFT: OO
RIGHT: 4

NOTE THE DIFFERENCE BETWEEN THE STROKES OF A WET (LOADED) AND A DRY BRUSH.

AS WELL AS BRUSH **SIZE**, THE **QUALITY** OF BOTH INK AND BRUSHES VARIES ENORMOUSLY. WHETHER **SYNTHETIC** OR **ANIMAL** HAIR, YOU CAN BUY A DOZEN AND LESS THAN HALF WILL WORK OUT... THE REST BELONG ON A BADGER'S ███.

THEY NEED LOOKING AFTER AND REGULAR CLEANING, OR ELSE THEY'LL END UP LOOKING LIKE A CHIMNEY SWEEP'S SET OF BRUSHES.

Chim chiminey, Chim chiminey...

HERE'S A TIP:

IF YOU HAVE LARGE AREAS OF BLACK TO FILL IN, DON'T RUIN YOUR BRUSHES, USE A **Q-TIP**. AN ABSORBANT COTTON BUD SOAKS UP LOTS OF INK AND SPREADS IT FAST AND EVENLY.

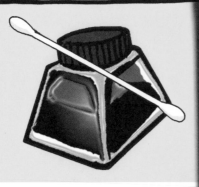

FOR ARTISTS (LIKE MYSELF) WHO STRUGGLE WITH BRUSHES, THANK HEAVENS THEY INVENTED THE **BRUSHPEN**.

A CARTRIDGE-LOADED PEN WITH A MAN-MADE BRISTLE TIP, THIS 'POCKET BRUSH' ALLOWS MUCH GREATER HAND CONTROL - **PLUS**, NO MORE SPILLS, DIPPING OR ENDLESS CLEANING. ALMOST EVERYONE I KNOW IN COMICS **SWEARS** BY THEM...INSTEAD OF **AT** THEM!

YAAH!

THERE ARE ALSO MANY KINDS OF **FELT-TIP** PEN (A PRE-LOADED INK PEN).

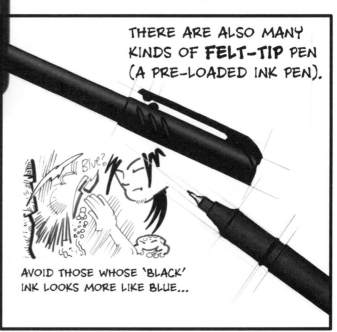

AVOID THOSE WHOSE 'BLACK' INK LOOKS MORE LIKE BLUE...

INKED WITH A BRUSHPEN

PERSONALLY I WOULD RECOMMEND MOST OF ALL THE **PITT ARTIST PEN** FROM **FABER-CASTELL**, IF YOU CAN FIND THEM.

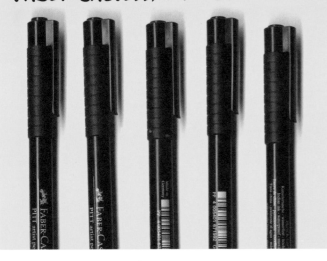

OPAQUE SOLID BLACK INK, ROBUST, AND IN A USEFUL VARIETY OF NIB SIZES...

S (SMALL)

F (FINE)

M (MEDIUM) AND

B (BRUSH TIP)

ALSO **C** (CALLIGRAPHIC), AND **XS** (EXTRA SMALL) THEY ARE QUICK TO RUN OUT, BUT - BOUGHT IN PACK SETS, OR IN BULK - RELATIVELY CHEAP AND DISPOSABLE.

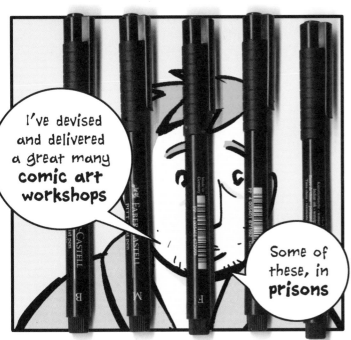

I've devised and delivered a great many **comic art workshops**

Some of these, in **prisons**

ON OCCASION THESE PENS PROVED TO BE VERY **POPULAR** - EVEN BEYOND THE CONFINES OF THE CLASSROOM, BECOMING THE 'HIT OF THE WING'...

...TRADED BACK AND FORTH FOR SNOUT (CIGARETTES).

ORIGINALLY I ASSUMED THIS MEANT MANY PRISONERS APPRECIATED BEING SUPPLIED WITH SUCH PROFESSIONAL QUALITY MARKERS - A PROPER BIT OF KIT, FOR ONCE.

LATTERLY IT TURNS OUT, MOST LIKELY THE WORKSHOP PENS WERE BEING USED TO MAKE **TATTOOS**...LATEST PRISON POLICY OFTEN STIPULATES, 'NO INKS'. ER...

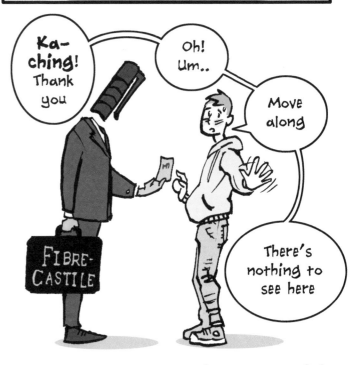

Ka-ching! Thank you

Oh! Um..

Move along

There's nothing to see here

FIBRE-CASTILE

Q. SO WHAT WAS **THIS** ABOUT?

A. HAND TO EYE CO-ORDINATION.

EVERYBODY'S **CO-ORDINATION**, HAND TO EYE, IS DIFFERENT. SOME DRAWERS STRIKE LIKE LIGHTNING, WHILE OTHERS MOVE SLOW AND STEADY.

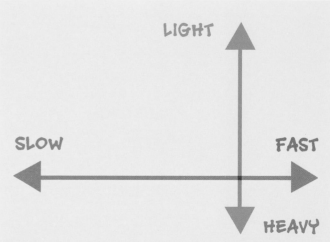

IT'S TORTOISE AND HARE. THERE'S NO RIGHT OR WRONG WAY. NO MATTER **HOW**, EVERYBODY GETS TO THE FINISH(ED) LINE.

IT ALL COMES DOWN TO FINDING OUT WHAT DRAWING TOOLS BEST SUIT YOU – NOT ONLY FOR THE KIND OF COMICS THAT YOU WANT TO DRAW, BUT ALSO ACCORDING TO HOW YOUR BRAIN BEST COMMUNICATES WITH YOUR HAND, VIA THE EYE (OR IS IT THE EYE VIA THE BRAIN?)

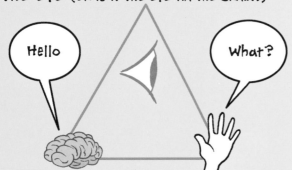

THE ONLY WAY TO REALLY FIND OUT IS TO **DRAW**, DRAW, THEN DRAW SOME MORE. TRY OUT EVERY DRAWING TOOL THAT YOU COME ACROSS, AND JUST **MAKE MARKS**. IT DOESN'T MATTER SO MUCH **WHAT**. IT DOESN'T HAVE TO **BE** ANYTHING.

YOU ARE GETTING TO KNOW HOW TO DRAW, BY FINDING OUT HOW **YOU** DRAW – WHAT WORKS BEST FOR YOU IN **YOUR** HANDS.

MY HAND MOVES **FAST**, AND I'M **HEAVY** HANDED. THIS MEANS I DRAW BEST IN FELT-TIP MARKER, OR WITH A BRUSHPEN. HARD PENCILS AND REAL INK BRUSHES ARE, FOR ME, A BUST. I SUCK WITH THOSE.

YOUR DRAWING NEEDS AND SOLUTIONS – THE TOOLS OF THE TRADE THAT BEST SUIT YOU – MAY WELL BE DIFFERENT.

SO **TRY THEM ALL!**

MOST SHOPS SELLING **STATIONERY** AND **ART MATERIALS** WILL HAVE SCRIBBLE PADS IN-STORE FOR YOU TO TRY BEFORE YOU BUY – MAKE THE **SCRIBBLE PAD** YOUR FRIEND.

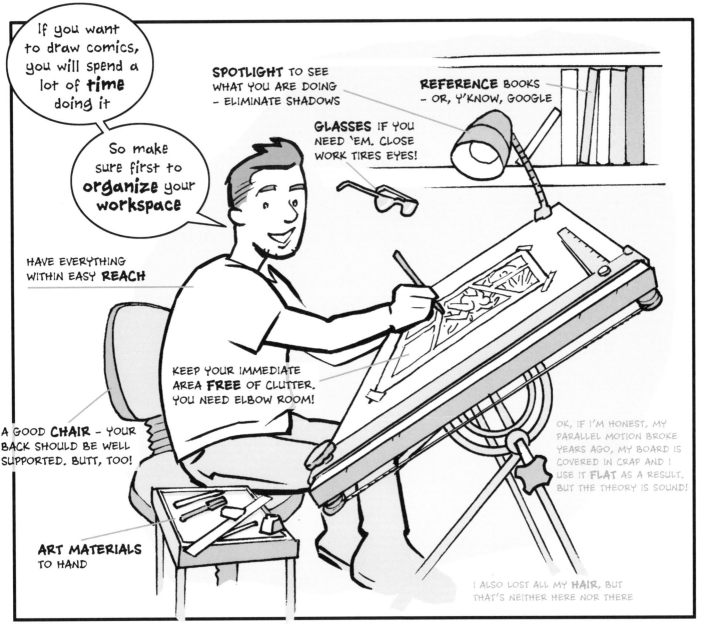

A PROFESSIONAL **DRAWING BOARD** IS A WORTHWHILE INVESTMENT, ONE WITH **PARALLEL MOTION** (A FIXED RULING SLIDE) EVEN BETTER – IT SPEEDS THINGS UP WHEN YOU NEED TO RULE OUT PANELS ACROSS HUNDREDS OF PAGES! **BUT** (THERE'S ALWAYS A BUT) IT ISN'T ESSENTIAL. EVEN FAMOUS COMICS ARTISTS STILL SOMETIMES WORK FROM THEIR KITCHEN TABLE...ONCE A TRAMP, ALWAYS A TRAMP...

IN AN IDEAL WORLD YOU SHOULD ALWAYS WORK AT A 45-DEGREE **ANGLE**. THIS IS BECAUSE WORKING ON A FLAT SURFACE CAN FOOL THE EYE SOMETHING ROTTEN.

YOU THINK YOU ARE DRAWING **THIS**...A MIGHTY SUPERHERO!

BUT WHEN YOU HOLD IT **UP**, WHAT YOU'VE ACTUALLY DRAWN IS THIS...SUCKY DWARF.

AND DON'T HUNCH OVER EITHER, IT WILL EVENTUALLY **KILL** YOUR BACK.

A LARGE, CLEAN, SOLID PIECE OF BOARD PROPPED AT AN ANGLE WILL DO FINE. ALL SET? THEN YOU'RE **READY TO DRAW**...

A STEP-BY-STEP GUIDE TO DRAWING THE HUMAN HEAD

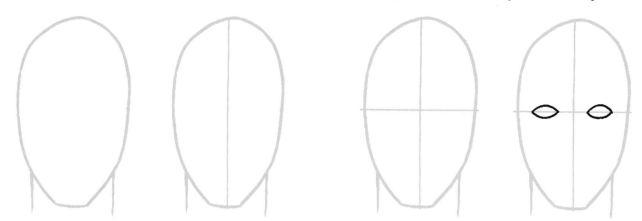

1) START BY DRAWING A SIMPLE OVAL SHAPE. 2) DIVIDE THE OVAL IN HALF, VERTICALLY. 3) DIVIDE IN HALF, HORIZONTALLY. 4) THIS IS YOUR **EYELINE** - IT CAN SEEM SURPRISING BUT OUR EYES IN FACT COME **HALF** THE WAY DOWN MOST NORMAL HEADS OR FACES...

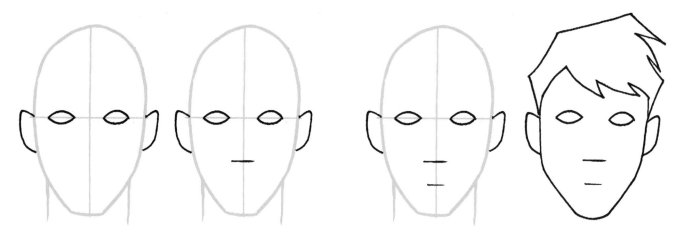

4) THE **EARS** HANG OFF THIS EYELINE, LEVEL WITH THE EYES. 5) HALFWAY AGAIN DOWN THE LOWER FACE COMES THE **NOSE**. 6) AND HALFWAY IN THE SPACE BELOW THAT, THE **MOUTH**. ADD THEM ALL TOGETHER AND - TA DA! - YOU'VE DRAWN **MICHAEL MYERS**.

YOU KNOW, MICHAEL MYERS - THE SHAPE FROM HALLOWEEN...WHICH IS TO SAY THAT ALL THIS WILL GIVE YOU IS A SIMPLE, GENERIC FACE IN PERFECT PROPORTION. IT WAS A MASK APPARENTLY CAST FROM ACTOR **WILLIAM SHATNER**, CAPTAIN **KIRK** FROM ORIGINAL **STAR TREK**.

(LEAVE ROOM FOR **HAIR**)

IT MAY BE **GENERIC**, BUT EVEN AFTER 30 YEARS OF DRAWING COMICS, I STILL START OUT CONSTRUCTING EVERY FACE ON EVERY FIGURE IN THIS SAME BASIC WAY.

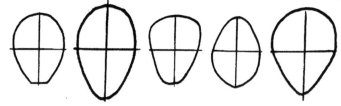

YOU CAN **MIX IT UP**, OF COURSE. HEADS COME IN ALL SHAPES AND SIZES, SO WORK SOME VARIATIONS INTO YOUR CHARACTERS. TRY DRAWING A **HEAD** YOURSELF, HERE -

HEAD TURNS

SO WHY IS IT USEFUL TO CONSTRUCT THE HEAD IN THIS WAY EVERY TIME? I'M GLAD YOU ASKED. IN ANY COMIC FEATURING THE SAME CHARACTER OVER AND OVER, IT'S CRUCIAL THAT THEY REMAIN INSTANTLY **RECOGNIZABLE** TO THE READER, NO MATTER WHAT.

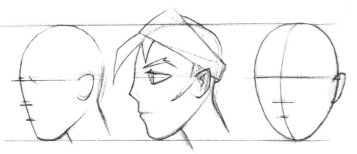

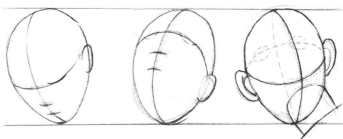

ONCE YOU HAVE THE BASIC DESIGN, YOU WORK OUT WHAT THE SAME CHARACTERS LOOK LIKE IN PROFILE (FROM THE SIDE). THEN IN THREE-QUARTER TURNS, ETC.

ALLOW THE BASIC HEAD SHAPE TO TURN IN SPACE, MAINTAINING PROPORTION. IN THIS WAY YOU CAN DRAW IT FROM ABOVE, OR BELOW - EVEN FROM BEHIND.

ONCE YOU HAVE DECIDED ON FACE AND HEAD SHAPES, THE **PROPORTIONS** OF EACH CHARACTER - THIS ONE WITH EYES FURTHER APART, THE NEXT CHINLESS, AND SO ON - THEN CONSTRUCTION DRAWINGS EACH TIME HELP KEEP THEM 'ON MODEL'.

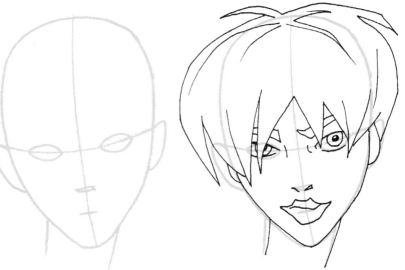

EVERY ANIMATION HOUSE PRODUCES MODEL SHEETS FOR EACH OF THEIR CHARACTERS IN EXACTLY THIS SAME WAY - A MASTER SET OF BASIC DESIGN PRINCIPLES SO THAT EVERY DIFFERENT ANIMATOR WORKING ON THE SAME PROJECT CAN MAINTAIN THE SAME DESIGN.

BUILD UP YOUR CHARACTER DRAWING ON TOP OF THE BASIC CONSTRUCTION LINES.

WHEN THEY TURN, YOU DO LIKEWISE. A SIGNATURE HAIRSTYLE OFTEN HELPS. MAKE CHARACTERS UNIQUE, INDIVIDUAL.

(IDEALLY THEIR SILHOUETTED OUTLINE SHOULD BE UNMISTAKEABLE, EVEN SEEN AT A DISTANCE.)

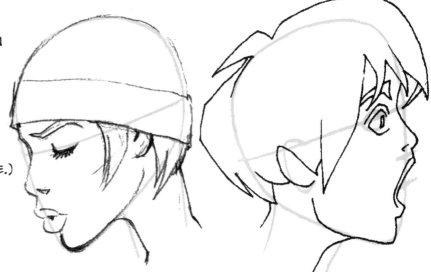

SAME DIFFERENCE - IN A COMIC FEATURING A GREAT MANY CHARACTERS, THEY ALL MUST BE DISTINCT FROM ONE ANOTHER. HEAD/FACIAL CONSTRUCTION IS BASIC IN THEIR DESIGN.

MODEL SHEETS LIKE THESE, PINNED ABOVE MY DESK, ARE A CONSTANT REFERENCE TOOL.

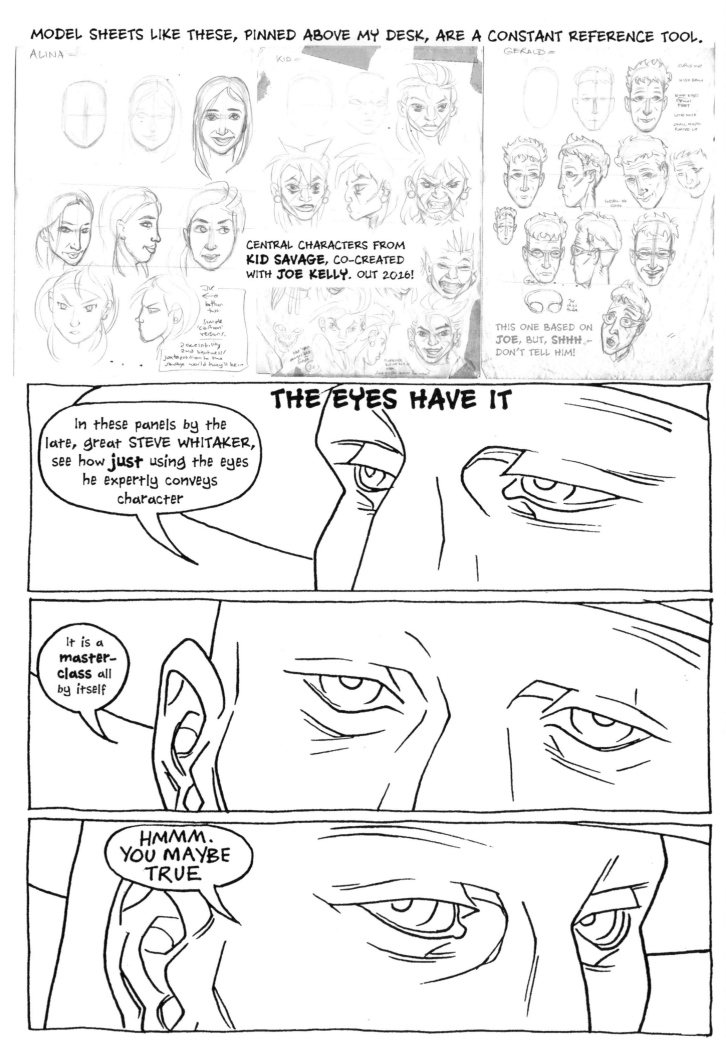

CENTRAL CHARACTERS FROM **KID SAVAGE**, CO-CREATED WITH **JOE KELLY.** OUT 2016!

THIS ONE BASED ON **JOE**, BUT, **SHHH** — DON'T TELL HIM!

THE EYES HAVE IT

In these panels by the late, great STEVE WHITAKER, see how **just** using the eyes he expertly conveys character

It is a **master-class** all by itself

HMMM. YOU MAYBE TRUE

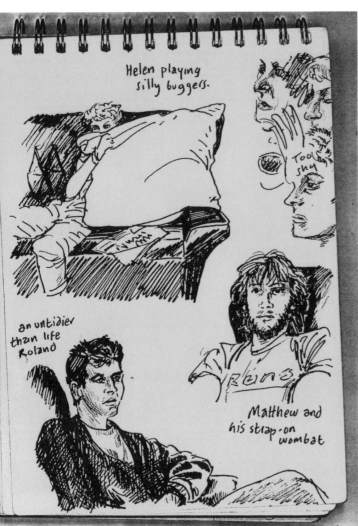

Helen playing silly buggers.

Too shy

an untidier than life Roland

Matthew and his strap-on wombat

MOST COMICS FEATURE AND REFLECT, IN SOME WAY, **HUMAN BEHAVIOUR** – SAME AS IF WE WERE LIZARDS, THEY'D BE MORE, UH, LIZARD-BASED. HOWEVER YOU ARRIVE AT IT, AND ALWAYS IN YOUR OWN WAY, AIM TO BECOME ADEPT AT DRAWING THE HUMAN FACE AND FIGURE.

SKETCH FROM LIFE. **LIFE DRAWING** IS **THE** BEST WAY TO LEARN HOW TO DRAW PEOPLE. IF YOU CAN'T FIND OR AFFORD CLASSES, PERSUADE **FRIENDS** TO POSE FOR YOU. USE A **MIRROR** FOR NO-TECH SELFIES. VOLUNTEER AT A GALLERY OR SIMILAR, TO OBSERVE AND SKETCH ALL SORTS OF PEOPLE AT WORK, REST AND PLAY, ALL DAY LONG.

OBSERVATION IS KEY TO UNDERSTANDING. **CARTOONING** – THE ABILITY TO **DEFINE**, **REFINE**, THEN **REDEFINE** THE WORLD – IS A SKILL CENTRAL TO COMICS. THIS IS HOW YOU START OUT, WITH THE DEFINING PART.

THE MORE FAMILIAR YOU BECOME WITH THE WORLD, HUMANITY FOREMOST, THE BETTER YOU WILL BECOME AT DEPICTING IT UNTIL YOUR COMICS ARE **THE BEST!** WOOT!!

THESE IMAGES DATE BACK TO MY COLLEGE DAYS, BUT WITH LIFE DRAWING, YOU **NEVER** STOP LEARNING...

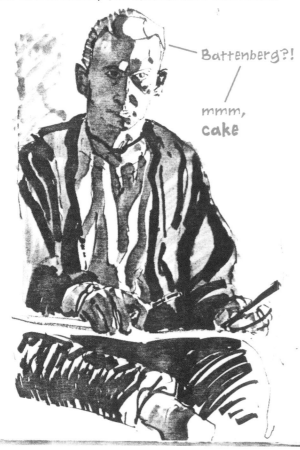

Battenberg?!

mmm, cake

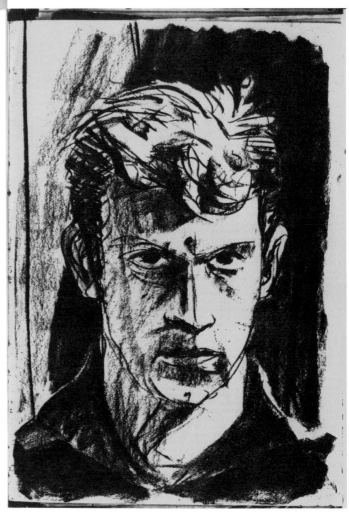

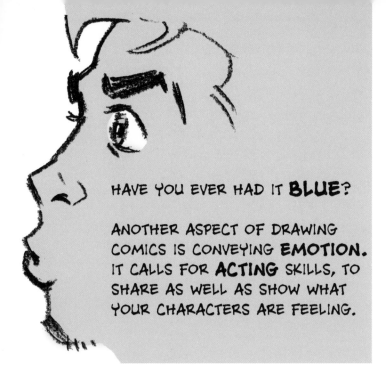

HAVE YOU EVER HAD IT **BLUE**?

ANOTHER ASPECT OF DRAWING COMICS IS CONVEYING **EMOTION**. IT CALLS FOR **ACTING** SKILLS, TO SHARE AS WELL AS SHOW WHAT YOUR CHARACTERS ARE FEELING.

IT MAY SEEM AN **ODD** COMPARISON, BUT I COMPARE THE HUMAN FACE TO A FIVE-BAR GATE. I SAID BEFORE, 'THE EYES HAVE IT', BUT IN THIS CASE THE EYE**BROWS** DO TOO. **EXPRESSIONS** CAN BE OPEN OR CLOSED.

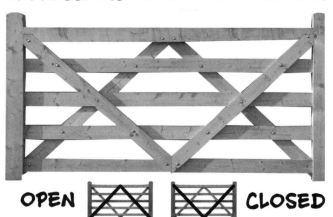

OPEN ⬦ ⬦ CLOSED

THIS MAY LOOK LIKE YOUNG MEN BEING MENACED BY CREEPY PARTY BALLOONS, BUT IT'S TO SHOW HOW ANY FACIAL EXPRESSION BOILS DOWN TO CLASSIC CARTOON ICONOGRAPHY. SIMPLE **DOTS** FOR EYES AND A **LINE** FOR THE MOUTH IS ALL THAT YOU ULTIMATELY NEED. THE REST IS GRAVY. OWN THE ICONS AND YOU CAN PULL ANY FACIAL EXPRESSION YOU LIKE.

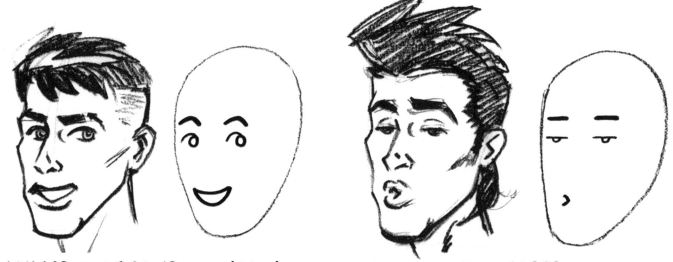

MOUTHS PLUS **BROWS** – THE 'GATE' – OPEN OR CLOSE THE FACE. **NOSES**? NOT SO MUCH.

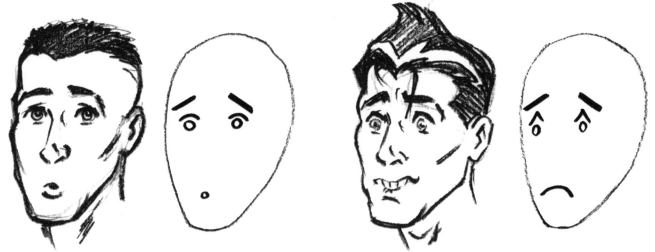

ANIMALS USE THEIR **EARS** AND **TAILS** IN THE SAME WAY – EARS BACK OR FORWARD, THE TAIL WAGGING (OR WAIT, IS IT **THRASHING**? UH OH). WE PROBABLY WOULD TOO IF WE HAD THEM.

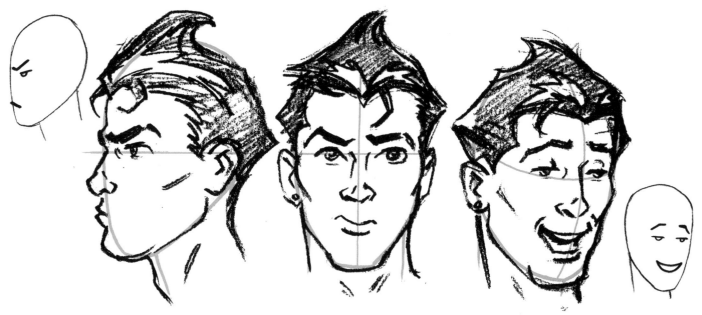

OK, SO, BY **HERE** – FOLLOWING A FEW 'LIVE' EXPERIMENTS ON THE PREVIOUS PAGE – I'VE SETTLED ON THE SIGNATURE **HAIRSTYLE** FOR MY CHARACTER. LET'S CALL HIM...**DOOFUS.** IT'S SORT OF A TRIBUTE TO A HIPSTER FIN, EXCEPT MORE LIKE JUMPING THE WHOLE SHARK.

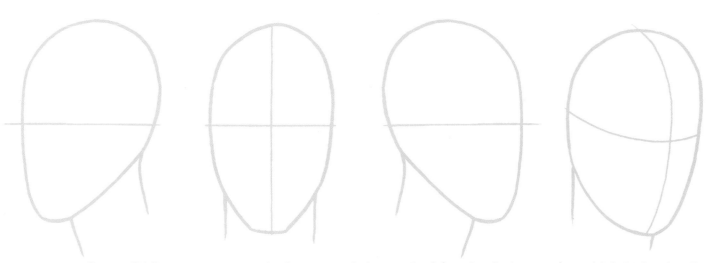

FORGET **DOOFUS**, INVENT A CHARACTER OF YOUR **OWN**. USING DUMMY HEADS LIKE THESE, WHILE MAKING SURE THEY REMAIN RECOGNIZABLY THE SAME PERSON, PRACTISE SHOWING A WHOLE RANGE OF DIFFERENT EMOTIONS: FROM EXTREME (SAD, ECSTATIC, TERRIFIED) TO SUBTLE (CURIOUS, HESITANT, BEMUSED), AND SO ON. I FIND IT HELPS TO IMAGINE YOURSELF IN SITUATIONS THAT INSPIRE THE SAME FEELINGS IN YOU (THE **SHARING**), EVEN SO FAR AS **PULLING FACES** AS YOU DRAW (THE **SHOW**, OR 'ACTING' PART). YOU'LL SENSE HOW YOUR OWN **EXPRESSION** CHANGES. THIS WORKS EVEN WITHOUT A MIRROR – ALTHOUGH ANYBODY WHO SEES YOU DOING IT MIGHT THINK YOU'VE CRACKED. I SIT IN MY STUDIO PULLING FACES, EVEN ADDING IN MY OWN SOUND EFFECTS, AND THEY HAVEN'T CARTED ME AWAY YET...

PHOTOGRAPHS ARE DEAD THINGS. THEY JUST DON'T CUT IT. IF YOU FEEL YOU NEED TO DRAW FROM THEM, MY ADVICE IS TO MAKE A FIRST DRAWING, THEN TO PUT THE PHOTO ASIDE. YOU MAKE A FRESH DRAWING USING YOUR FIRST AS REFERENCE. THIS BRINGS THE IMAGE BACK TO LIFE, LESS 'FROZEN'.

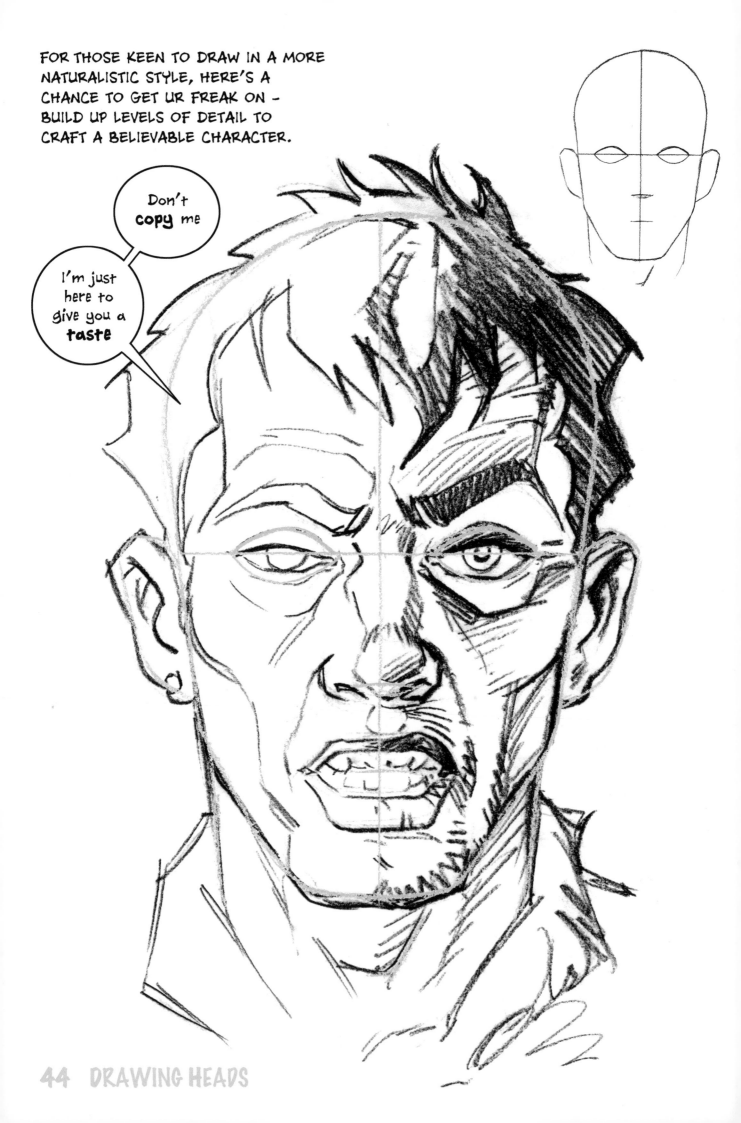

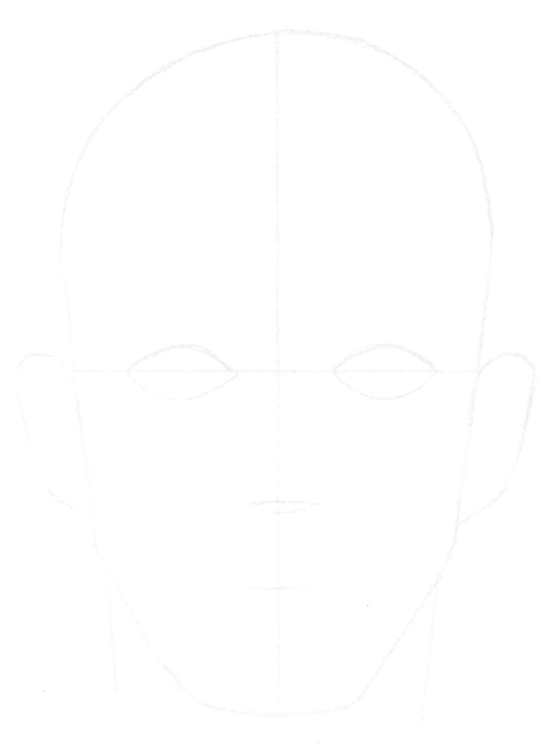

THE STRUCTURE BENEATH
HELPS TO KEEP THE FACE
PROPORTIONATE AND RECOGNIZABLE
– BUT USE THIS LARGER TEMPLATE ANY
WHICH WAY YOU WANT TO. FEEL FREE TO DEVIATE FROM THE GENERIC MODEL –
A BIGGER NOSE OR EARS, LOPSIDED MOUTH, EYES CLOSER OR FARTHER APART.
IRREGULAR FEATURES ARE MORE FUN AND MAKE FOR LIVELIER CHARACTERS.

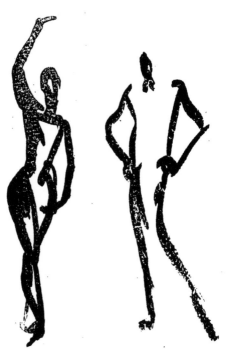

SKETCHING FROM LIFE IS A FOUNDATION OF FIGURE DRAWING. MAKE A STUDY OF SCULPTURE — THE LIKES OF **DURER, ERIC GILL**, MICHELANGELO'S **DAVID**, AND **RODIN**'S **THE KISS**. POSES AT LEFT WERE RECORDED BY ATTENDING DANCE CLASS, ALSO A FAVOURITE SUBJECT OF THE PAINTER, **DEGAS**. NOTE HOW I TRY TO CAPTURE THE ESSENTIAL MOVEMENT WITH QUICK GESTURAL MARKS. RECOMMENDED BOOKS — JENO BARCSAY'S **ANATOMY FOR THE ARTIST** IS THE BEST; BURNE HOGARTH'S **DYNAMIC ANATOMY** IS ECCENTRIC; ANATOMY FOR FANTASY ARTISTS HAS ITS MOMENTS; JOHN BUSCEMA, **HOW TO DRAW COMICS THE MARVEL WAY**...

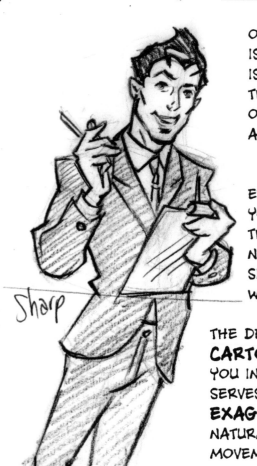

OH LOOK, **DOOFUS** IS BACK. THE **STANCE** IS OFF-CENTRE, YET THIS ADDS TO A SENSE OF CONSTANT MOTION, A SPRING IN HIS STEP...

EVEN SAT DOWN, YOU CAN KEEP THINGS **LIVELY**. NO TWO PEOPLE SIT THE SAME WAY...

THE DEGREE OF **CARTOONING** YOU INTRODUCE SERVES TO **EXAGGERATE** NATURAL BODY MOVEMENTS.

Sharp

Chelsea Boots

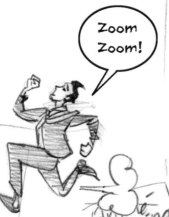

Zoom Zoom!

Colouring

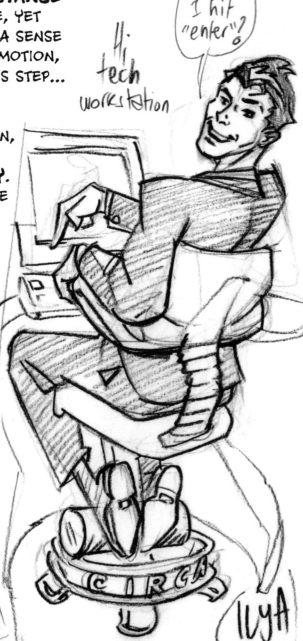

Hi tech workstation

Shall I hit "enter"?

ILYA

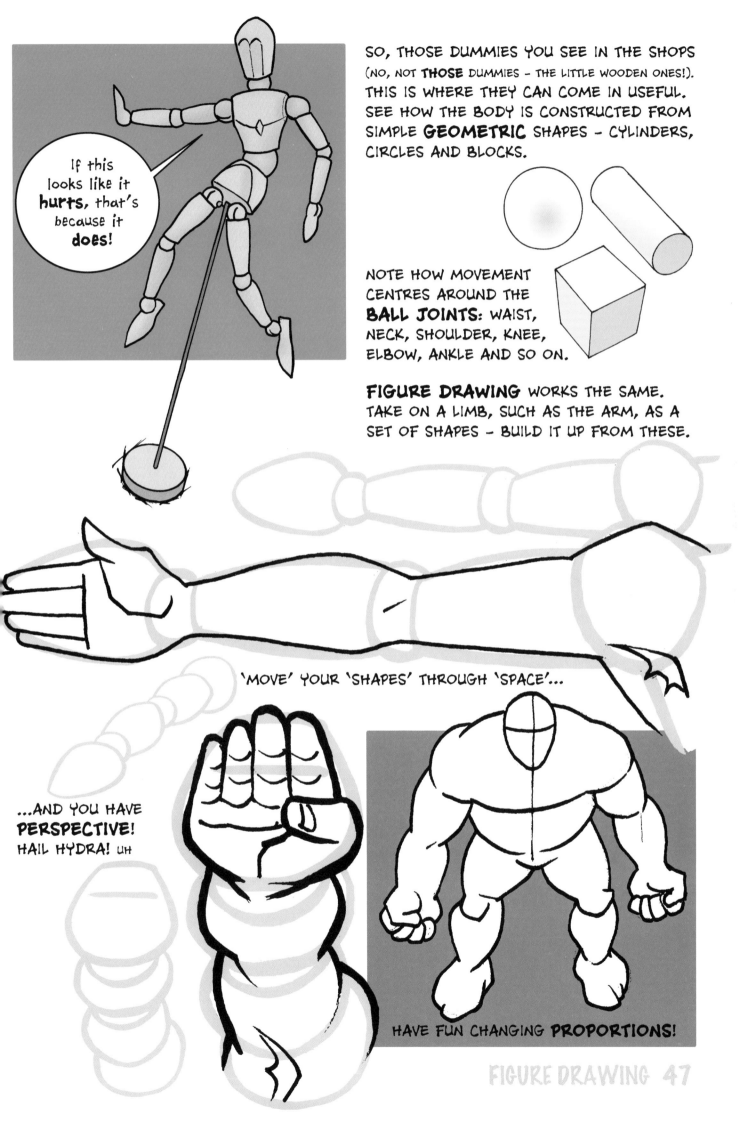

TO CONSTRUCT A FIGURINE (1) IN WHATEVER PROPORTION, IN ANY POSE, BUILD IT UP FROM A SIMPLE WIRE FRAME DRAWING (2). TRY THIS OUT YOURSELF USING THE THIRD EXAMPLE.

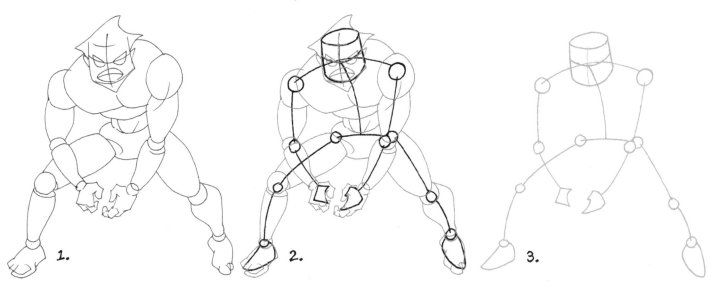

1. 2. 3.

TRY OUT ALL **DIFFERENT** SORTS OF BODY SHAPES, SIZES, REST **AND** ACTION POSES.

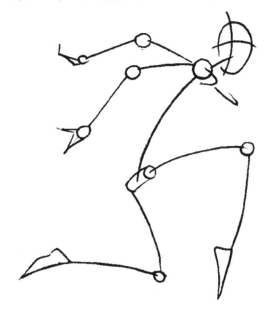

STARTING OUT WITH A LIGHTLY DRAWN WIRE FRAME, SKETCH OUT YOUR FIGURINE ON TOP.

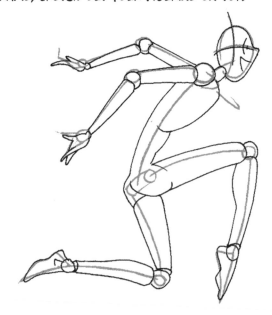

PRACTISE MORE USING THE PAGE OPPOSITE. **COSTUME** AND **DESIGN** THE FIGURES YOU MAKE. START OUT BY USING **THIS** ONE...

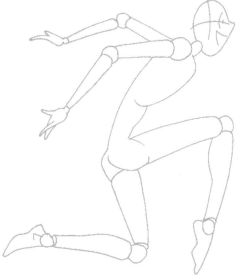

IN USING THESE EXAMPLES, AND WHEN MAKING UP MORE OF YOUR OWN, BE THINKING – WHO, OR WHAT, ARE THEY?

WHAT ARE THEY **WEARING**?

WHY THIS OR THAT POSE OR ACTION? WHAT **SITUATION** MIGHT THEY BE IN? AND **WHERE**?

WHO OR WHAT COULD THEY BE **INTERACTING** WITH?

YOU CAN BEGIN TO ADD SOME OF THESE DETAILS IN. THEN, BEFORE YOU KNOW IT, YOU'RE STARTING TO TELL **STORIES**...

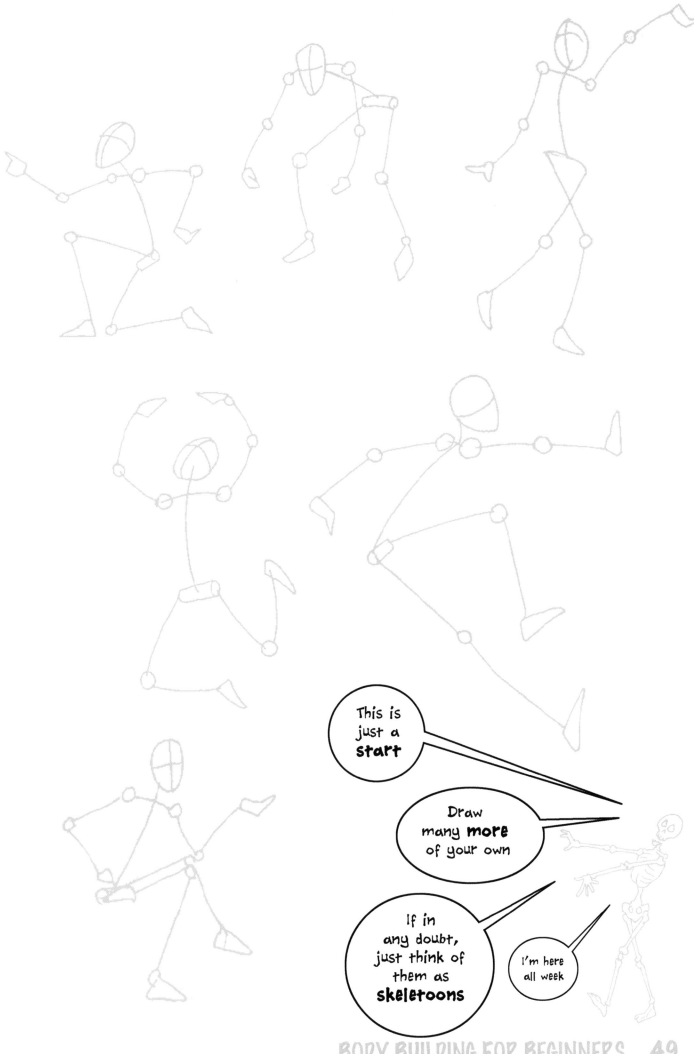

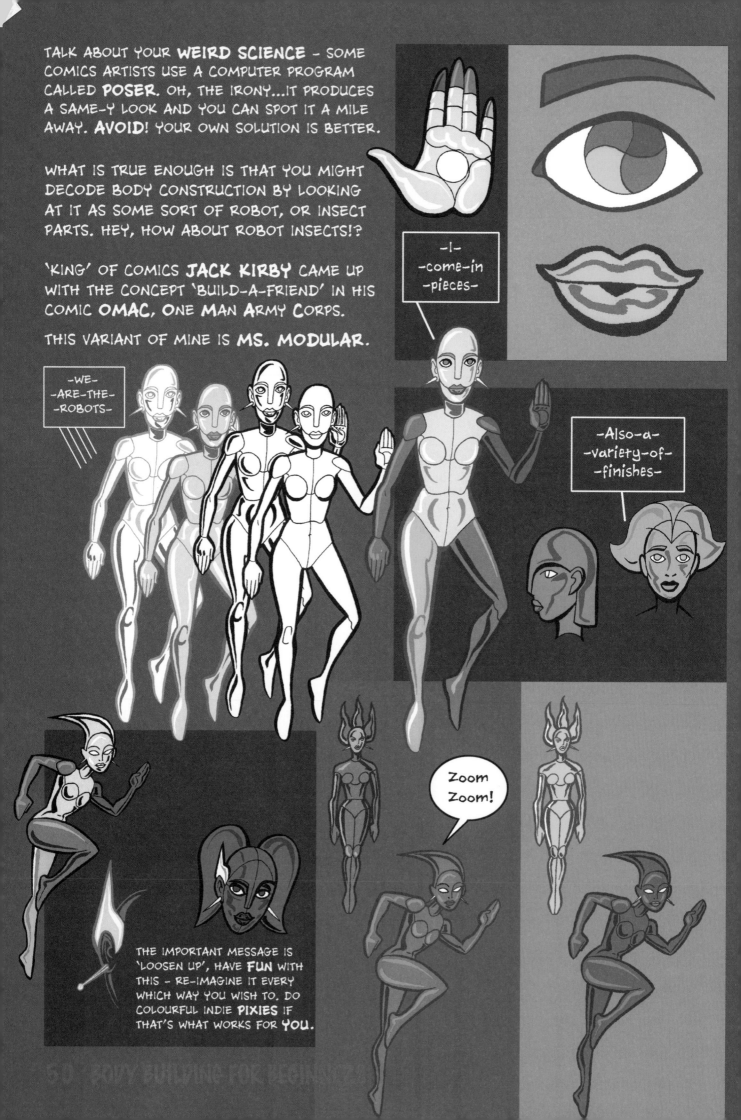

TALK ABOUT YOUR **WEIRD SCIENCE** – SOME COMICS ARTISTS USE A COMPUTER PROGRAM CALLED **POSER**. OH, THE IRONY...IT PRODUCES A SAME-Y LOOK AND YOU CAN SPOT IT A MILE AWAY. **AVOID!** YOUR OWN SOLUTION IS BETTER.

WHAT IS TRUE ENOUGH IS THAT YOU MIGHT DECODE BODY CONSTRUCTION BY LOOKING AT IT AS SOME SORT OF ROBOT, OR INSECT PARTS. HEY, HOW ABOUT ROBOT INSECTS!?

'KING' OF COMICS **JACK KIRBY** CAME UP WITH THE CONCEPT 'BUILD-A-FRIEND' IN HIS COMIC **OMAC**, ONE MAN ARMY CORPS.

THIS VARIANT OF MINE IS **MS. MODULAR**.

–I–
–come–in
–pieces–

–WE–
–ARE–THE–
–ROBOTS–

–Also–a–
–variety–of–
–finishes–

Zoom Zoom!

THE IMPORTANT MESSAGE IS 'LOOSEN UP', HAVE **FUN** WITH THIS – RE-IMAGINE IT EVERY WHICH WAY YOU WISH TO. DO COLOURFUL INDIE **PIXIES** IF THAT'S WHAT WORKS FOR **YOU**.

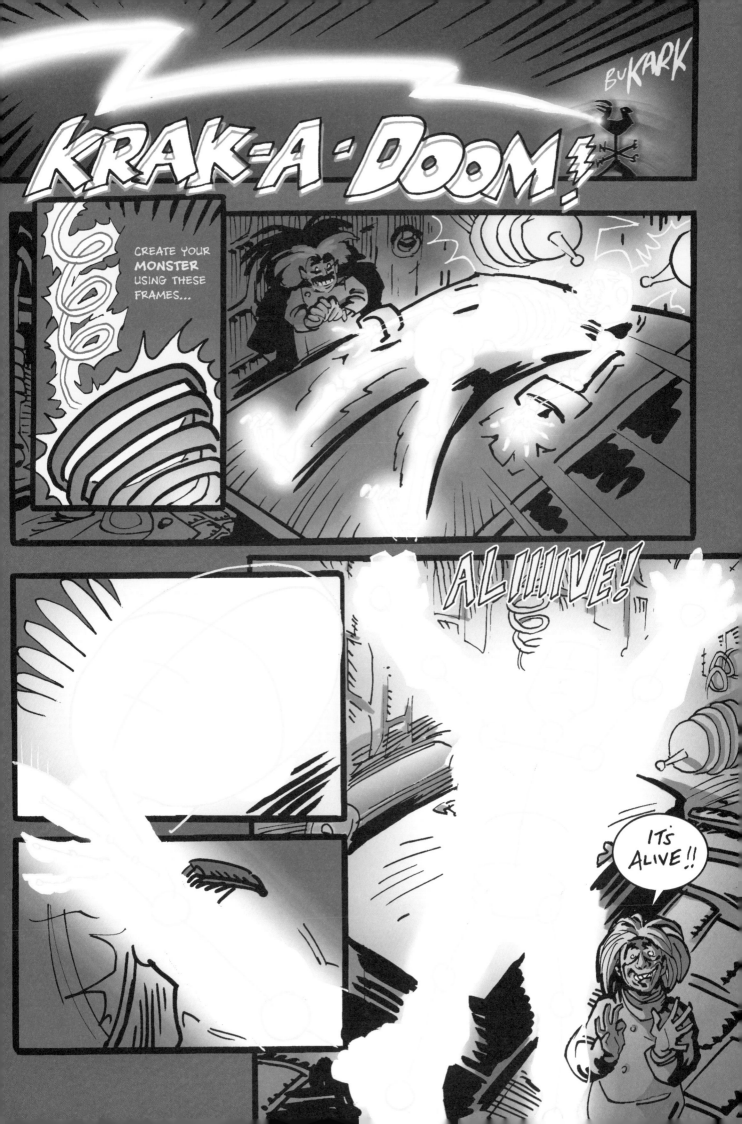

THE BODILY PROPORTION OF THE AVERAGE ADULT IS APPROXIMATELY SIX HEADS HIGH.

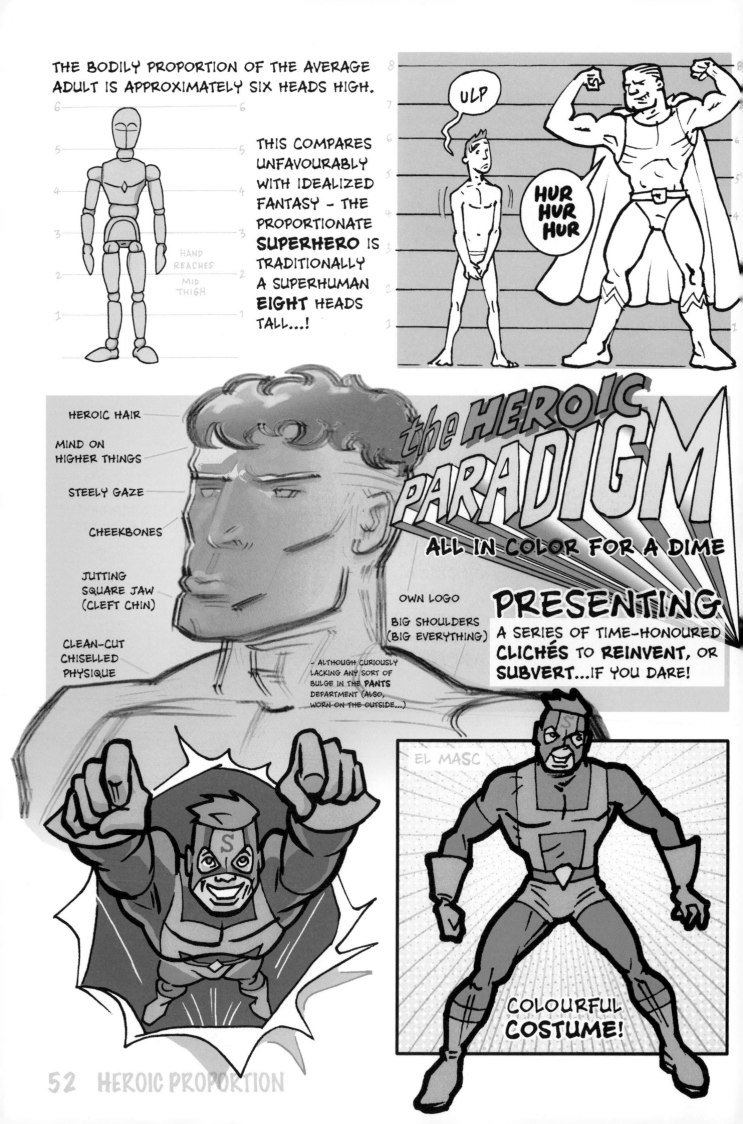

THIS COMPARES UNFAVOURABLY WITH IDEALIZED FANTASY - THE PROPORTIONATE **SUPERHERO** IS TRADITIONALLY A SUPERHUMAN **EIGHT** HEADS TALL...!

HAND REACHES MID THIGH

ULP

HUR HUR HUR

HEROIC HAIR

MIND ON HIGHER THINGS

STEELY GAZE

CHEEKBONES

JUTTING SQUARE JAW (CLEFT CHIN)

CLEAN-CUT CHISELLED PHYSIQUE

- ALTHOUGH CURIOUSLY LACKING ANY SORT OF BULGE IN THE **PANTS** DEPARTMENT (ALSO, WORN ON THE OUTSIDE...)

OWN LOGO

BIG SHOULDERS (BIG EVERYTHING)

the **HEROIC PARADIGM**

ALL IN COLOR FOR A DIME

PRESENTING

A SERIES OF TIME-HONOURED **CLICHÉS** TO REINVENT, OR **SUBVERT**...IF YOU DARE!

EL MASC

COLOURFUL COSTUME!

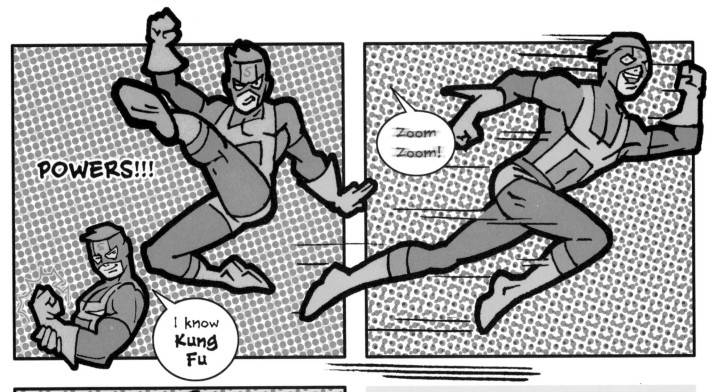

STANDING UP FOR IDEALS OF **TRUTH, JUSTICE,** AND...ER, WASN'T THERE SOMETHING **ELSE?**

OR IS IT **MIGHT** THAT **MAKES RIGHT?**

THEN OF COURSE THERE'S THE HANDY CIVILIAN **ALTER EGO,** THAT SOMEHOW NO ONE EVER RECOGNIZES...

A ROGUE'S GALLERY OF NEFARIOUS **VILLAINS,** INCLUDING THE WORST, AN **ARCH-ENEMY,** YOUR EVIL OPPOSITE NUMBER – ALTHOUGH TECHNICALLY ONLY THE **HERO** CAN BE THE(IR) **NEMESIS** (NAMED FOR THE GODDESS OF RETRIBUTIVE JUSTICE).

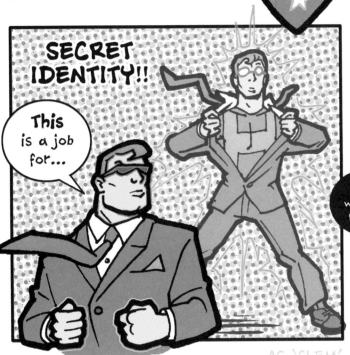

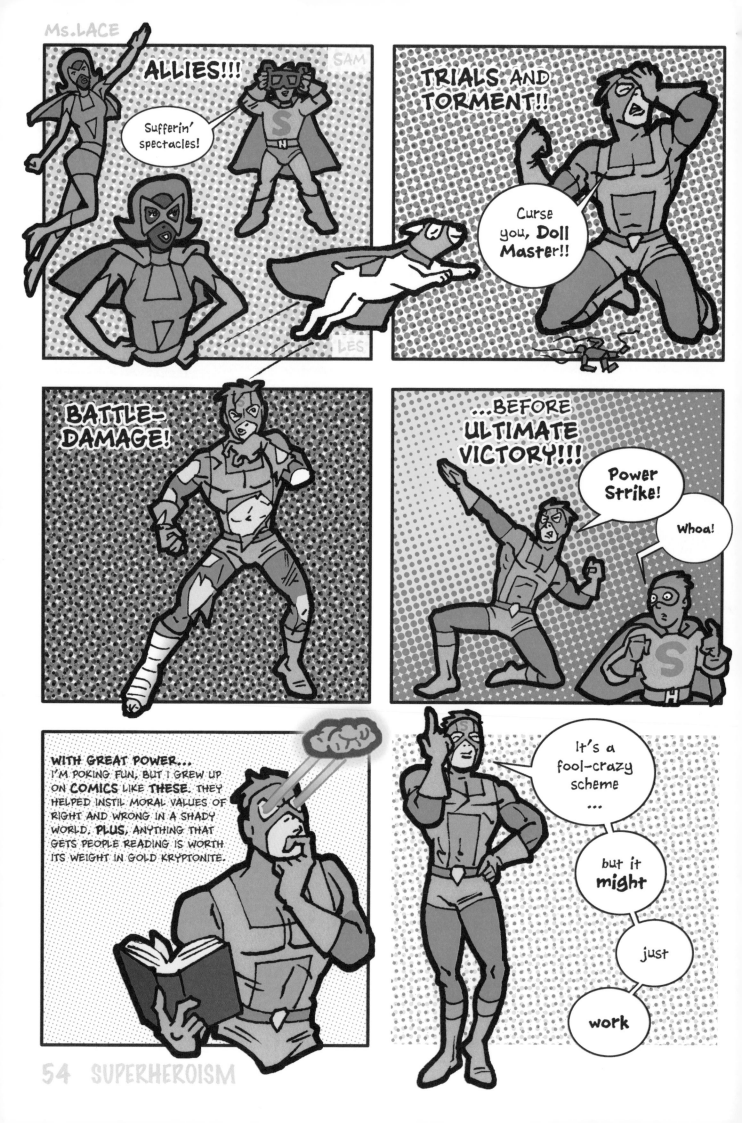

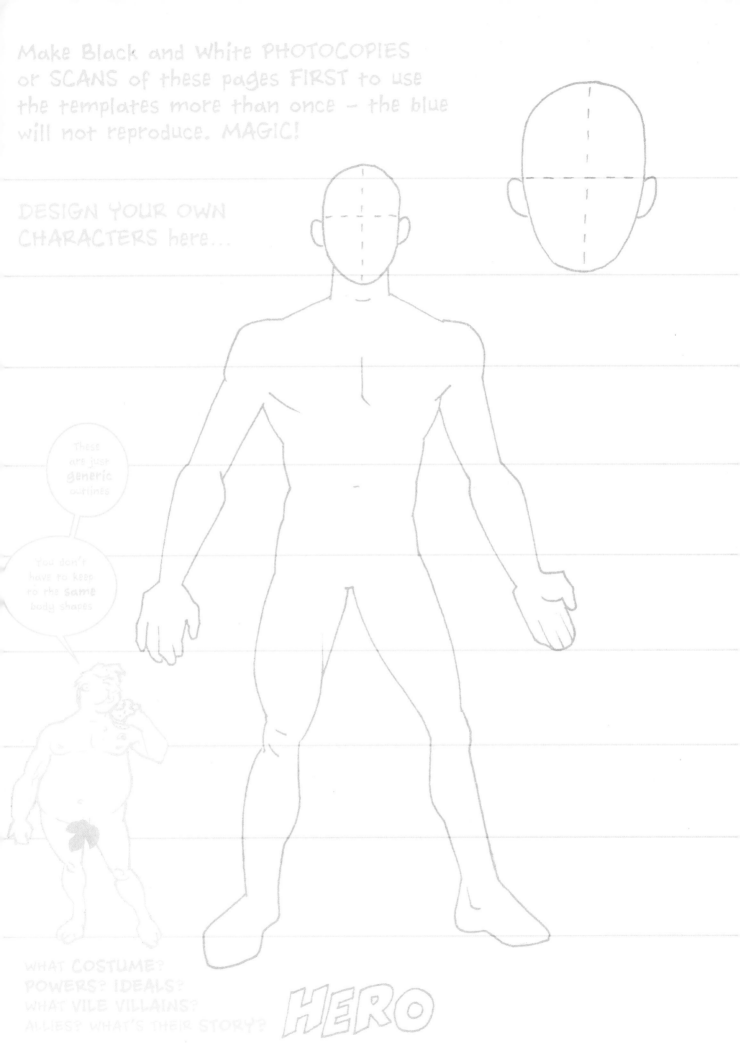

Make Black and White PHOTOCOPIES or SCANS of these pages FIRST to use the templates more than once - the blue will not reproduce. MAGIC!

DESIGN YOUR OWN CHARACTERS here...

These are just generic outlines

You don't have to keep to the same body shapes

WHAT COSTUME?
POWERS? IDEALS?
WHAT VILE VILLAINS?
ALLIES? WHAT'S THEIR STORY?

HERO

REMEMBER: THE AVERAGE ADULT
HUMAN PROPORTION IS SIX HEADS HIGH.
THE IDEALIZED **SUPERHUMAN** BECOMES
EIGHT HEADS TALL.
BUT FEEL FREE TO BREAK WITH
TRADITION – THERE ARE **NO RULES!**
REMAKE THE HEROIC IDEAL YOUR WAY.

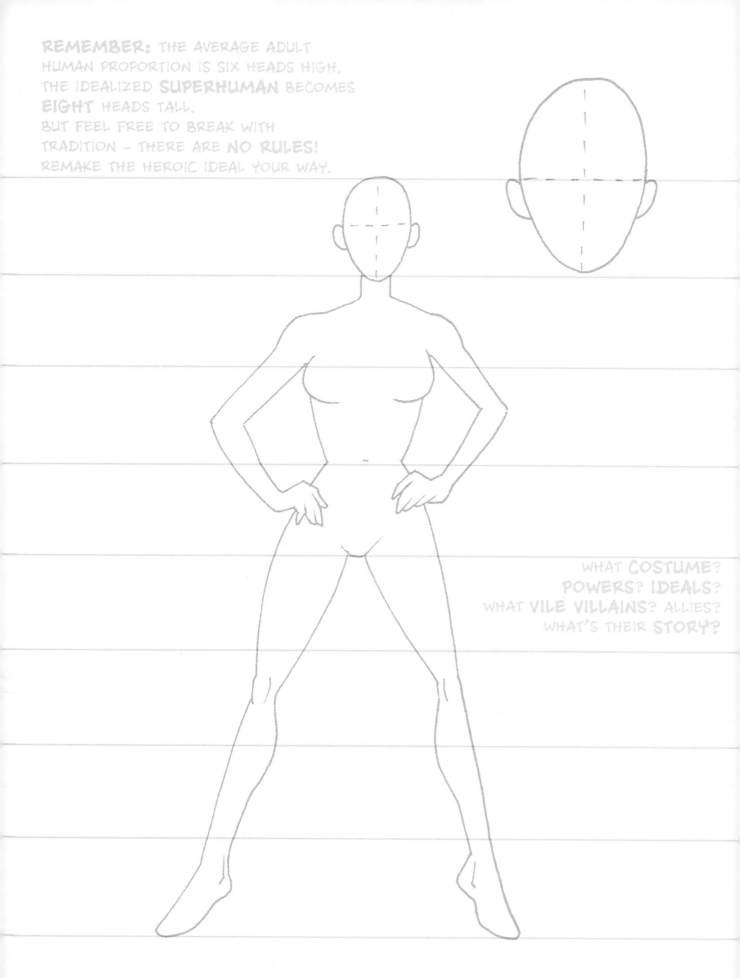

WHAT **COSTUME?**
POWERS? IDEALS?
WHAT **VILE VILLAINS?** ALLIES?
WHAT'S THEIR **STORY?**

HEROINE

GIVE YOUR **CHARACTERS**
NAMES – **WHO ARE THEY?**

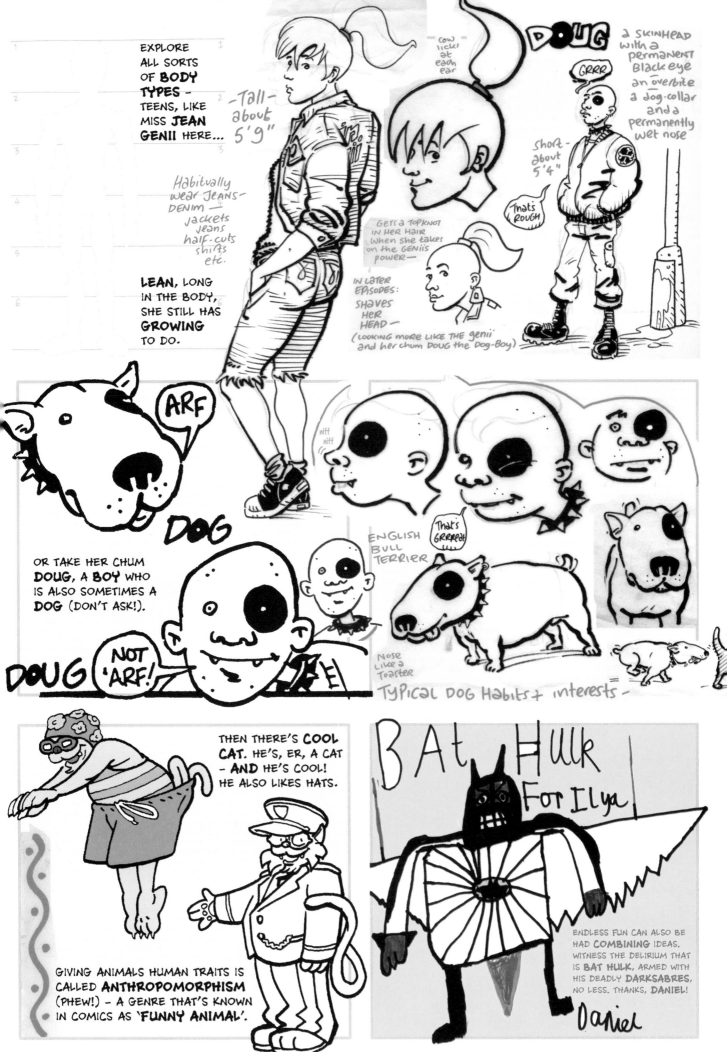

AIM FOR A PROPERLY **DIVERSE** CAST OF CHARACTERS, WITHOUT RESORTING TO TOKENISM OR OVERSTRETCHING THE POINT. REFLECT **REALITY** BOTH AS YOU KNOW IT, AND AS YOU WOULD LIKE IT TO BE. FOLKS NEED TO SEE THEMSELVES REFLECTED IN THE STORIES THEY BEST ENJOY — EVEN WHEN FANTASIES. IN RECENT TIMES THE **MARVEL** UNIVERSE, **STAR WARS**, THE **OSCARS** TOO, HAVE ALL HAD TO BRUSH UP THEIR ACT. BE A RESPECTER OF **AGE**, **RACE, GENDER, SEXUALITY, FAITH, CLASS, CULTURE, SPECIES***, AND NOT JUST OF BODY SHAPE. HEAVENS, PEOPLE, **IT'S THE 21ST CENTURY!**

*PLUS OTHER STUFF I PROBABLY FORGOT

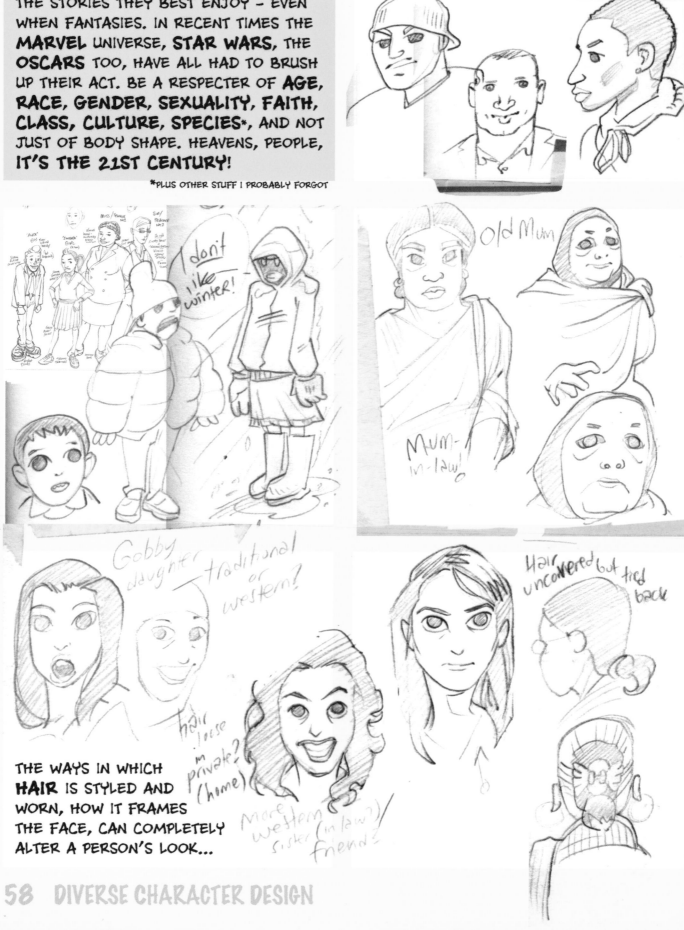

THE WAYS IN WHICH **HAIR** IS STYLED AND WORN, HOW IT FRAMES THE FACE, CAN COMPLETELY ALTER A PERSON'S LOOK...

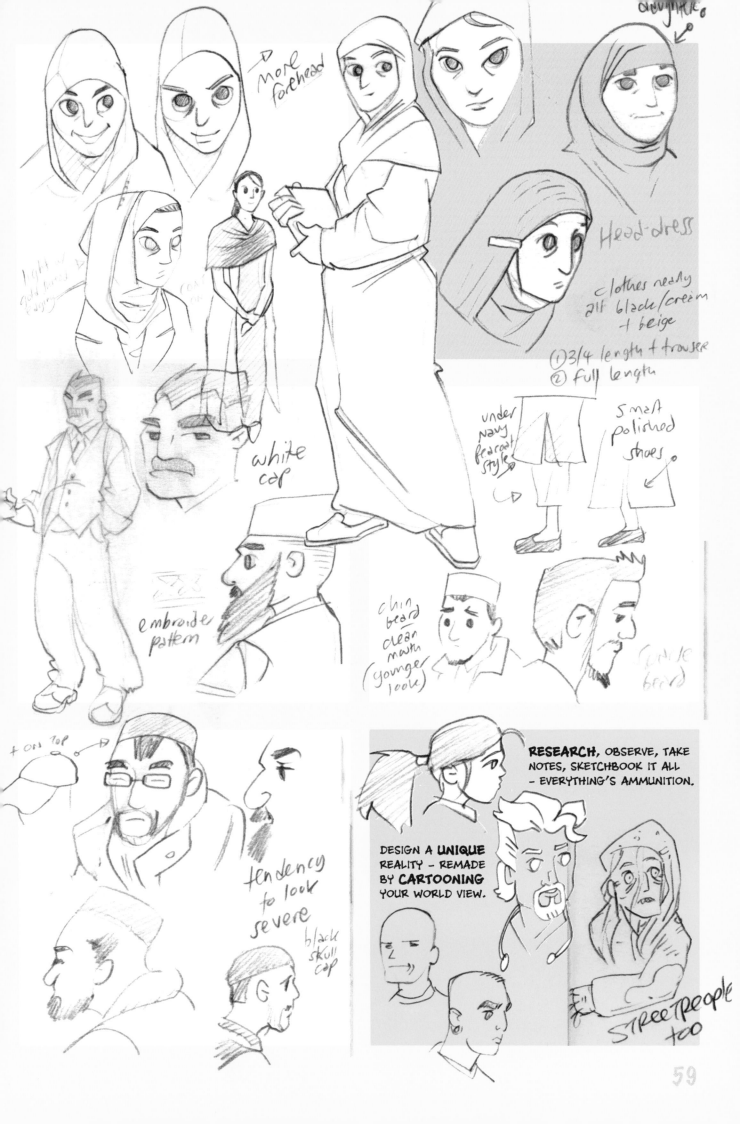

More forehead

Head-dress

clothes nearly all black/cream + beige

① 3/4 length + trouser
② full length

under navy peacoat style

smart polished shoes

white cap

embroider pattern

chin beard = clean mouth (younger look)

subtle beard

tendency to look severe

black skull cap

+ on top

RESEARCH, OBSERVE, TAKE NOTES, SKETCHBOOK IT ALL - EVERYTHING'S AMMUNITION.

DESIGN A UNIQUE REALITY - REMADE BY CARTOONING YOUR WORLD VIEW.

Street people too

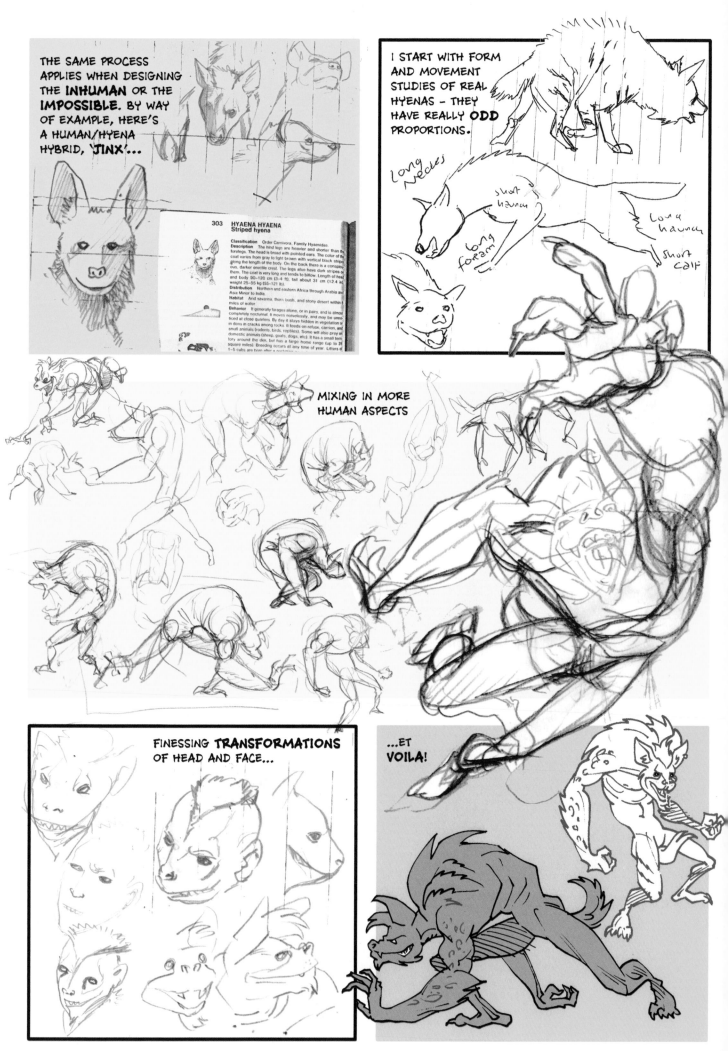

THE SAME PROCESS APPLIES WHEN DESIGNING THE **INHUMAN** OR THE **IMPOSSIBLE.** BY WAY OF EXAMPLE, HERE'S A HUMAN/HYENA HYBRID, 'JINX'...

303 **HYAENA HYAENA**
Striped hyena

Classification Order Carnivora, Family Hyaenidae.
Description The hind legs are heavier and shorter than the forelegs. The head is broad with pointed ears. The color of the coat varies from gray to light brown with vertical black stripes along the length of the body. On the back there is a conspicuous, darker erectile crest. The legs also have dark stripes on them. The coat is very long and tends to billow. Length of head and body 90–120 cm (3–4 ft), tail about 31 cm (12.4 in), weight 25–55 kg (55–121 lb).
Distribution Northern and eastern Arabia and Asia Minor to India.
Habitat Arid savanna, thorn bush, and stony desert within a few miles of water.
Behavior It generally forages alone, or in pairs, and is almost completely nocturnal. It moves noiselessly, and may be unnoticed at close quarters. By day it stays hidden in vegetation or in dens in cracks among rocks. It feeds on refuse, carrion, and small animals (rodents, birds, reptiles). Some will also prey on domestic animals (sheep, goats, dogs, etc.). It has a large territory around the den, but has a large home range (up to 28 square miles). Breeding occurs at any time of year. Litters of 1–5 cubs are born after a gestation...

I START WITH FORM AND MOVEMENT STUDIES OF REAL HYENAS - THEY HAVE REALLY **ODD** PROPORTIONS.

long necks

short haunch

long foream

long haunch

short calf

MIXING IN MORE HUMAN ASPECTS

FINESSING **TRANSFORMATIONS** OF HEAD AND FACE...

...ET VOILA!

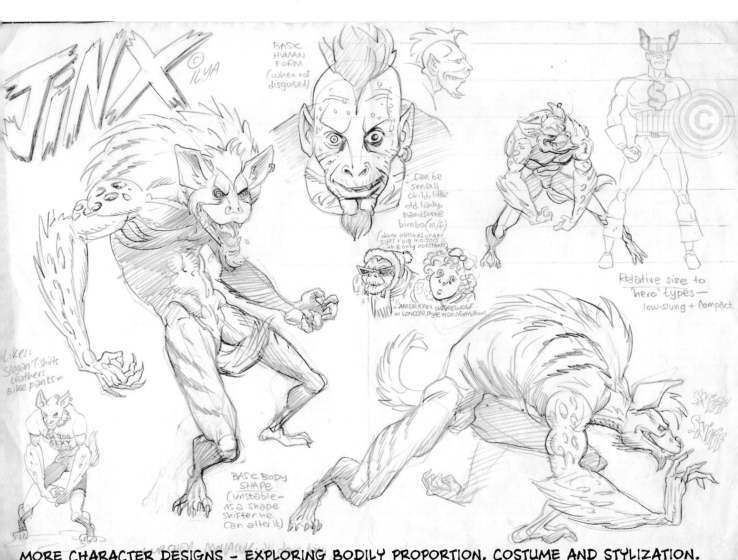

MORE CHARACTER DESIGNS – EXPLORING BODILY PROPORTION, COSTUME AND STYLIZATION.

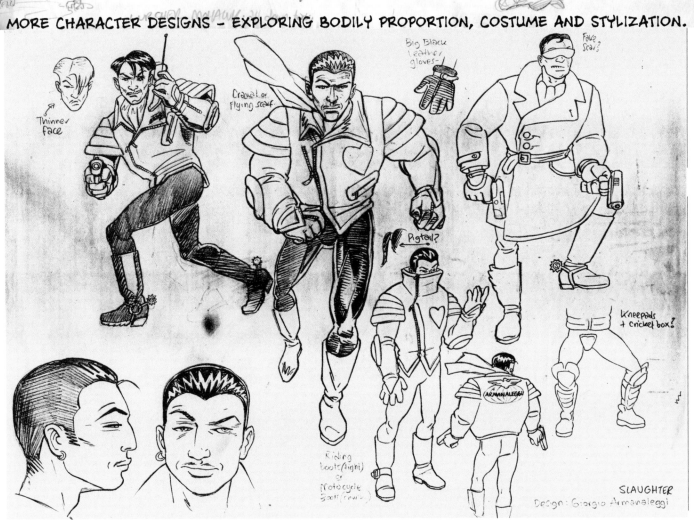

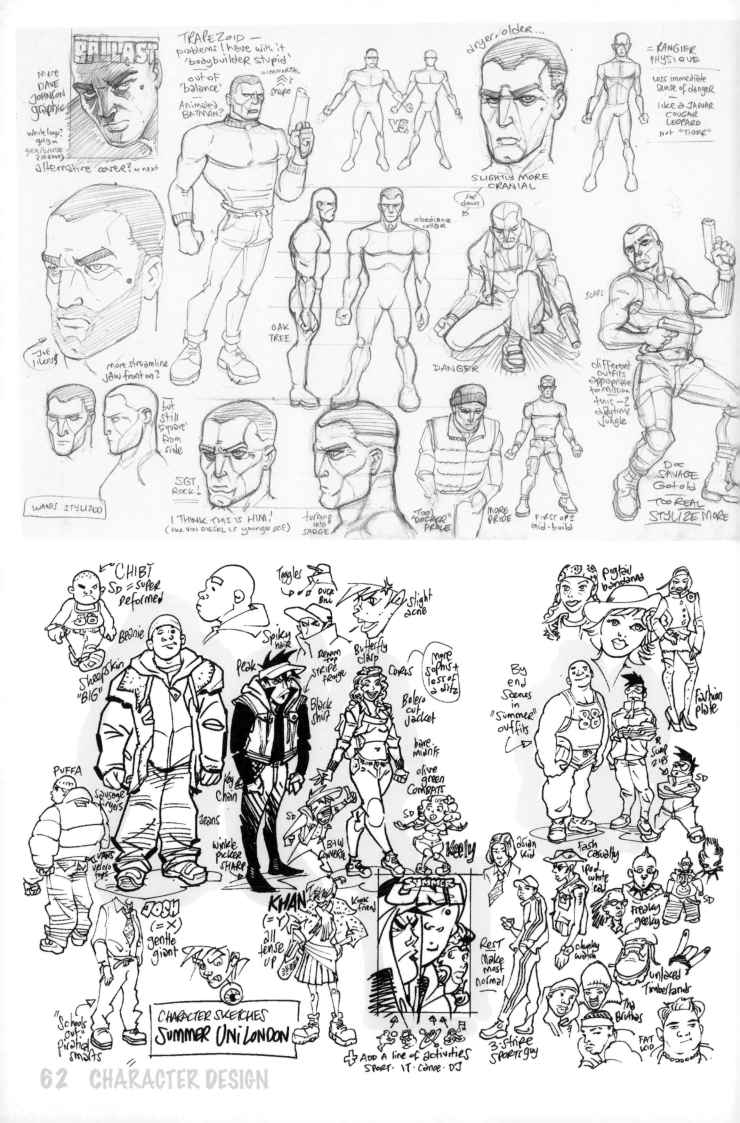

RELATIVELY SPEAKING, COMICS, AS A FORM OF **ART**, IS STILL VERY **YOUNG**.

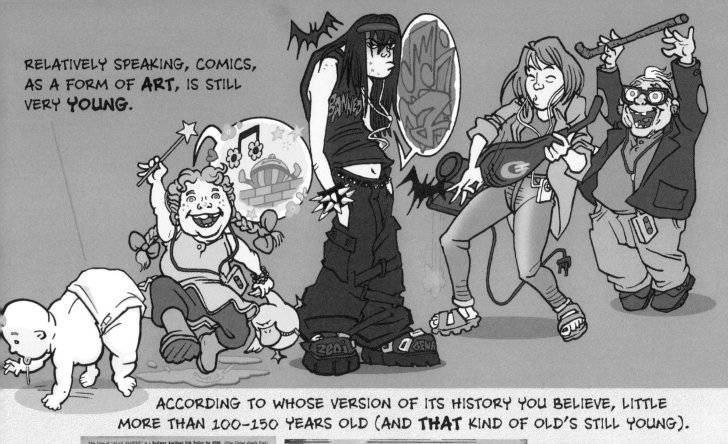

ACCORDING TO WHOSE VERSION OF ITS HISTORY YOU BELIEVE, LITTLE MORE THAN 100-150 YEARS OLD (AND **THAT** KIND OF OLD'S STILL YOUNG).

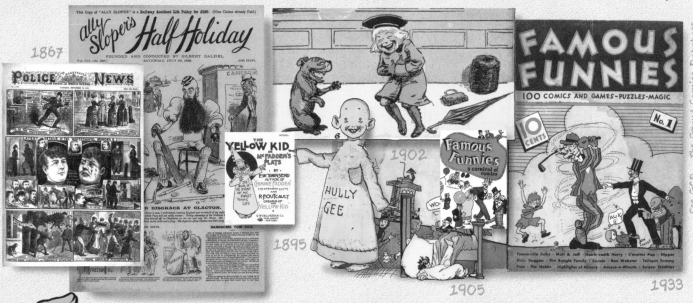

IN FACT, IT'S FAIR TO SAY THAT COMICS IS STILL VERY MUCH **EVOLVING** – SO LET'S TAKE IT BACK...

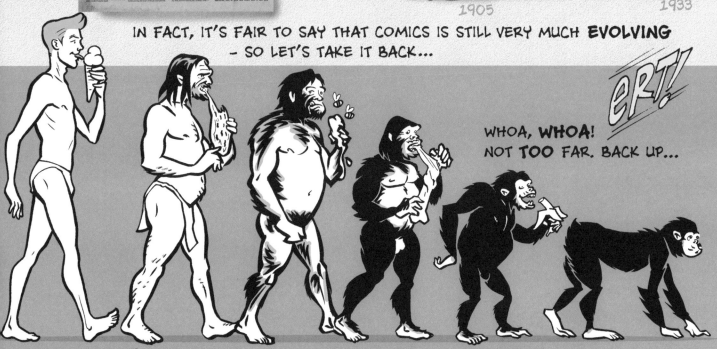

WHOA, **WHOA!** NOT **TOO** FAR. BACK UP...

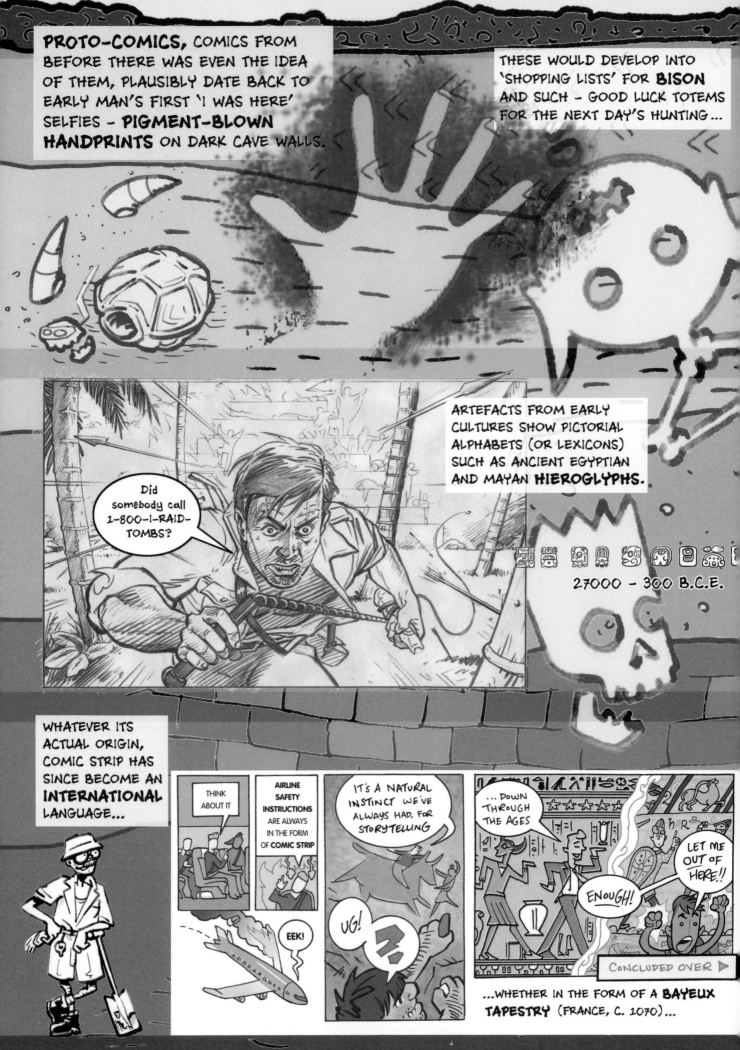

PROTO-COMICS, COMICS FROM BEFORE THERE WAS EVEN THE IDEA OF THEM, PLAUSIBLY DATE BACK TO EARLY MAN'S FIRST 'I WAS HERE' SELFIES - **PIGMENT-BLOWN HANDPRINTS** ON DARK CAVE WALLS.

THESE WOULD DEVELOP INTO 'SHOPPING LISTS' FOR **BISON** AND SUCH - GOOD LUCK TOTEMS FOR THE NEXT DAY'S HUNTING...

Did somebody call 1-800-I-RAID-TOMBS?

ARTEFACTS FROM EARLY CULTURES SHOW PICTORIAL ALPHABETS (OR LEXICONS) SUCH AS ANCIENT EGYPTIAN AND MAYAN **HIEROGLYPHS.**

27000 - 300 B.C.E.

WHATEVER ITS ACTUAL ORIGIN, COMIC STRIP HAS SINCE BECOME AN **INTERNATIONAL** LANGUAGE...

THINK ABOUT IT

AIRLINE SAFETY INSTRUCTIONS ARE ALWAYS IN THE FORM OF **COMIC STRIP**

EEK!

IT'S A NATURAL INSTINCT WE'VE ALWAYS HAD, FOR STORYTELLING

UG!

...DOWN THROUGH THE AGES

ENOUGH!

LET ME OUT OF HERE!!

CONCLUDED OVER ▷

...WHETHER IN THE FORM OF A **BAYEUX TAPESTRY** (FRANCE, C. 1070)...

...AND OTHER OBSCURE OBJECTS OF DESIRE...

Are you looking at my **posterity**?

The VENUS OF WILLENDORF, Circa 28000-25000 B.C.E.

...¡you dirty rat!...

Whip crack awaaay!

POIT

...OR MODERN **ETHIOPIAN** NARRATIVE ART.

BY OUR HANDS WE LIVE

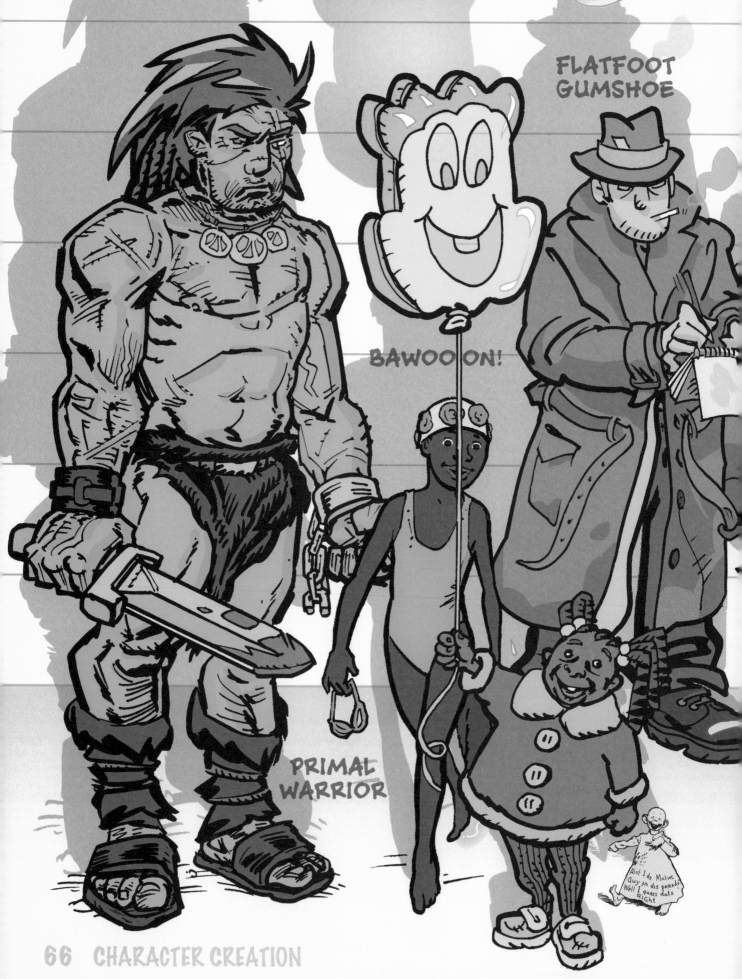

Q. AS COMICS ART EVOLVES AND MATURES, WHAT IS IT GROWING INTO?

A. WHATEVER YOU WANT IT TO BE...

FLATFOOT GUMSHOE

BAWOOON!

PRIMAL WARRIOR

Aint I de Maine Guy in dis parade? Well I guess dats Right

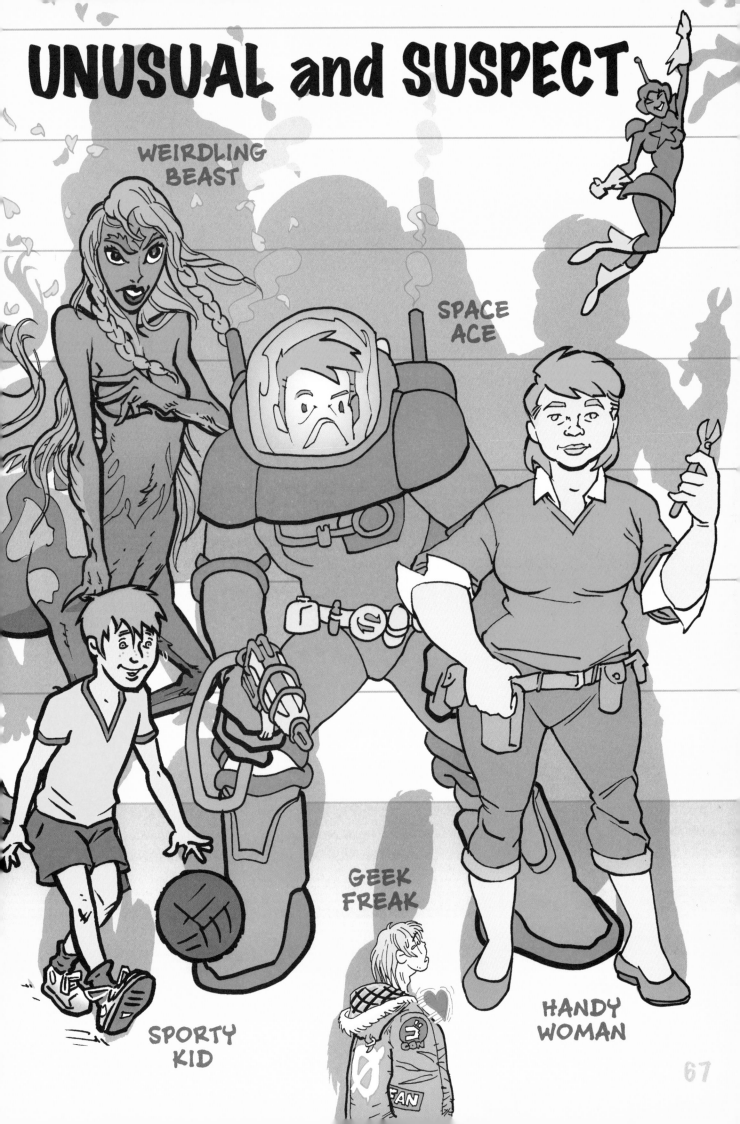

UNUSUAL and SUSPECT

WEIRDLING
BEAST

SPACE
ACE

GEEK
FREAK

SPORTY
KID

HANDY
WOMAN

67

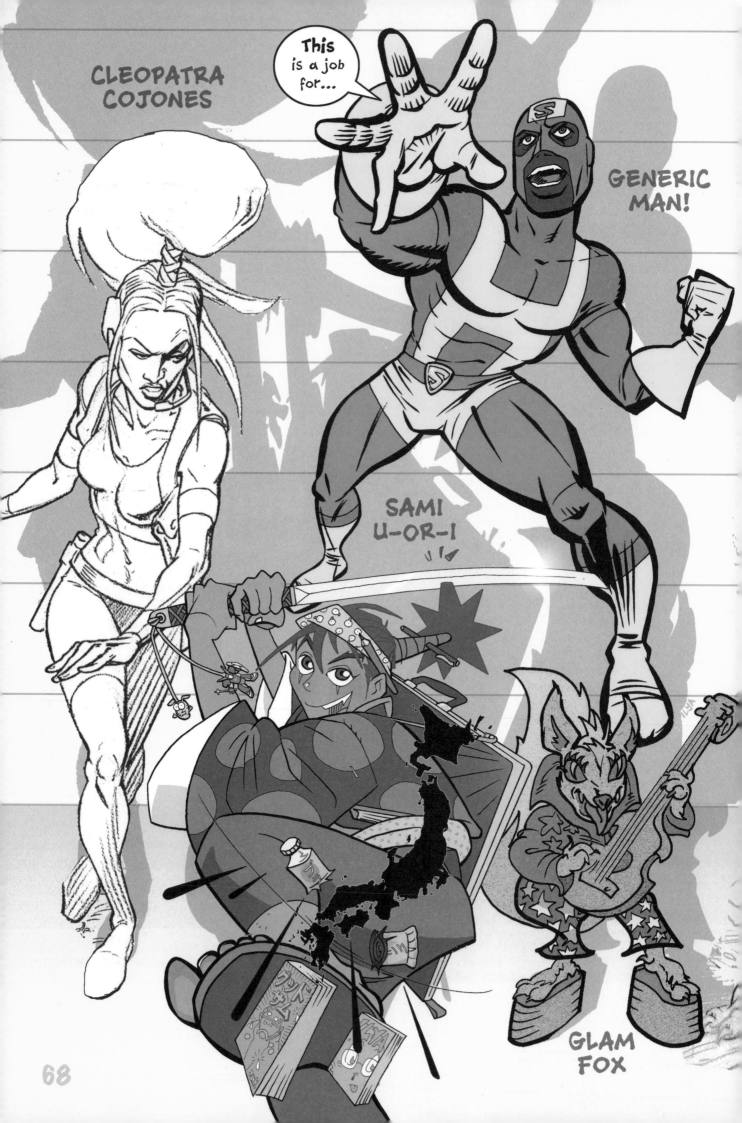

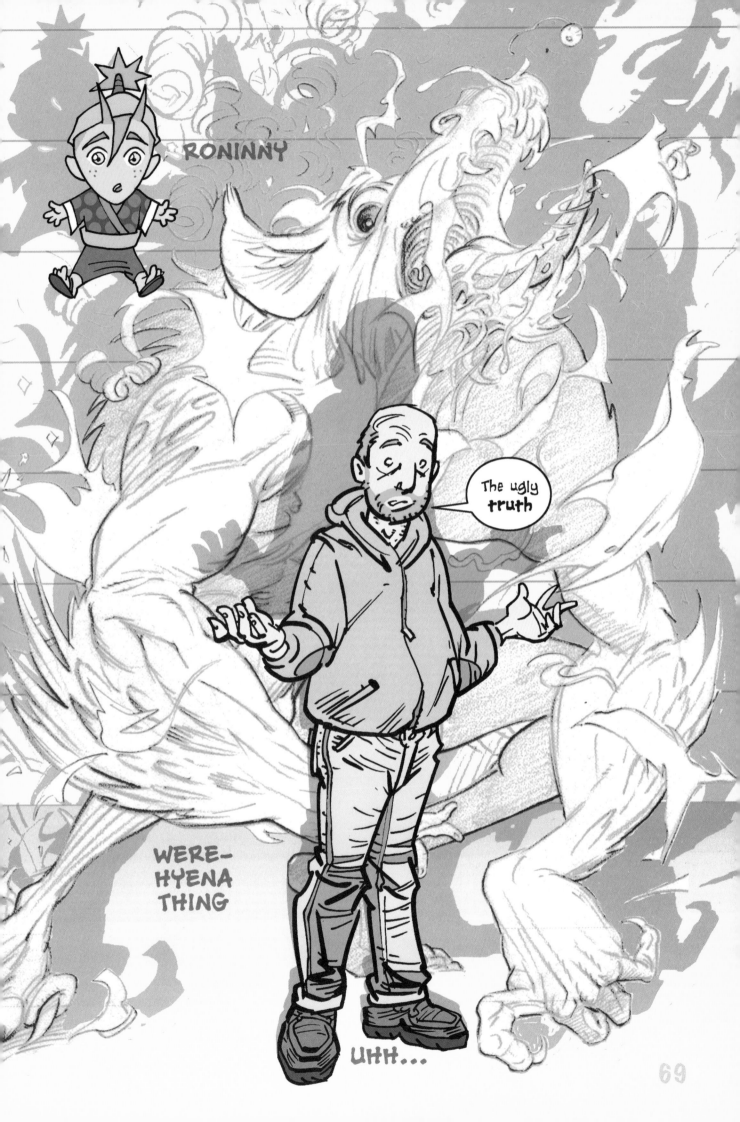

RONINNY

WERE-
HYENA
THING

The ugly **truth**

UHH...

FUNNY ANIMAL PULP HEROES SUPERHERO

WESTERN ACTION ADVENTURE WAR HORROR

TEENAGE SCI-FI MONSTERS MORE SUPERHEROES

SWORD & SORCERY INDIE COOKING? AUTOBIO

70 GENRES ROMANCE SPORT CRIME/NOIR/DETECTIVE ...

AN OLD SAW POSITS THAT THERE SHOULD ALWAYS BE CHARACTERS FOR THE AUDIENCE TO **IDENTIFY** WITH – A BELIEF THAT DOMINATED TV CARTOONS FOR DECADES. BUT THIS IS **HOGWASH**. WE DON'T NEED A LOIS LANE OR JIMMY OLSEN FOR PERSPECTIVE. **TANK GIRL** IS NOT 'REBECCA'. THINK **SPONGEBOB SQUAREPANTS**.

YOUR CHARACTERS DON'T **HAVE** TO BE **RELATABLE**, OR EVEN BELIEVEABLE...

ALSO...

...YOU CAN DRAW **BADLY**

...YOU CAN LEARN FROM **COPYING**

...JUST DON'T BE BORING

SEE **ABOVE** MY FIRST SKETCH FOR A PANEL MEANT FOR THE COVER. THERE'S NOTHING WRONG IN IT, IT'S JUST **DULL**. SO I DECIDED TO DRAW IT AGAIN – SEE **LEFT**.

THE **NATURALISM** DRUMMED INTO ME WHEN I FIRST GOT WORK IN COMICS REMAINS A **BUG** IN MY SYSTEM – UNLESS I REALLY CONCENTRATE, MY DEFAULT SETTING. YOU COULD SAY I'M LUCKY, BEING ABLE TO DRAW IN A 'REALISTIC' STYLE – BUT IT DOESN'T INTEREST ME, AND I DON'T THINK IT'S GOOD COMICS. REALISM IS JUST LIMITING THE IMAGINATION, AND NOTHING COMPARED TO THE SKILL OF **CARTOONING** – AN ABILITY TO SIMPLIFY REALITY INTO A SERIES OF RECOGNIZABLE ICONS.

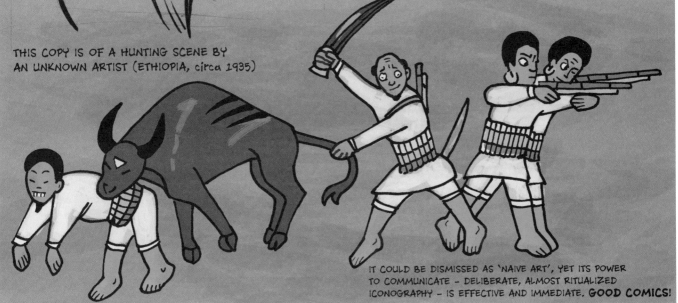

THIS COPY IS OF A HUNTING SCENE BY AN UNKNOWN ARTIST (ETHIOPIA, circa 1935)

IT COULD BE DISMISSED AS 'NAIVE ART', YET ITS POWER TO COMMUNICATE – DELIBERATE, ALMOST RITUALIZED ICONOGRAPHY – IS EFFECTIVE AND IMMEDIATE. **GOOD COMICS!**

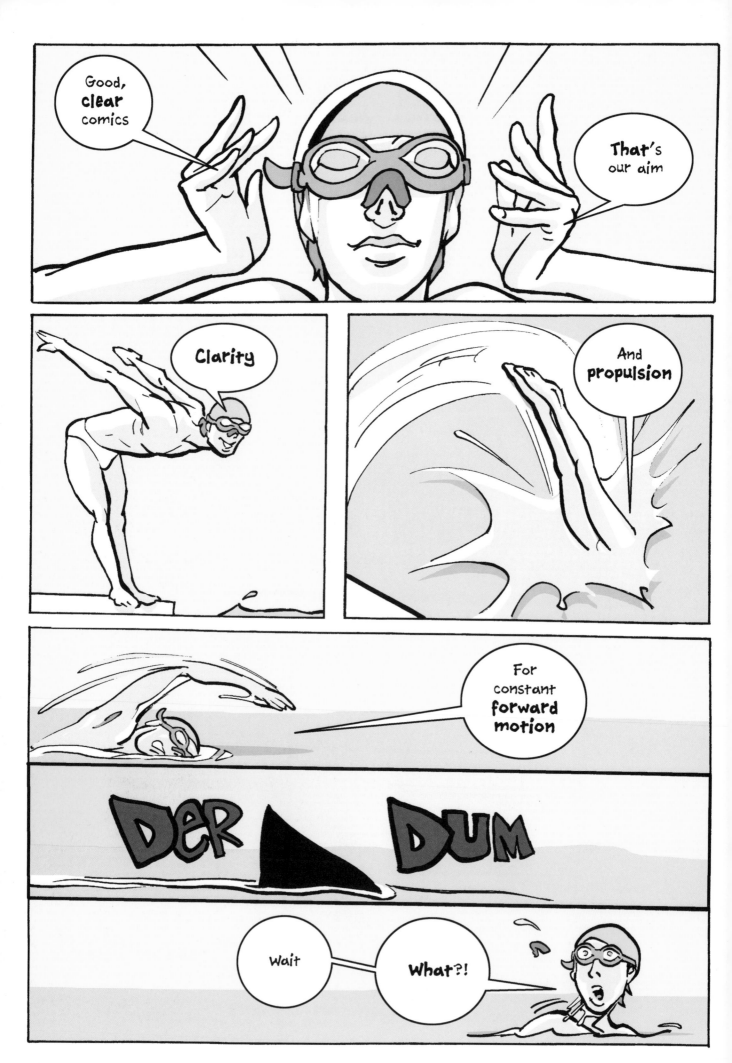

IN A FUTURE WHERE WARS ARE FOUGHT OVER WATER ...

CHOPANDI KAMPER

1 – DOGFIGHT

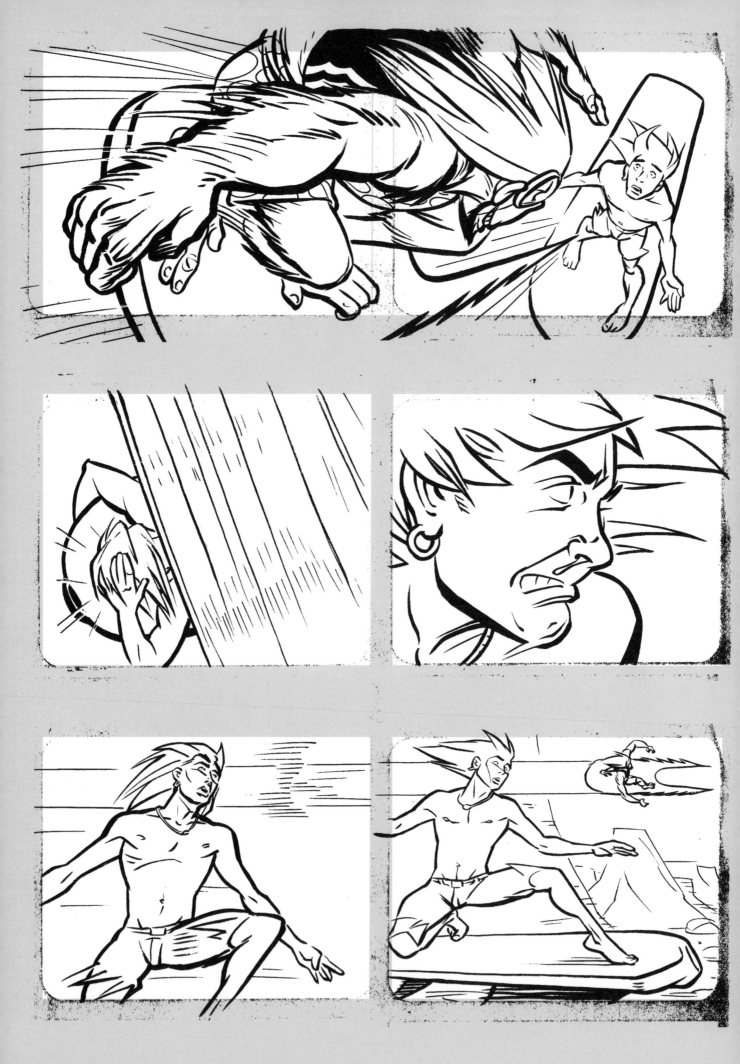

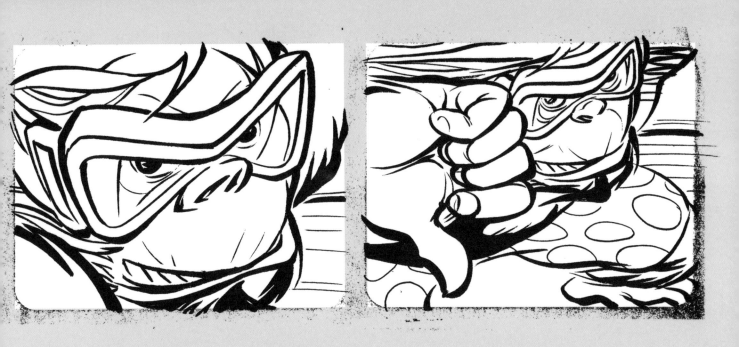

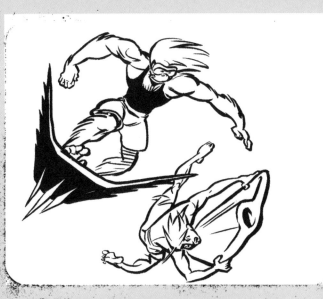

DON'T IMAGINE A SEQUENCE LIKE THAT HAPPENS BY **MAGIC** - THERE'S A LOT OF THOUGHT AND PLANNING AS WELL AS EXPERIMENTATION THAT GOES INTO IT. SEE HERE AND OPPOSITE.

EVERY COMIC STRIP PROPERLY STARTS OFF AS A SERIES OF **THUMBNAILS** - SMALL SKETCH DRAWINGS OF THE SEPARATE **MOMENTS** IN YOUR STORY.

THESE MAY - OR MAY **NOT** - EVENTUALLY BECOME PANELS. AT THIS EARLY STAGE YOU ARE DOING JUST THAT - **STAGING** THE ACTION, LIKE A FILM'S STORYBOARD. YOU DECIDE ON THE ANGLES AND **POV**S (POINTS OF VIEW) OF YOUR 'SHOTS'. SOMETIMES YOU WILL FIND THAT YOU NEED TO ADD ANOTHER IN, OR TAKE ONE OR MORE OUT TO MAKE YOUR SEQUENCE 'PLAY' BETTER. OTHER TIMES YOU CAN COMBINE TWO MOMENTS INTO ONE, OR SPLIT ANOTHER INTO TWO.

THUMBNAILS ARE THE NUTS AND BOLTS OF COMICS: THE REST IS JUST MAKING PICTURES PRETTY TO ENTICE READERS - ALL THE **ACTION** HAPPENS RIGHT HERE.

USING THE BOXES BELOW, **THUMBNAIL** OUT HOW PAGES 73-75 MIGHT CONTINUE.

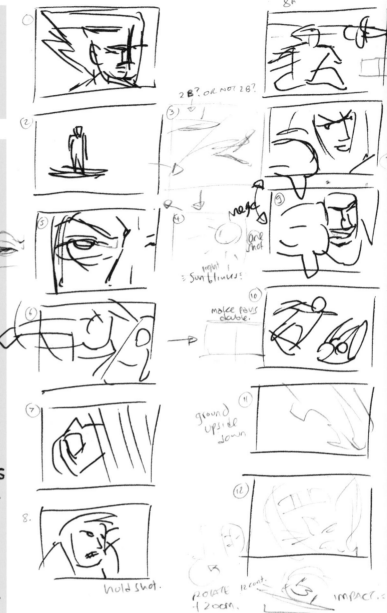

FOR FUN I LAID OUT THESE THUMBNAIL **MOMENTS** LIKE A FILM STRIP, RUNNING **VERTICALLY**. SO LONG AS THEIR ORDER IS CLEAR, LAY THEM OUT HOWEVER YOU LIKE.

TAKE **ONE** TAKE **TWO**

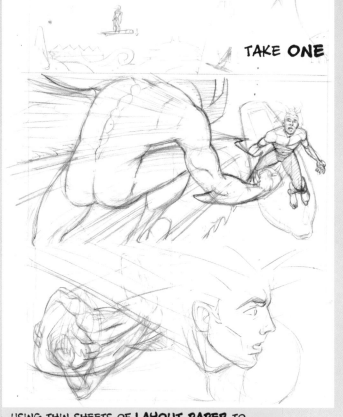

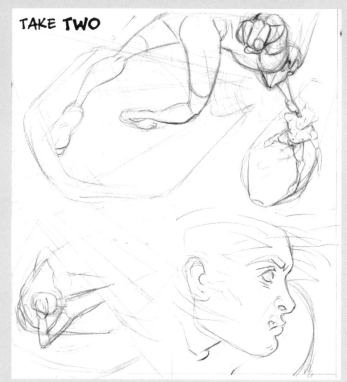

USING THIN SHEETS OF **LAYOUT PAPER** TO
RE-TRACE OVER MY DRAWINGS EACH TIME, IT
TAKES A NUMBER OF **SKETCH** DRAFTS TO GET
THE ACTION AND CHARACTERS HOW I WANT THEM.

ONE WORKS O.K. BUT I NEED TO SEE MORE
SURFBOARD. **TWO** HAS MORE FLOW, BUT LOOK
AT THOSE BORING FACES. **THREE**, YAY, I GOT IT!
THESE ARE THE PENCILS FOR MY PAGES.
I'M STILL NOT HAPPY WITH MY ATTACKING FIGURE
THOUGH, SO (**FOUR**) I SCRIBBLE UP A NEW POSE
THAT RETAINS MORE MASS. THEN, I TIGHTEN UP
MY PENCILS AGAIN, SHOWING MORE OF THE FIRST
GUY (**FIVE**). FINALLY, TRY NOT TO **OVERDO** IT...
(I HAVE – IT'S EASY TO GET LOST IN DETAILS!)

TAKE **THREE**

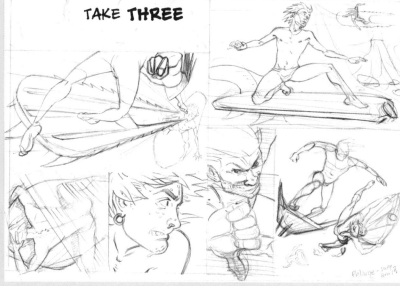

FOUR

FIVE

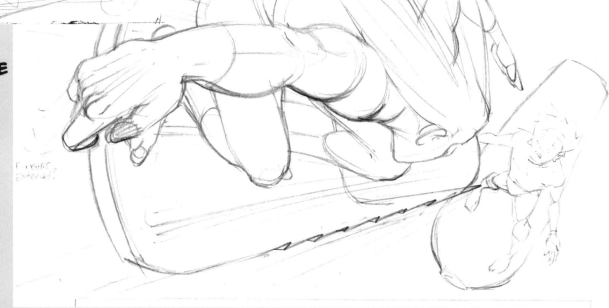

YOU CAN TELL YOUR STORY USING ANY NUMBER OF **SHOTS**. THESE INCLUDE...

ESTABLISHING SHOT

THESE HELP INFORM YOUR READER WHENEVER YOU BEGIN A NEW SCENE, OR CHANGE SCENE. THEY ESTABLISH **WHERE** YOUR CHARACTERS ARE, AND WHERE THEY ARE **IN RELATION** TO ONE ANOTHER. YOU SHOULD SETTLE NOT ONLY PLACE, BUT **TIME**.

HIGH ANGLE (BIRD'S EYE)

AN ALTERNATIVE VIEWPOINT, FROM A FOOT ABOVE TO HIGH IN THE SKY (HERE, A VULTURE'S POV). USEFUL FOR ATMOSPHERICS OR CLARITY.

LOW ANGLE (WORM'S EYE)

DITTO, BUT IN REVERSE.

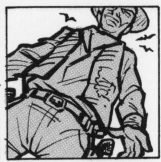

MID-SHOT (HEAD AND SHOULDERS)

ONE OF THE MORE COMMON VIEWPOINTS. YOU MIGHT CROP TIGHTER FOR A HEADSHOT, OR **ZOOM** OUT TO A HALF- OR FULL-FIGURE, DEPENDING ON THE LEVEL OF INTENSITY YOU WANT. MORE THAN ONE PERSON MAKES FOR A **TWO**-SHOT; MORE, A **GROUP**-SHOT.

CLOSE-UP

WHAT IT SAYS. AND, IN THIS CASE, COMBINED WITH A LOW ANGLE TO INCREASE A FEELING OF MENACE.

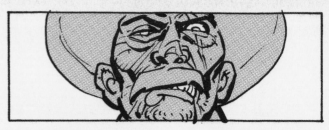

ULTRA (OR EXTREME) CLOSE-UP

EFFECTIVELY, JUST THE EYES. THIS OFTEN WORKS IN SEQUENCE AS A ZOOM-IN FROM A PREVIOUS SHOT - THIS CAN WORK IN ANY NUMBER OF WAYS. INSTEAD HERE, PERHAPS CLOSING IN ON A HAND OVER A GUN.

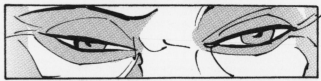

DISTANCE SHOT, also REPEAT SHOT
(aka FIXED or HELD SHOT)

WIDE SHOTS ARE USEFUL, SINCE THEY ALSO HELP TO RE-ESTABLISH WHO AND WHERE. NOT ALL DRAMA PLAYS OUT BEST IN TIGHT CLOSE-UP. THE TRICK IS KNOWING WHEN TO VARY YOUR SHOTS, AND WHEN TO STAY PUT, LETTING THE ACTION MOVE THE STORY.

FORCED PERSPECTIVE (A TRICK SHOT)

THERE ARE ALSO VARIOUS SPECIAL EFFECTS SHOTS. USED JUDICIOUSLY, THEY INCREASE THE THRILLS - BUT IF YOU OVERDO IT THEY MIGHT JUST CONFUSE.

FROM THIS BASIC MENU YOU CAN COOK UP A STORM...IT'S ALL IN HOW YOU **SEGUE** FROM ONE SHOT TO THE NEXT.

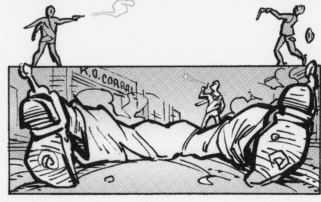

IT IS IMPORTANT TO ACKNOWLEDGE THAT

COMICS ARE NOT FILM

- IN SPITE OF USING TERMS IN COMMON (CAMERA ANGLES, SHOTS, FRAMES, CUTS ZOOMS AND SO ON). YOU ARE NO MORE ADVISED TO STRUCTURE YOUR COMIC LIKE A FILM THAN TO ATTEMPT TO SHOOT OR EDIT ANY FILM AS YOU WOULD A COMIC.

YOU **CAN**, BUT THIS WOULDN'T PLAY TO THE **DISTINCT QUALITIES** OF EITHER MEDIUM.

DON'T **MISTAKE** ONE FOR THE OTHER.

I ALREADY MADE THIS MISTAKE **FOR** YOU

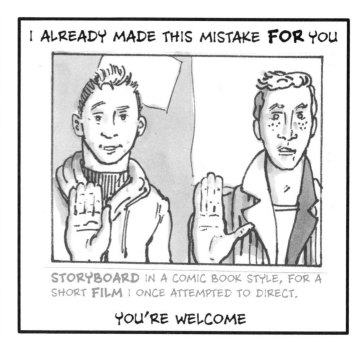

STORYBOARD IN A COMIC BOOK STYLE, FOR A SHORT **FILM** I ONCE ATTEMPTED TO DIRECT.

YOU'RE WELCOME

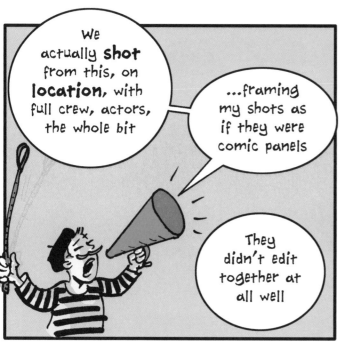

We actually **shot** from this, on **location**, with full crew, actors, the whole bit

...framing my shots as if they were comic panels

They didn't edit together at all well

I THEN USED THE SAME STORYBOARDED PANELS TO MAKE A PRETTY **DULL** COMIC BASED IN PART ON THE FILM'S SCRIPT...

HOW!

NOT TO DO IT

WHAT WAS I THINKING?!

TV AND **FILM** REWARD **PASSIVE** VIEWING. THE CAMERA DOES ALL OF THE LOOKING. EDITING CUTS AND MUSIC ARE DESIGNED TO CUE YOUR RESPONSES - THEY TELL YOU NOT ONLY WHAT TO FEEL BUT ALSO **WHEN**. YOU WATCH, WITH NOTHING ELSE REQUIRED. EXCELLENT ENTERTAINMENT, AND RELAXING.

THINK OF THEM, PERHAPS, AS **EYEWASH**.

COMICS ON THE OTHER HAND, REQUIRE AN **ACTIVE** AND ENGAGED AUDIENCE TO PARTICIPATE IN THEIR PROCESS.

LESS EYEWASH, MORE...**BRAINFOOD**.

URRP

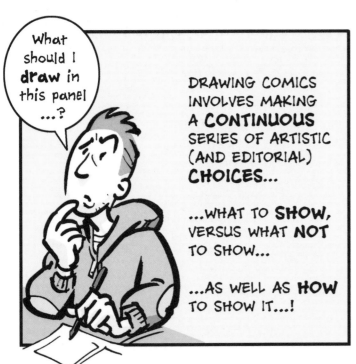

What should I **draw** in this panel ...?

DRAWING COMICS INVOLVES MAKING A **CONTINUOUS** SERIES OF ARTISTIC (AND EDITORIAL) **CHOICES**...

...WHAT TO **SHOW**, VERSUS WHAT **NOT** TO SHOW...

...AS WELL AS **HOW** TO SHOW IT...!

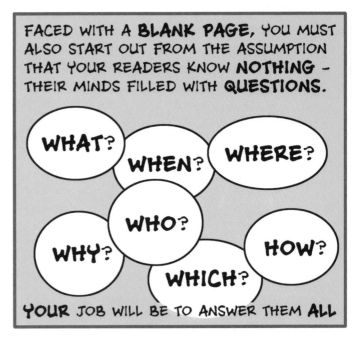

FACED WITH A **BLANK PAGE**, YOU MUST ALSO START OUT FROM THE ASSUMPTION THAT YOUR READERS KNOW **NOTHING** – THEIR MINDS FILLED WITH **QUESTIONS**.

WHAT? WHEN? WHERE? WHO? WHY? WHICH? HOW?

YOUR JOB WILL BE TO ANSWER THEM **ALL**

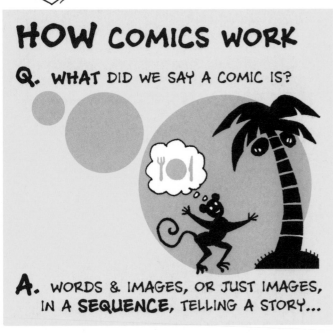

HOW COMICS WORK

Q. **WHAT** DID WE SAY A COMIC IS?

A. WORDS & IMAGES, OR JUST IMAGES, IN A **SEQUENCE**, TELLING A STORY...

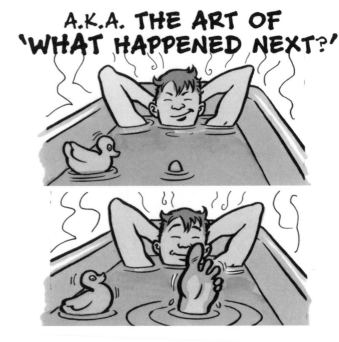

A.K.A. **THE ART OF 'WHAT HAPPENED NEXT?'**

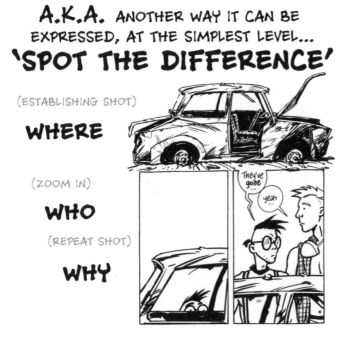

A.K.A. ANOTHER WAY IT CAN BE EXPRESSED, AT THE SIMPLEST LEVEL...

'SPOT THE DIFFERENCE'

(ESTABLISHING SHOT)

WHERE

(ZOOM IN)

WHO

(REPEAT SHOT)

WHY

They've gone ...

yeah

THE FACT THAT, UNLIKE **FILM/TV** OR **ANIMATION** (OR, FOR THAT MATTER, THEATRE OR COMPUTER GAMES), COMICS **DO NOT MOVE** IS NOT A WEAKNESS...

...BUT THEIR STRENGTH

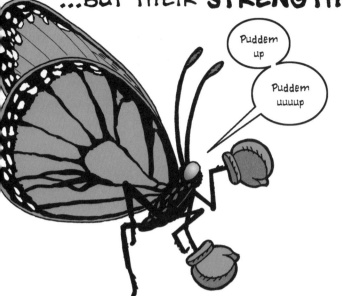

Puddem up

Puddem uuuup

MIND THE G.A.P.

CRUCIALLY, THE MOVEMENT IN A COMIC IS SUPPLIED BY THE READER, AND IT HAPPENS IN BETWEEN PANELS, A SPACE KNOWN AS THE 'GUTTER'

SCOTT MCCLOUD IN COMICS REFERS TO THIS AS 'CLOSURE', BUT IT...

HIS UNDERSTANDING I PREFER TO CALL

ACTION OR

THE **GUTTER ACTION PRINCIPLE**

THE ACTION HAPPENS **HERE**

THE ARM NEVER MOVES. MORE THAN ONE ARM IS DRAWN. THE **PUNCH** IS NOT THROWN, EXCEPT **BY** THE READER...

THE READER PARTAKES IN THE ACTION AND, **SPOTTING** THE **DIFFERENCES**, SUPPLIES THE **MOVEMENT** IN BETWEEN. THE READER **LIVES** THE MOMENT...

'INTERACTIVE' IS A WIDELY OVER-APPLIED BUZZWORD, YET **THIS** IS WHAT MAKES COMICS A TRULY **INTERACTIVE** MEDIUM.

IT'S OUR **SECRET WEAPON**

COMICS HAPPEN **INSIDE YOUR MIND**

FORMING PICTURES DIRECTLY ON YOUR **BRAIN CORTEX**

...NOT EYEWASH, **BRAINWASH!**

WE MAY BE IN THE **GUTTER**, BUT WE'RE SEEING **STARS!**

COMICS ARE ABOUT A LOT MORE THAN PUNCHING, OF COURSE. THIS SAME PHENOMENON, THAT **WHERE** STORY ACTUALLY HAPPENS IS **IN BETWEEN** THE PANELS, APPLIES EQUALLY TO MORE **SUBTLE** MOMENTS...

BELOW IS A SEQUENCE FROM GRAPHIC NOVEL SERIES **THE END OF THE CENTURY CLUB.** ONE OF MY LEAD CHARACTERS, **CASHMERE**, RECOGNIZES A TRAMP IN THE PARK AS HER ESTRANGED FATHER...DOES HE KNOW **HER**?

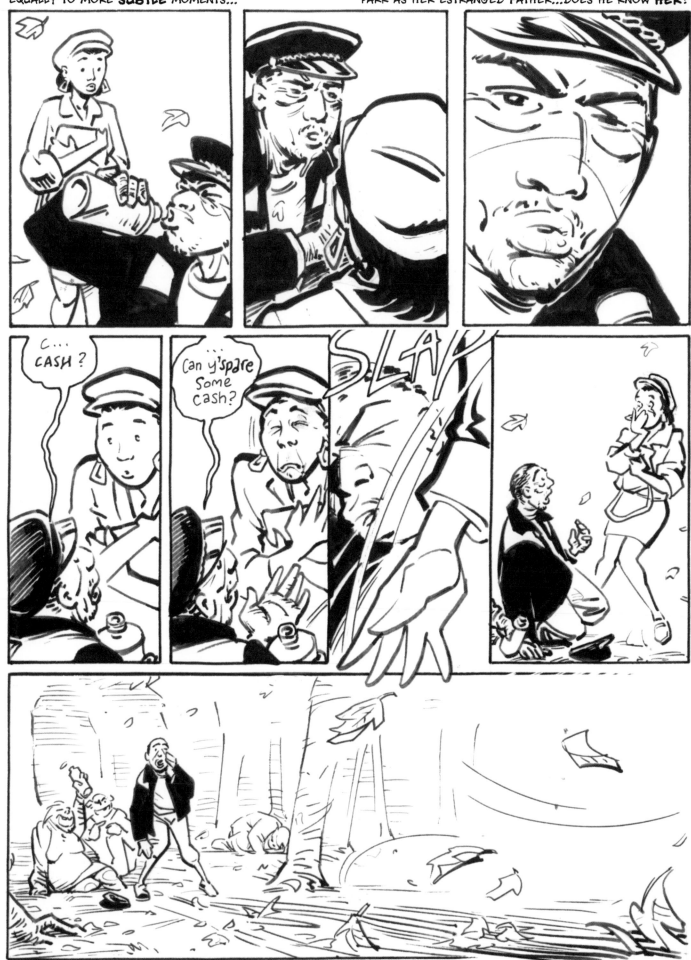

THERE, SO YOU SEE? NOT JUST PUNCHING. ALSO, ER, **SLAPPING**...

We shouldn't think of comic panels, or pages, in isolation.

Every **MOMENT** that you choose to depict is affected not only by what comes **BEFORE**...
...but also what comes **AFTER**.

This is **WHY** you will most likely end up choosing to draw those moments just before or just after what crucially happens, and **NOT** the incident itself. This is the **ART** of '**WHAT HAPPENED NEXT?**'...

...THE MAID SEES THE BOY...

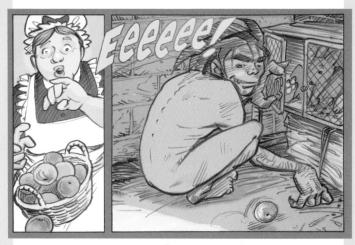

ROMO (UNPUBLISHED)

...A DISTURBANCE IN THE MUSEUM...

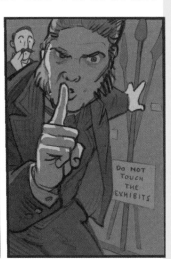

ROMO (UNPUBLISHED)

...THE BOY LEAVES THE BUILDING...

NIMBY (MINI-COMIC) SLAB'O'CONCRETE MISSIVE DEVICE

...IN SCOTLAND, THE BUS COMES...

THE TAR GITS (MINI-COMIC) - TARTAN GIT VERSION

...A FRIEND APPROACHES TO HELP...

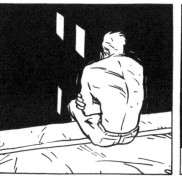

IT'S ALL ABOUT THE **NEXT**, AND THEN THE **NEXT** ONE. IT'S GOT TO **KEEP MOVING FORWARD**...

WHEN COMICS DON'T WORK

COMICS IS A PRIMAL, VERY DIRECT FORM OF COMMUNICATION...A TRANSPORT OF DELIGHT.

THE JOY OF A GOOD COMIC IS **IMMERSIVE** INVOLVEMENT. WHILE READING, YOU JOURNEY TO AND EXPERIENCE AN ALTERNATE REALITY.

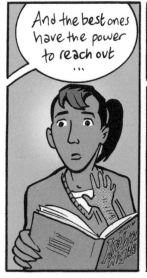

And the best ones have the power to reach out...

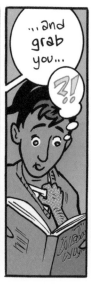

...and grab you...

?!

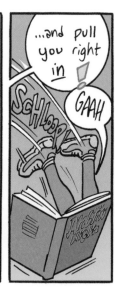

...and pull you right **in**!

SCHLOOP

GAAH

IT'S WORTH AVOIDING ANY **JOLT**ING DOUBT, UPSET OR HICCUP THAT MIGHT GIVE **PAUSE** TO YOUR READER, OR ELSE THROWS THEM OFF COMPLETELY...

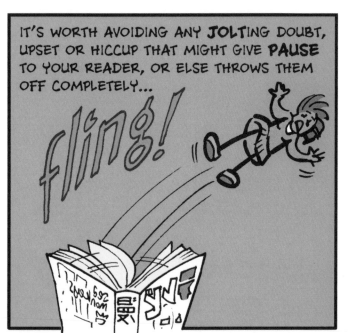

fling!

...LIKE AN **OVERLOAD** OF SOUND EFFECTS.

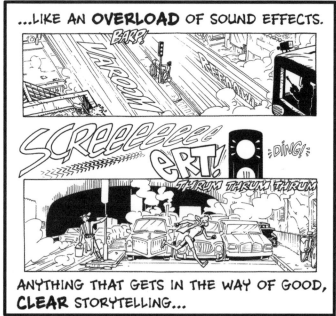

BARP!

ZAPOW

SCREEEEEE ERT!

·DING!

THRUM THRUM THRUM

ANYTHING THAT GETS IN THE WAY OF GOOD, **CLEAR** STORYTELLING...

THIS MEANS ANY SORT OF **CONFUSION** −

DISRUPTION OF THE READING ORDER, LIKE A WORD BALLOON IN THE WRONG PLACE...

...**IN**CONSISTENT OR **UN**FINISHED ARTWORK, LETTERING THAT FOR WHATEVER REASON IS **HARD** TO READ, ~~MISPELLING~~ MISSPELLINGS OR GRAMMATICAL ERRORS...

...OR SIMPLY TOO MUCH GOING ON AT ONCE.

...INCLUDING ANY **WORD** OR **IMAGE** THAT ONLY DRAWS ATTENTION TO **ITSELF**, AT THE EXPENSE OF THE WHOLE.

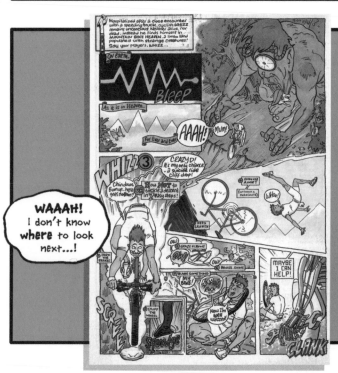

WAAAH! I don't know **where** to look next...!

TIMING (TEMPO, OR PACING) IS KEY IN ALMOST ANY FORM OF **STORYTELLING**, **COMICS** ESPECIALLY. **COMICS** HAVE A **CHEWING GUM** SENSE OF TIME – VERY ELASTIC, VERY MALLEABLE.

ANOTHER FAVOURITE **METAPHOR** TO ILLUSTRATE THIS FEATURES A TYPE OF MUSICAL INSTRUMENT VARIOUSLY CALLED AN ACCORDIAN, A BANDONEON (SEE RIGHT) SQUEEZEBOX, AND SO ON...BUT WE CALL IT

PLAYING THE COMICS CONCERTINA

ILLO: OSCAR ZARATE

PLAY IT **FAST**

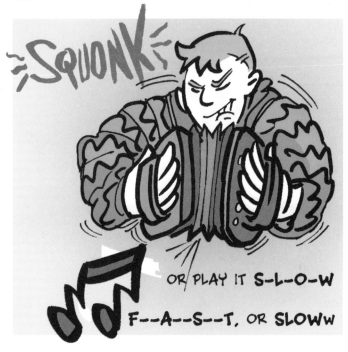

≈SQUONK≈

OR PLAY IT S-L-O-W

F--A--S--T, OR SLOWW

NOW THIS IS THE IMPORTANT BIT.

WHETHER GOING FAST **OR** SLOW, YOU MAY USE A **LOT** OF PANELS...

...OR ONLY A **FEW**

...**OPEN** THINGS OUT...
- OR **COMPRESS** -

GO AHEAD, LET'S **PLAY** THAT CONCERTINA!

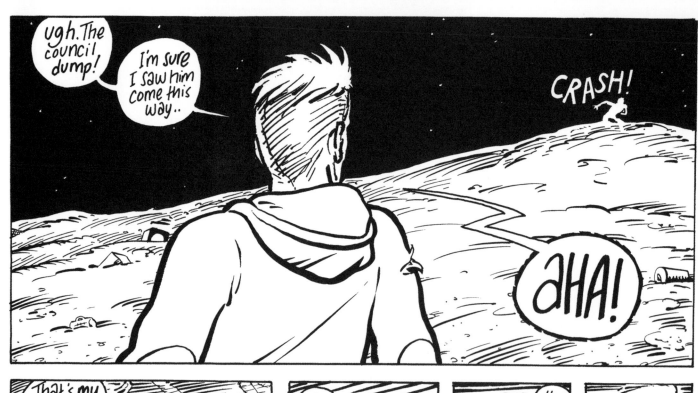
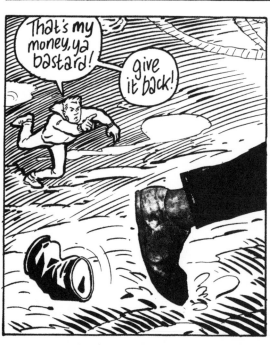

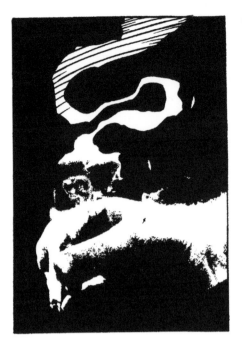

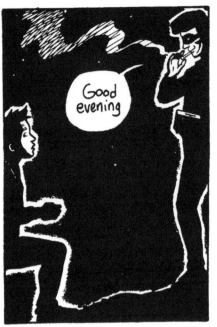

Good evening

STARTING OUT FROM AN ESTABLISHING SHOT, WE WENT INTO A **STACCATO SERIES** OF FAST PANELS – **CLIPPED** VIEWS. THEIR PACE INCREASING AS THEY **NARROW**, BEFORE (ERT!) BRAKING SUDDENLY...

...**PAUSED,** IN HEAVY BLACK, EVEN THE DRIFTING SMOKE HAS BEEN **CROSSHATCHED** WITH **INK LINES** TO SLOW IT MORE.

MANY PANELS = FAST, FEWER PANELS = SLOW.

OR IS IT **FEW PANELS = FAST,** MANY PANELS **SLOW**? THESE TWO SEQUENCES MIGHT SEEM SUPERFICIALLY SIMILAR, BUT THEY WORK IN ENTIRELY **OPPOSITE** WAYS.

EXAMINE FOR A MOMENT THE EXAMPLE ON THE **RIGHT** ⟩

HAVING **MORE PANELS** (IN THE SECOND TIER) **SLOWS** THE ACTION – ALSO NOTE, MORE **DETAILS** TO ABSORB, WHILE **LESS ELSEWHERE** – FEWER PANELS, LESS DETAIL, **SPEEDS** THINGS UP.

NOW DO WE PLAY THAT CONCERTINA **WITH** OR **WITHOUT** VOCALS? BY THAT I MEAN **SPEECH**, AND ALSO **SOUND EFFECTS**...

IN THE FIRST STORY SEQUENCE (PAGE LEFT) THERE'S **ABBREVIATED** SPEECH, AND GASPING FOR BREATH...

...BY THE TIME I COME TO CRAFT THE SECOND SEQUENCE (RIGHT), I'M MORE CONVINCED THAT USING EVEN MINIMAL 'SOUNDS' SLOWS THE PACE, AND USE THEM ACCORDINGLY TO ACHIEVE THAT.

SILENT SEQUENCES READ **FASTER.**

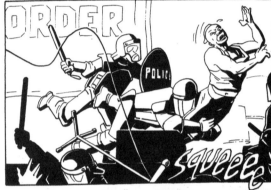

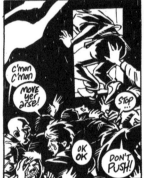

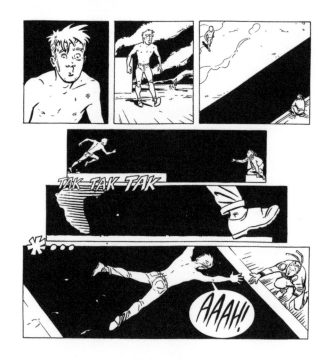

VARIETY IS THE SPICE

< IN **THIS** EXAMPLE THE TIMING ISN'T AFFECTED BY THE NUMBER OF PANELS. INSTEAD, IT IS CHOICE OF **ANGLES** IN TANDEM WITH THE **LAYOUT** THAT LENDS AN ILLUSION OF ELASTIC TIME. MAKING THE LAST 3 FRAMES **PROGRESSIVELY WIDER** ONLY EMPHASIZES THE EFFECT.

CHOICES AND CHANGES OF P.O.V. TRY NOT TO PLOD ALONG AT AN EVEN TEMPO. LOOK FOR WAYS TO **VARY** YOUR PACING. IF YOU'VE BEEN GOING SLOW FOR A WHILE, PICK UP THE PACE; IF RACING, WHOA THINGS DOWN. **DRAMA!**

UNIQUE TO THE DRAWING **AND** READING OF COMICS, EXACT TEMPO IS ALL IMPLIED. THE READER'S EYE IS GUIDED ACROSS THE PAGE ON A PATH ELECTED BY THE **ARTIST** (AND LETTERING PLACEMENT), **BUT** (ALWAYS A BIG BUT) ALLOWED TO GO AT A VARIABLE PACE THE **READERS** SET, AT THEIR OWN COMFORT LEVEL, TO SUIT THEMSELVES.

AND THEN OF COURSE THERE'S THE GREAT ADVANTAGE OF BEING ABLE TO FLICK BACK AND FORTH THROUGH PAGES, EITHER TO REWIND OR ELSE TO FAST FORWARD << >> SO COMPLEX MESSAGES CAN BE ENCODED AND DECODED – ARTIST AND READER IN CAHOOTS: **INTERACTIVE** COMMUNICATION. THE TIME, THE PLACE, **AND** THE MOTION: IT'S GOT **GROOVE**, IT'S GOT **MEANING**. NOT TO MENTION, **FEELING**...

THERE'S NO NEED TO CONSTANTLY CHANGE THE 'CAMERA ANGLE'. A 'FIXED CAMERA' MAKES BOTH ARTIST **AND** READER MORE AWARE OF BODY LANGUAGE/POSTURE ETC.

EVEN STICKING WITH A FIXED P.O.V., YOU CAN **ZOOM** IN AND OUT TO VARY TIMING AND/OR DIAL THE DRAMA UP AND DOWN.

A QUICK TOUR...

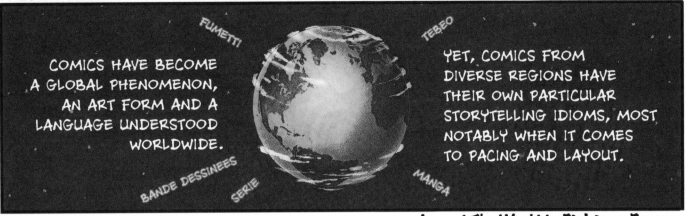

COMICS HAVE BECOME A GLOBAL PHENOMENON, AN ART FORM AND A LANGUAGE UNDERSTOOD WORLDWIDE.

YET, COMICS FROM DIVERSE REGIONS HAVE THEIR OWN PARTICULAR STORYTELLING IDIOMS, MOST NOTABLY WHEN IT COMES TO PACING AND LAYOUT.

FUMETTI • TEBEO • BANDE DESSINEES • SERIE • MANGA

...Around The World in Eighteen Frames

THE **UK** HAS A LONG HERITAGE OF **HUMOUR** COMICS, CLASSIC TITLES...

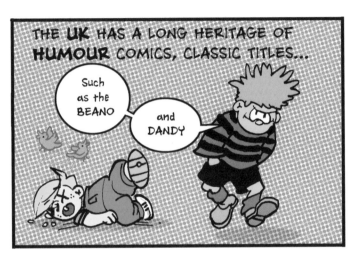

Such as the BEANO

and DANDY

viz. **VIZ**, OFF COLOUR IN THE TRADITIONAL TWO COLOURS. FUTURE HISTORY SCI-FI **2000 AD** CLINGS ON, BUT MOST OTHER GENRES HAVE FALLEN AWAY.

ER...

POKE POKE POKE POKE POKE

ILLO BY PAUL B RAINEY

THE WIDER **EUROPEAN SCENE** IS DOMINATED BY **FRANCE**, WHERE COMICS IS THE 'NINTH ART', AND **BELGIUM**. THINK OF **HERGÉ'S TINTIN**, OR **ASTERIX**.

UK TINTIN TRIBUTES

ILYA

PHOENIX

Bambos

Hergé*, aka Georges Remi (1907–83), has inspired many generations of cartoonists

To be precise, he **rocks**

*originator of the ligne claire, or 'clear line' style

FRENCH COMICS GENIUS **MOEBIUS/GIRAUD** (see page 6) CONQUERED BOTH **SPACETIME** AND THE **WILD WEST**...

EUROPEAN COMICS ARE TYPICALLY DENSE AND INTENSE, SHOWCASING A SUPERB **COLOUR SENSE**. PAGES ARE OFTEN COMPRESSED INTO FOUR TIERS, USING FEWER PANELS TO BREAK DOWN THE ACTION BY CRAMMING DETAIL INTO THEM. LESS USE OF VARIABLE ANGLES, A 'FRONT ON' AND FIXED P.O.V. IS THE NORM, KEEPING A COOL DISTANCE. AND YET, EVEN WITHIN THESE RESTRICTIONS, THEY ACHIEVE 'WIDESCREEN' THRILLS, DOWN TO SHEER **ILLUSTRATIVE** SKILL.

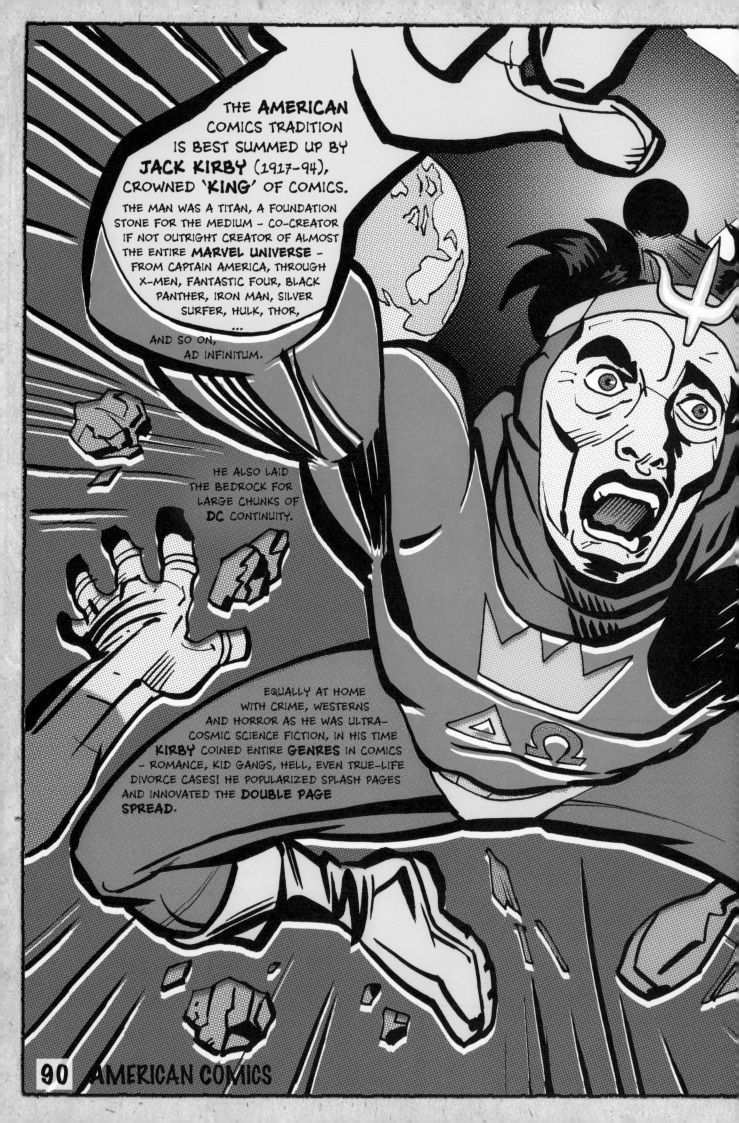

THE **AMERICAN** COMICS TRADITION IS BEST SUMMED UP BY **JACK KIRBY** (1917–94), CROWNED 'KING' OF COMICS. THE MAN WAS A TITAN, A FOUNDATION STONE FOR THE MEDIUM – CO-CREATOR IF NOT OUTRIGHT CREATOR OF ALMOST THE ENTIRE **MARVEL UNIVERSE** – FROM CAPTAIN AMERICA, THROUGH X-MEN, FANTASTIC FOUR, BLACK PANTHER, IRON MAN, SILVER SURFER, HULK, THOR, ... AND SO ON, AD INFINITUM.

HE ALSO LAID THE BEDROCK FOR LARGE CHUNKS OF **DC** CONTINUITY.

EQUALLY AT HOME WITH CRIME, WESTERNS AND HORROR AS HE WAS ULTRA-COSMIC SCIENCE FICTION, IN HIS TIME **KIRBY** COINED ENTIRE **GENRES** IN COMICS – ROMANCE, KID GANGS, HELL, EVEN TRUE-LIFE DIVORCE CASES! HE POPULARIZED SPLASH PAGES AND INNOVATED THE **DOUBLE PAGE SPREAD**.

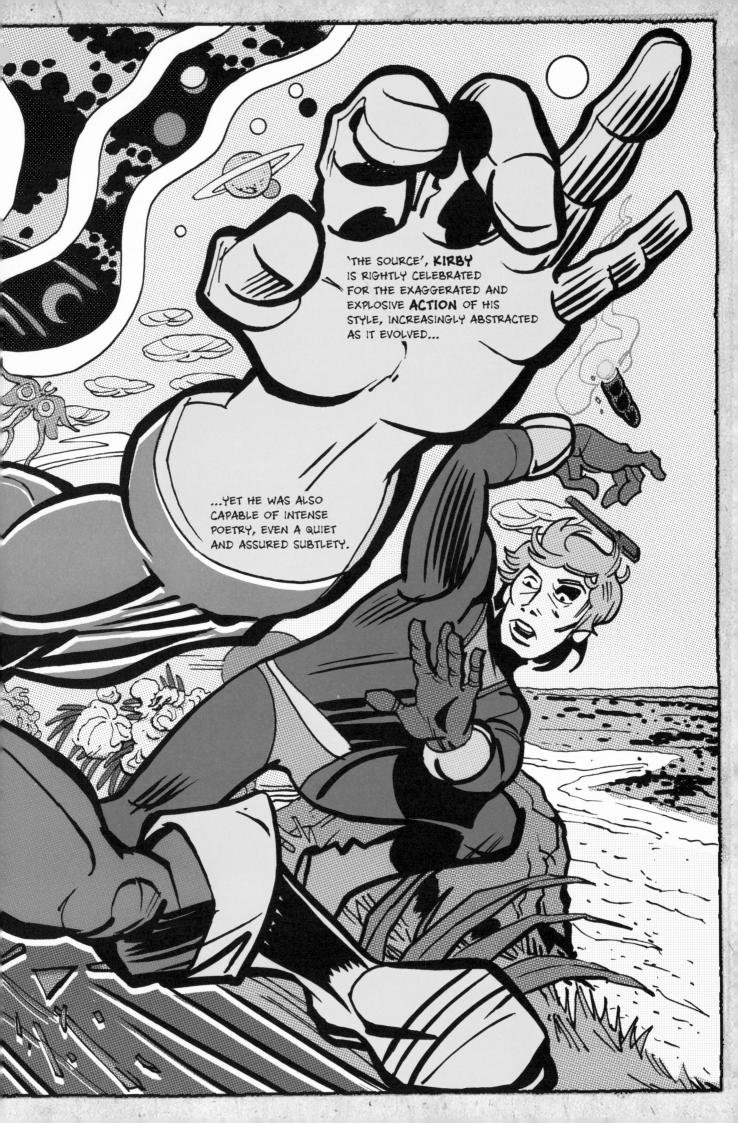

THE MOST FLUID FORM OF COMICS IS JAPANESE **MANGA.** AMERICAN POPULAR CULTURE (COMIC BOOKS AND POPEYE CARTOONS) CAME ALONG WITH OCCUPYING FORCES IN THE YEARS IMMEDIATELY FOLLOWING **WORLD WAR TWO** (1945-51).

THESE INFLUENCES MET AND MERGED WITH JAPAN'S OWN CULTURAL HERITAGE – A RICH TRADITION OF **POPULAR PRINTS** (WHAT THE ARTIST **HOKUSAI** TERMED 'IRRESPONSIBLE PICTURES', OR **MAN GA.** WE'RE NOT TALKING VIEWS OF MOUNT FUJI HERE…MOST LIKELY, INSTEAD, PORN AND POLITICAL CARTOONS – PROPERLY POPULAR CULTURE!), AS WELL AS THE TRAVELLING SHOWS FOR **KAMISHIBAI,** OR 'PAPER THEATRE'.

THEN OF COURSE, THERE ARE THE **IDEOGRAMS** THAT MAKE UP JAPANESE 'ALPHABETS'.

THESE ARE PICTOGRAMS THAT REPRESENT **IDEAS** AS WELL AS **SOUNDS:** AND THEY HAVE THOUSANDS OF THEM ACROSS **THREE** MAIN ALPHABETS. IF YOU ALREADY HAVE A PICTORIAL LANGUAGE, NATURALLY YOU **EXCEL** AT COMICS!

ABOVE LEFT ARE THE **KANJI** (ADOPTED LOGOGRAPHIC CHINESE CHARACTERS) THAT SIGNIFY **MAN** AND **GA. MANGA!**

92 JAPANESE MANGA

WHILE **KIRBY** IS KING OF COMICS, **TEZUKA OSAMU** (1928-89) IS THE 'GOD OF MANGA' (WE WOULD SAY GODFATHER, BUT FALL SHORT...). A STUDENT WHEN **HIROSHIMA** AND **NAGASAKI** WERE DEVASTATED BY NUCLEAR WAR, HE CREATED **TETSUWAN ATOM** ('MIGHTY ATOM', AKA **ASTRO BOY**) IN 1952.

鉄腕アトム

BORN FROM THE HEART OF THE ATOM

AND THIS WAS JUST THE **START** OF HIS CAREER OF ASTONISHING INVENTION.

JAPANESE MANGA

PRE-DOMINANT **THEMES** IN MANGA — AS WITH THEIR **ANIMATED FILMS**, WHETHER **OTOMO'S AKIRA**, OR **STUDIO GHIBLI** — ARE THOSE OF MUTATION, TRANSFORMATION, URBANIZATION AND MECHANIZATION — THE AFTER-EFFECTS OF A **HYPER-INDUSTRIAL** REVOLUTION THAT PREDATES EVEN THE **CRUCIBLE** THAT WAS WWII.

REBORN LIKE A **PHOENIX** FROM THE ASHES, MANGA IS NOW THE MOST INFLUENTIAL FORM OF COMICS.

WOO! YEAH!!

Hi no Tori 'The Firebird' © Tezuka Osamu

93

TO FULLY EXPLAIN **MANGA** WOULD TAKE A BOOK OF ITS OWN. A CHIEF DIFFERENCE IS THE FREQUENCY OF **PUBLICATION**. UK AND AMERICAN COMICS PUBLISH ROUGHLY 18-24 STRIP PAGES PER MONTH. **ZASSHI**, THE WEEKLY MAGAZINES SOLD IN JAPAN, ARE HUNDREDS OF PAGES IN LENGTH AND BURN THROUGH THAT MUCH EVERY WEEK. **EEK!** (ONE REASON THAT MANGA ARE MOSTLY BLACK AND WHITE – THERE'S NO **TIME** TO COLOUR THEM!). THESE STORY SERIALS ARE LATER COLLECTED INTO SMALL BOOK FORMATS, AS WE SEE THEM IN THE WEST. OFTEN THEY WILL CONTINUE ON FOR THOUSANDS OF PAGES.

GENRES UNIQUE TO MANGA INCLUDE **SD** (OR **CHIBI** – LITERALLY 'CHILD' PROPORTIONS), PLAYED FOR LAUGHS (BELOW), **MECHA** (ROBOTS), **KAIJU** (MONSTERS), **CHAMBARA** ('FENCING', i.e. SAMURAI)...

MANGA ARE BIGGER LOUDER **FASTER STRONGER**

...AND **SALARYMAN** (TALES OF OFFICE POLITICS). THIS SHEER VARIETY IN GENRE, BEYOND JUST SUPERHEROES, HAS EQUAL APPEAL FOR WOMEN...

...AS READERS **AND** CREATORS.

STORYTELLING IN MANGA IS **DECOMPRESSED** – IT RUNS OVER A GREAT MANY PAGES, UNLIKE EUROPEAN STYLES. THERE'S LESS USE OF CAPTIONS OR THOUGHT BUBBLES. FLASHBACKS ARE UNCOMMON – EVENTS TEND TO HAPPEN IN A SORT OF ETERNAL PRESENT TENSE. IT COULD USEFULLY BE SUMMED UP AS **THE ART OF WHAT IS HAPPENING.**

MANGA **EATS** PAPER!

THUMBNAILS

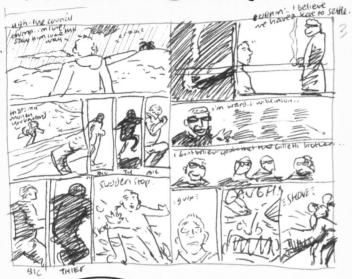

THE MOST **IMPORTANT** DRAWINGS THAT YOU DO WILL ALSO BE THE **SIMPLEST**.

BEFORE PUTTING PENCIL TO PAPER (**OR STYLUS TO SCREEN**) TO CRAFT ANY COMIC PANELS, THE SCRIBBLED **PRE-PLANNING** COMES IN THE FORM OF **THUMBNAILS**. (SEE ALSO ON PAGE 76.)
THIS IS YOU **THINKING ALOUD** ON PAPER. **LOOKING**, BEFORE YOU **LEAP**.

COMICS IS NARRATIVE ART, STORYTELLING. THE **THINKING** BEHIND EACH TALE IS AS **FUNDAMENTAL** TO ITS SUCCESS AS THE DRAWING OF IT – IF NOT EVEN **MORE** SO.

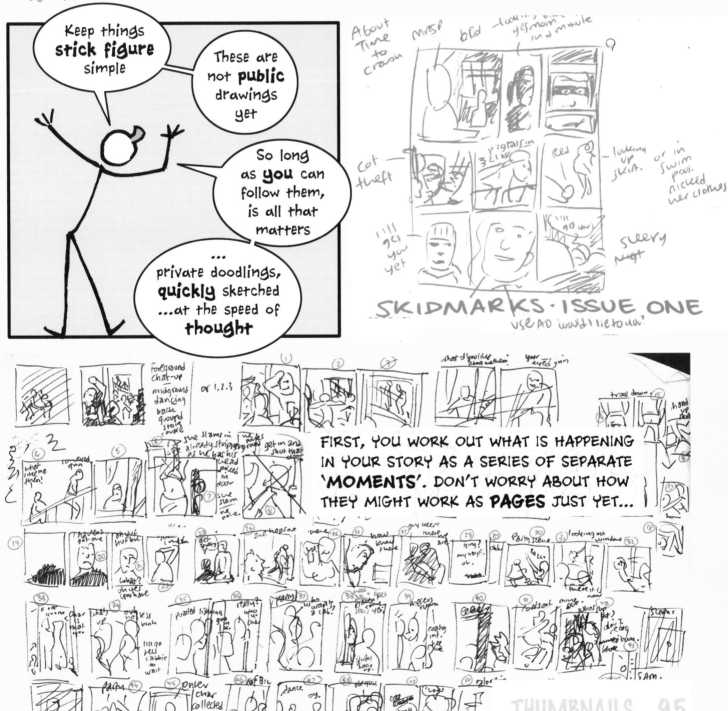

Keep things **stick figure** simple

These are not **public** drawings yet

So long as **you** can follow them, is all that matters

... private doodlings, **quickly** sketched ...at the speed of **thought**

SKIDMARKS · ISSUE ONE

FIRST, YOU WORK OUT WHAT IS HAPPENING IN YOUR STORY AS A SERIES OF SEPARATE **'MOMENTS'**. DON'T WORRY ABOUT HOW THEY MIGHT WORK AS **PAGES** JUST YET...

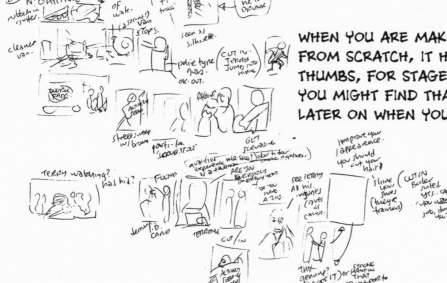

WHEN YOU ARE MAKING UP A STORY FOR YOURSELF, FROM SCRATCH, IT HELPS TO MAKE **NOTES** ON THE THUMBS, FOR STAGE DIRECTIONS AND SUCH, OR ELSE YOU MIGHT FIND THAT THEY ARE HARD TO **DECODE** LATER ON WHEN YOU COME TO DRAW FROM THEM.

SNATCHES OF **DIALOGUE**, **SCRIPT** AND **PLOT** MIGHT OCCUR TO YOU AT ANY TIME – GO AHEAD, ADD THEM IN.

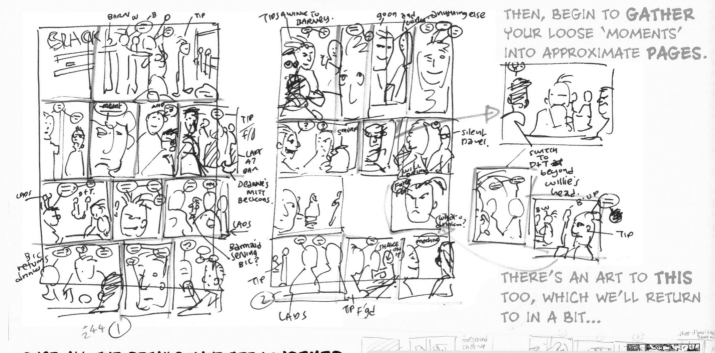

THEN, BEGIN TO **GATHER** YOUR LOOSE 'MOMENTS' INTO APPROXIMATE **PAGES**.

THERE'S AN ART TO **THIS** TOO, WHICH WE'LL RETURN TO IN A BIT...

ONCE ALL THE DETAILS HAVE BEEN **WORKED OUT** AT THIS THUMBNAIL STAGE, MAKING ANY **REVISIONS** AS NECESSARY, **THEN** YOU CAN BEGIN PENCILLING YOUR COMIC BOOK PAGES, **CONFIDENT** IN THE KNOWLEDGE EVERYTHING IS IN THE **RIGHT** PLACE, AT THE **RIGHT** TIME...

EVERY **MINUTE** SPENT THUMBNAILING SAVES AN **HOUR** FURTHER ON DOWN THE LINE.

RUNNING **COMICS WORKSHOPS** AS A TUTOR, I HAVE FOUND THIS THE HARDEST SKILL TO INSTIL IN MANY STUDENTS. AND YET, I DON'T KNOW OF A SINGLE COMICS PROFESSIONAL WHO DOESN'T THUMBNAIL FIRST. THE **LAST THING** YOU WANT TO HAPPEN IS THAT YOU DRAW THE PERFECT IMAGE, ONLY TO FIND THAT IT'S IN THE WRONG PLACE, OR AT THE WRONG SIZE, (NO ROOM FOR THE HEAD, OR FEET OFF THE EDGE OF THE PAGE), OR THE WRONG WAY AROUND TO WORK BEST; SOMETHING VITAL LEFT OUT, OR, POSSIBLY, TOO MUCH DETAIL PUT IN TO MAKE FOR AN EFFECTIVE STORY READERS MAY EASILY UNDERSTAND.

WE'RE GOING TO **RE-RUN** THAT. BUT THIS TIME, WORK **WITH** ME TO THUMBNAIL OUT A FULL SEQUENCE YOURSELF. THIS CAN BE A STORYLINE OF YOUR OWN. OR, IF YOU'RE NOT SURE **WHAT** YOU'D LIKE TO DO, WORK WITH ONE OR MORE OF THESE FOLLOWING SCENARIOS - IN ANY **GENRE** YOU PREFER.

'GETTING HOME FROM WORK/SCHOOL'

'PLAYING IN THE WAVES'

'RECEIVING BAD NEWS'

'HITTING THE TARGET'

'SOMETHING WICKED THIS WAY COMES'

FIRST, CHOOSE YOUR STORY MOMENTS. **EXPLORE** FREELY. CONSIDER YOUR CHOICES OF P.O.V., INCLUDING WHEN TO **CHANGE** P.O.V. DON'T DO THIS ARBITRARILY - DO IT FOR A REASON. ASKING YOURSELF EACH TIME, 'WHAT'S MOST IMPORTANT?' GOVERNS **WHERE** YOU WILL SEE IT FROM...

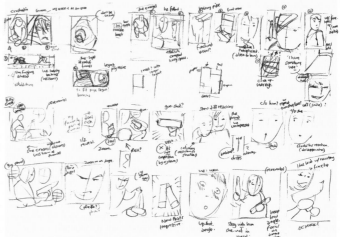

HAVING DRAWN THESE OUT ON ANY SCRAP OF PAPER, WORK ON YOUR **CHOICE** OF MOMENTS. **ADD** IN A PANEL IF YOU FIND THERE'S ONE MISSING, OR, **EDIT** THEM DOWN WHEN THERE SEEMS TO BE TOO MANY.

A SINGLE MOMENT MAY BE SPLIT UP TO MAKE **TWO** OR MORE (FOR INSTANCE, BREAKING DOWN AN ACTION). OTHER MOMENTS MIGHT ALSO WORK BETTER COMBINED INTO ONE (COMPRESSING THE ACTION, SPEEDING IT UP).

NEXT, **GATHER** UP YOUR REFINED MOMENTS INTO PAGE UNITS. CONTINUE TO ADD IN ANY NOTES AS THEY OCCUR TO YOU, INCLUDING, IF YOU LIKE, WHAT THE CHARACTERS MIGHT BE **SAYING**, AS WELL AS WHAT THEY ARE DOING.

YOU CAN USE THE THUMBNAIL **PAGE** TEMPLATES BELOW. PHOTOCOPY THEM FIRST TO USE THEM MORE THAN ONCE.

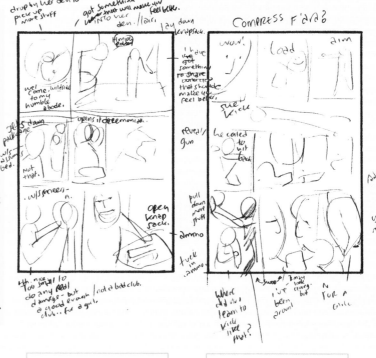

MAKE SURE TO DECIDE FIRST WHAT STYLE OF COMIC YOU WANT TO DRAW - IS IT PERHAPS **EUROPEAN,** WITH MORE ELABORATE PANELS, USUALLY OF EQUAL SIZE? OR IS IT MORE **AMERICAN,** GETTING UP CLOSE TO THE ACTION, CHANGING ANGLE AND SIZE OFTEN? OR IS IT MORE LIKE A **JAPANESE** MANGA? EACH SPREADS ACROSS **MORE** OR **FEWER** PAGES.

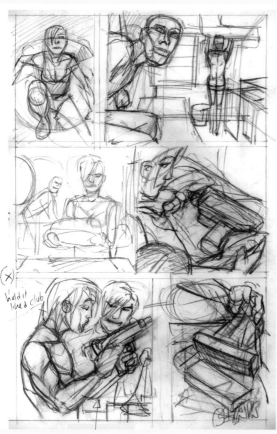

NOW YOU CAN CREATE **PENCILLED PAGES** BASED ON YOUR THUMBS. (SEE THE THUMBNAILED VERSIONS OF THEM ON THE PREVIOUS PAGE)

THEY MIGHT STILL START OUT AS FAIRLY **ROUGH LAYOUTS**, LIKE THESE.

WHEN **SIZING UP** YOUR THUMBS TO **ARTWORK** PAGES, YOU'LL MOST LIKELY FIND YOU HAVE TO MAKE **ADJUSTMENTS**, FINE TUNING SOME PARTS - OR YOU MIGHT JUST FIND **BETTER** WAYS TO DEVELOP YOUR STORYLINE AS IT GOES ALONG.

YOUR THUMBNAILS ARE YOUR **GUIDE**, BUT NOT HOLY WRIT.

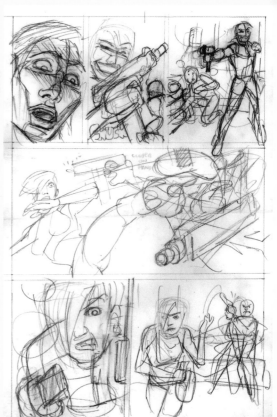

SOMETIMES IT CAN PROVE HARD TO KEEP OR CAPTURE THE **ENERGY** OF YOUR FIRST SKETCHES FROM THE THUMBNAIL STAGE - IF THIS HAPPENS, AND ESPECIALLY IF YOUR THUMBNAIL PAGES ARE QUITE 'TIGHT', YOU COULD ENLARGE THEM ON A PHOTOCOPIER AND THEN **LIGHTBOX** YOUR PENCIL LAYOUTS.

SHINING A **LIGHT** THROUGH IT ALLOWS YOU TO MORE EASILY TRACE THE DRAWING OR PHOTOCOPY BENEATH - THE SAME PRINCIPLE WORKS ON A **COMPUTER**, USING 'LAYERS'.

CAN'T AFFORD, OR MAKE, A LIGHTBOX? TAPING YOUR IMAGES TO A **WINDOW** TO TRACE OVER THEM WORKS JUST AS WELL - IN DAYLIGHT, OF COURSE. NOT AT NIGHT!

AND ALWAYS REMEMBER TO PLAY THE **COMICS CONCERTINA** (SEE PAGES 85-88) - ASK YOURSELF WITH EACH DRAWING, 'IS THIS GOING TO BE A **FAST** OR A **SLOW** PANEL?'

 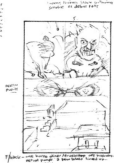 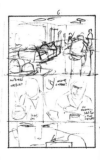

KEEP AN EYE TO **CONTINUITY** (WATCH OUT SHOULD YOUR CHARACTERS SUDDENLY CHANGE FROM RIGHT- TO LEFT-HANDED, ETC.). PLUS, HAVE FUN WITH STUFF LIKE **FORESHADOWING**...

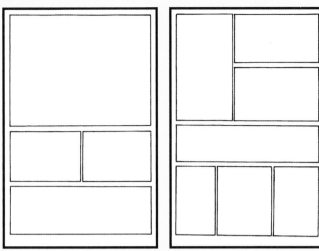

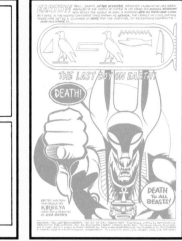

THIS IS YOUR **PAGE** UNIT, MADE UP OF A NUMBER OF PANELS. SOMETIMES **MORE...**

...SOMETIMES **LESS**. WHEN A SINGLE IMAGE OCCUPIES THE WHOLE IT IS A 'SPLASH' PAGE.

WHEN PANELS EXTEND ACROSS TWO PAGES, AT **TWICE** THE NORMAL WIDTH, THIS IS A **'DOUBLE PAGE SPREAD'**, OR DOUBLE SPLASH FOR A SINGLE, GIGANTIC IMAGE. (YOU MUST **CLUE** YOUR READER IN YOU ARE DOING THIS, USUALLY BY BREACHING THE DIVIDING CENTRAL MARGIN IN SOME WAY OR OTHER).

GRIDS ARE WHEN YOU MAINTAIN AN UNDERLYING STANDARD PANEL TO PAGE RATIO THROUGHOUT – ANYTHING FROM TWO TO EIGHT PANELS OR MORE... THIS BOOK IS MOSTLY ON A **6**-PANEL GRID, THREE TIERS OF TWO PANELS EACH. (THE **TIER** IS A **ROW** OF PANELS).

4 PANEL GRID 6 PANEL GRID

THE GRID IS A **STRUCTURAL** GUIDE ONLY – NOT ALL OF THE PANELS WITHIN IT HAVE TO BE ALWAYS OF THE **SAME SIZE**.

THE **PAGE** TURN

WHEN LAYING OUT YOUR PAGES, ALWAYS BE AWARE OF THE PANEL THAT FALLS AT THE **PAGE TURN**.

(HERE, AT THE LOWER RIGHT HAND CORNER)

WHENEVER POSSIBLE, ITS CONTENT SHOULD **COMPEL** READERS TO TURN THE PAGE. USE IT TO INCREASE THE SHEER **DRAMA**.

8 PANEL GRID

8 PANEL GRID STILL

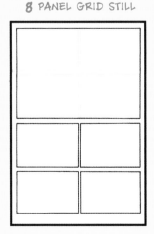

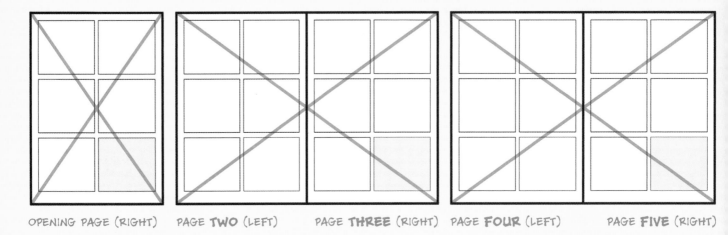

OPENING PAGE (RIGHT) PAGE **TWO** (LEFT) PAGE **THREE** (RIGHT) PAGE **FOUR** (LEFT) PAGE **FIVE** (RIGHT)

EVEN WHEN LAYING OUT YOUR COMIC AT THE THUMBNAIL STAGE, IF IT IS A **CONTINUOUS STORY**, THEN – AFTER THE FIRST OR OPENING PAGE, WHICH IS USUALLY A RIGHT-HANDER – THINK OF AND DESIGN THE PAGES AS SPREADS (EVEN IF THEY ARE NOT **JOINED UP** DOUBLE PAGE SPREADS).

SYNONYMOUS WITH THE ART OF THE **PAGE TURN**, TRY SAVING ANY SPECIAL MOMENT OR 'REVEAL' FOR THE LEFT HAND PAGE FOLLOWING A PAGE TURN – THIS CAN SURPRISE AND DELIGHT THE READER WITH SOMETHING REVELATORY OR UNEXPECTED (THE ANTI-SPOILER).

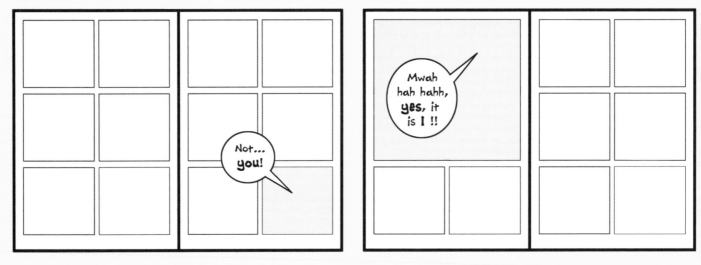

CONVERSELY, **SPLASH** PAGES WORK BEST (WHEN NOT ALSO REVEALS) ON A RIGHT HAND PAGE, CATCHING A CRUISING READER'S (OR POTENTIAL CUSTOMER'S) **EYE** AS THEY FLICK BACK AND FORTH THROUGH THE COMIC.

OF COURSE, YOU CAN FLOW YOUR PANELS FREELY ACROSS THE PAGES – THEY DON'T HAVE TO STAY UNIFORM GRID BOX SHAPES.

JUST BEAR IN MIND THAT THE MORE YOU DO THIS, THE HARDER READERS HAVE TO **CONCENTRATE** IN ORDER TO FOLLOW THE INTENDED READING ORDER.

MANY PEOPLE ARE STILL NOT SO VERY USED TO READING COMICS...

IN ANY EVENT, MAKE SURE TO KEEP THINGS GOING LEFT TO RIGHT AND FROM UP TO DOWN...OR **EVERYBODY** WILL GET LOST!

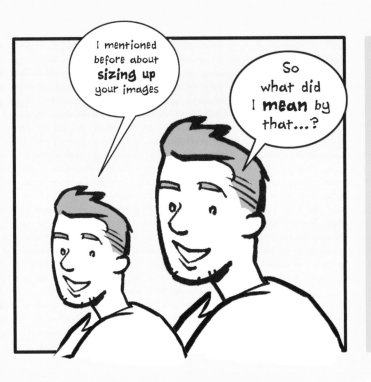

"I mentioned before about **sizing up** your images"

"So what did I **mean** by that...?"

IF YOU LOOK AT DRAWINGS IN COMICS AND THINK THEM IMPOSSIBLY DETAILED, WONDERING HOW THE ARTIST COULD POSSIBLY DRAW SO WELL AT THAT SIZE, WELL, THAT'S BECAUSE THEY **DIDN'T**...

ORIGINAL COMIC ART IS PRODUCED AT BETWEEN A **THIRD** TO A **HALF** UP, WHICH IS TO SAY, **THAT** MUCH BIGGER THAN YOU SEE IT WHEN IT IS PRINTED.

$\frac{1}{3}$ $\frac{1}{2}$ **SCALING UP**

THIS TIGHTENS THE DRAWINGS UP NICELY.

WORKING **ONE THIRD** UP WOULD MEAN THAT IF YOUR COMIC IS GOING TO BE **A5** IN SIZE, THEN YOUR ARTWORK SHOULD BE **A4**.

SIMILARLY, IF YOUR COMIC IS MEANT TO BE **A4**, THEN YOUR ARTWORK'S GOING TO BE **A3** IN SIZE.

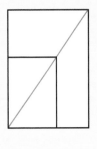

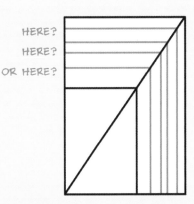

HERE?
HERE?
OR HERE?

EVERYONE HAS THEIR OWN COMFORT ZONE WHEN IT COMES TO THE **SIZE** THEY DRAW AT – SCALE UP YOUR ART PAGES FROM THE INTENDED SIZE OF YOUR COMIC TO SUIT YOURSELF.

IDEALLY – WHETHER **PAPER** OR **DIGITAL** – THE PAGE ON WHICH YOU ARE GOING TO DRAW YOUR **ORIGINAL ARTWORK** WILL LOOK SOMETHING LIKE THIS.

YOU WANT IT TO HAVE **MARGINS** – A FRAME OF EMPTY **SPACE** AROUND THE ARTWORK ITSELF – SO THAT YOU ARE NOT DRAWING RIGHT UP TO THE **EDGES** OF THE PAPER... **UNLESS** YOU WANT YOUR IMAGES TO GO TO **BLEED.**

WHAT? "BLEED"? WHY?
TURN THE PAGE TO FIND OUT...!

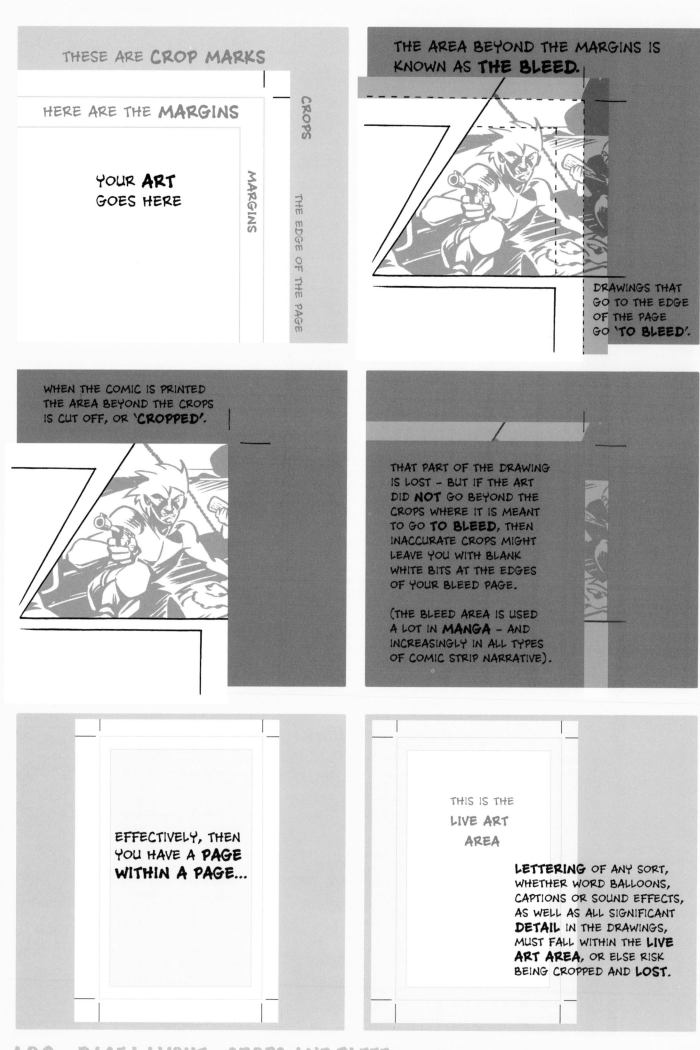

THESE ARE **CROP MARKS**

HERE ARE THE **MARGINS**

CROPS

MARGINS

THE EDGE OF THE PAGE

YOUR **ART** GOES HERE

THE AREA BEYOND THE MARGINS IS KNOWN AS **THE BLEED.**

DRAWINGS THAT GO TO THE EDGE OF THE PAGE GO 'TO BLEED'.

WHEN THE COMIC IS PRINTED THE AREA BEYOND THE CROPS IS CUT OFF, OR '**CROPPED**'.

THAT PART OF THE DRAWING IS LOST - BUT IF THE ART DID **NOT** GO BEYOND THE CROPS WHERE IT IS MEANT TO GO **TO BLEED**, THEN INACCURATE CROPS MIGHT LEAVE YOU WITH BLANK WHITE BITS AT THE EDGES OF YOUR BLEED PAGE.

(THE BLEED AREA IS USED A LOT IN **MANGA** - AND INCREASINGLY IN ALL TYPES OF COMIC STRIP NARRATIVE).

EFFECTIVELY, THEN YOU HAVE A **PAGE WITHIN A PAGE**...

THIS IS THE **LIVE ART AREA**

LETTERING OF ANY SORT, WHETHER WORD BALLOONS, CAPTIONS OR SOUND EFFECTS, AS WELL AS ALL SIGNIFICANT **DETAIL** IN THE DRAWINGS, MUST FALL WITHIN THE **LIVE ART AREA**, OR ELSE RISK BEING CROPPED AND **LOST**.

HAVING SCALED UP YOUR DRAWINGS TO **WORK** ON THEM, YOU ALSO NEED TO DO THE **REVERSE** WHEN IT COMES TO **REPRODUCING** THEM AS A COMIC.

IF YOU ENLARGED BY A **HALF** (50%) THEN YOU SHRINK BY A **THIRD** (33%).

ART

UP 50%

LAYOUT

STRICTLY SPEAKING IT'S BY **33.3%**, AND A REDUCTION TO **66.6%** (RECURRING!), BUT THERE'S NO POINT GETTING FIDDLY.

ART

CALL IT **67**

DOWN TO 67%

PRINT

LITTLE OF THIS APPLIES IF YOU ARE WORKING DIGITALLY, WITH A COMPUTER. STILL, YOU NEED TO STAY AWARE OF THE **DPI** (Dots Per Inch)

SCREEN RESOLUTION =	**72** DPI
COLOUR PRINT =	**300** DPI
BLACK AND WHITE PRINT =	**600** DPI

EVEN IF YOU INTEND YOUR ART ONLY FOR **ONLINE**, DON'T DENY YOURSELF A FUTURE OPTION FOR **PRINT**. DESPITE THE LARGER FILE SIZES AND SLOWER SAVES, IT IS WORTH STICKING TO AN **OPTIMUM 400** DPI (MORE FOR LINE ART).

BLOWING UP OR REPRODUCING IMAGES FROM 72DPI INTO **PRINT** RESOLUTION RESULTS IN **SOFT** IMAGES (SEE ABOVE, RIGHT), ALSO, BITMAPPING (THE JAGGED APPEARANCE OF THE 'INK' LINES). **UGH!**

LIKEWISE, TRY NOT TO SAVE YOUR FILES ONLY AS JPEGS – **JPEG** IS A TRANSPORT AND COMPRESSION FORMAT. YOU MIGHT LOSE VALUABLE DATA. JPEGS ARE GOOD FOR EMAIL ATTACHMENTS BUT KEEP A MASTER SET OF HI-RES FILES (**TIFF** OR SIMILAR) TAKEN FROM YOUR FIRST GENERATION ARTWORK (LAYERS OR FLAT).

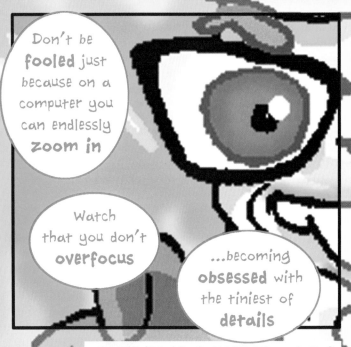

Don't be **fooled** just because on a computer you can endlessly **zoom in**

Watch that you don't **overfocus**

...becoming **obsessed** with the tiniest of **details**

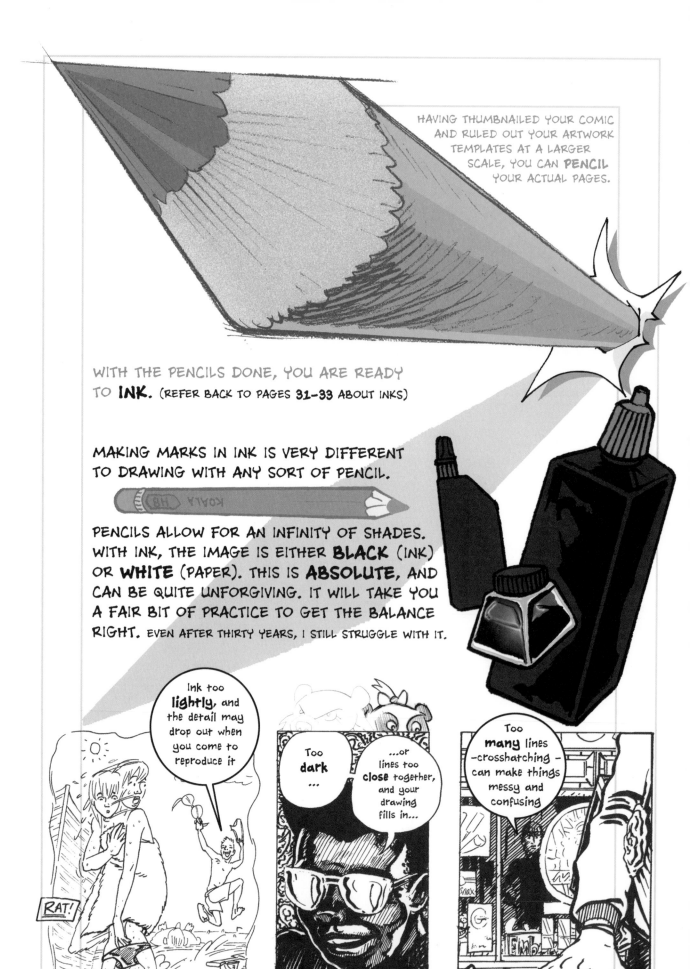

HAVING THUMBNAILED YOUR COMIC AND RULED OUT YOUR ARTWORK TEMPLATES AT A LARGER SCALE, YOU CAN **PENCIL** YOUR ACTUAL PAGES.

WITH THE PENCILS DONE, YOU ARE READY TO **INK.** (REFER BACK TO PAGES **31-33** ABOUT INKS)

MAKING MARKS IN INK IS VERY DIFFERENT TO DRAWING WITH ANY SORT OF PENCIL.

PENCILS ALLOW FOR AN INFINITY OF SHADES. WITH INK, THE IMAGE IS EITHER **BLACK** (INK) OR **WHITE** (PAPER). THIS IS **ABSOLUTE,** AND CAN BE QUITE UNFORGIVING. IT WILL TAKE YOU A FAIR BIT OF PRACTICE TO GET THE BALANCE RIGHT. EVEN AFTER THIRTY YEARS, I STILL STRUGGLE WITH IT.

Ink too **lightly,** and the detail may drop out when you come to reproduce it

RAT!

Too **dark** ...

...or lines too **close** together, and your drawing fills in...

... becoming murky and **indefinite**

Too **many** lines –crosshatching– can make things messy and confusing

PANELS FROM **SKIDMARKS** – ONE OF MY FIRST COMICS

Ideally, you will want a varied balance of **thin** and **thick** lines

...SO, YOU WILL BE INKING WITH **MORE** THAN ONE PEN – AT LEAST ONE **FINE** POINT (**0.5MM** OR LESS, PROBABLY), ANOTHER, **THICKER** LINE PEN, AND A **BRUSH** LINE TOOL.

thick line, thin line

A **RAPIDOGRAPH** OR **ISOGRAPH** TECHNICAL PEN GIVES THE MOST ACCURATE OF THIN LINES – MAKING THEM ESPECIALLY GOOD FOR HAND-DRAWN **LOGO** DESIGN AND DISPLAY LETTERING...

...BUT, AS WE HAVE SAID, THEIR EXPENSE AND UPKEEP CAN BE A PAIN...

QUALITY

...A GOOD HARD-NIBBED MARKER PEN WITH A THIN POINT (AROUND **0.25** OR SO) DOES ALMOST AS WELL.

U WANT IT

VROOM-BEEP!

SEE HOW, IN THIS FINE LINE ESTABLISHING SHOT, EVEN **SLIGHT** VARIATION IN **THICK**NESS OF LINE, AND A FEW TOUCHES OF **BRUSH**, HELP TO LEND THE ILLUSION OF **SPACE** AND **DIMENSION**...

THE RIVER THAMES, LONDON.

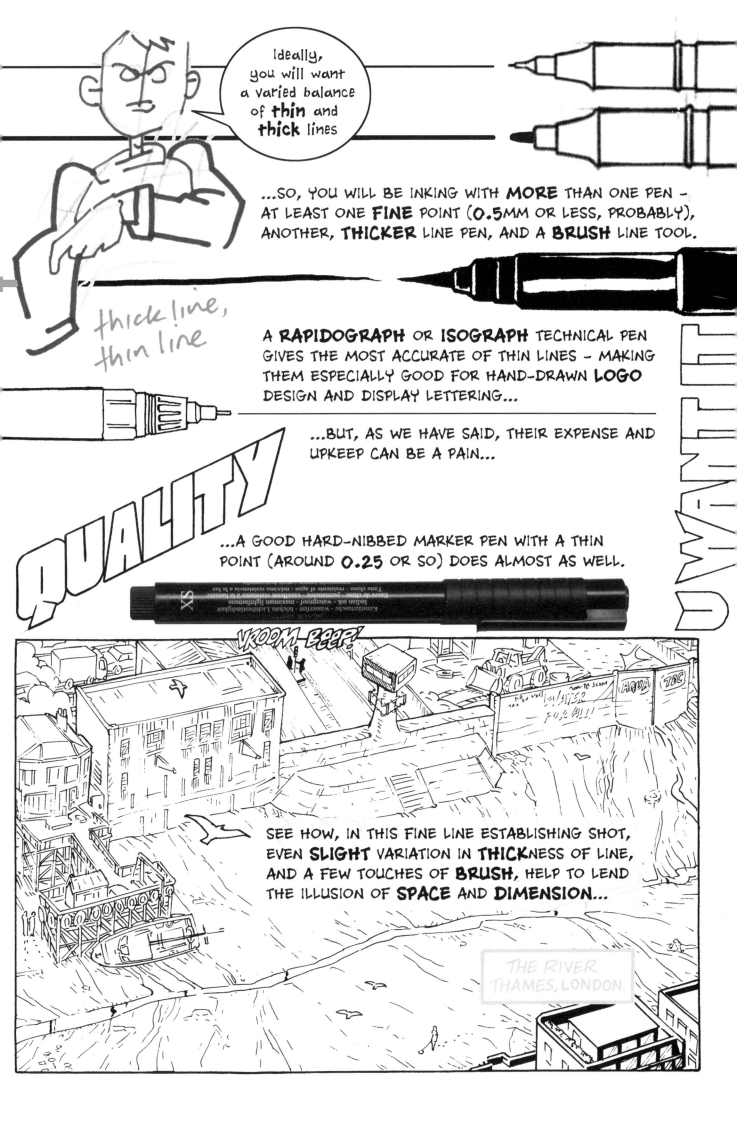

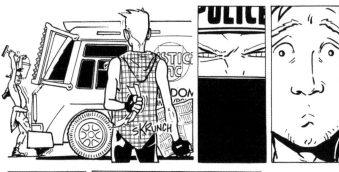

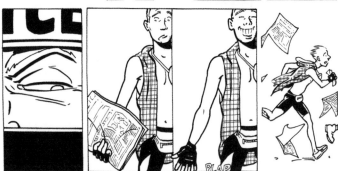

AGAIN, WITH ONLY SLIGHT VARIATIONS IN THE THICKNESS OF LINES, **FORM** AND **DIMENSION** ARE SUGGESTED.

THICKER **OUTLINES** HELP TO ESTABLISH PERSONS OR OBJECTS AS DISTINCT FROM ONE ANOTHER - ALSO, TO DIFFERENTIATE **PICTURE PLANES** - HERE, FROM **FORE**GROUND TO **MID**GROUND...

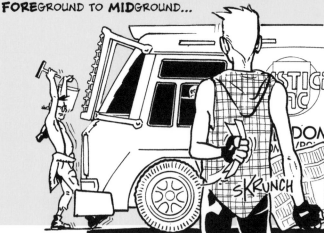

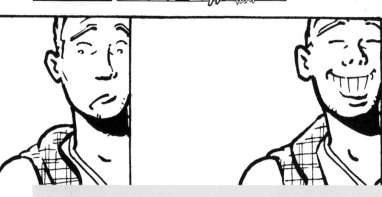

ADDING **SHADOW** TO THE UNDERSIDE OF OBJECTS IS A WAY TO GROUND THEM, TO REINFORCE THEIR MASS AND A SENSE OF THEIR REALITY.

THIS IS ESPECIALLY TRUE WHEN IT COMES TO DRAWING HEADS AND FACES - A THICKER LINE OR AREA OF SHADE BENEATH THE **CHIN** INSTANTLY MAKES AN IMPROVEMENT.

THIS SIMPLE **MODELLING** - VARIED LINE WIDTHS; OVERHEAD LIGHTING TO CREATE SHADOWS BENEATH SHAPES, LENDING WEIGHT; THICKER OUTLINES - CAN BE ENDLESSLY EFFECTIVE.

NOTE HOW DROPPING OUT THE PATTERN OF THE **SHIRT** - HERE BELOW - SPEEDS THE ACTION POSE ALONG - AND RIGHT, ADDS TO MODELLING.

ALSO, IN THE EXAMPLES BELOW **AND** ABOVE, DROPPING OUT THE **PANEL BORDERS** ON OCCASION INCREASES A SENSE OF **RHYTHM**.

- WHAT YOU CHOOSE **NOT** TO RENDER IS EQUALLY AS IMPORTANT.

..page seven. Page?...

AH!

Oh it!

As long as I put a **cover** on the front no-one will know the difference!

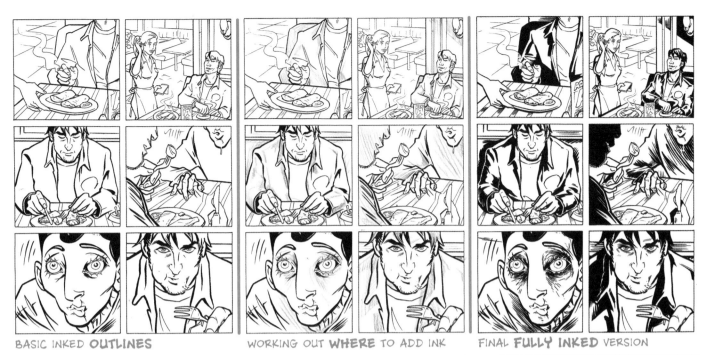

BASIC INKED **OUTLINES** WORKING OUT **WHERE** TO ADD INK FINAL **FULLY INKED** VERSION

SPOTTING BLACKS – KNOWING WHEN AND WHERE TO FILL IN AREAS WITH INK, WHETHER SHADOW, OR OBJECTS LIKE BLACK HAIR OR CLOTHING, IS AN ART IN ITSELF. IF IN **DOUBT**, HAVING INK-OUTLINED THE BASIC SHAPES, YOU CAN THEN MAKE A **PHOTOCOPY** AND WORK IT OUT FIRST, AS A VISUAL AID – DONE HERE (AS ABOVE) IN BLUE PENCIL.

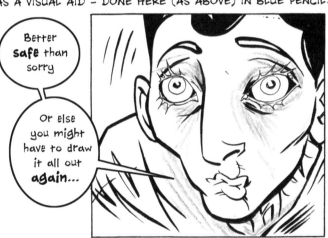

Better **safe** than sorry

Or else you might have to draw it all out **again**...

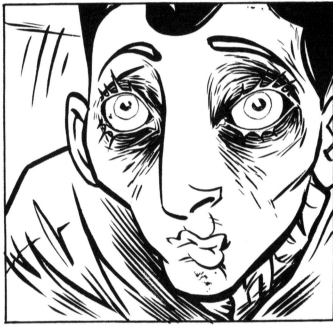

A RELATIVELY **SIMPLE** PAGE SUCH AS THIS ONE (LEFT), KEEPS AREAS OF HEAVY **BLACK** (THE NIGHT) SEPARATE FROM THE **WHITE**.

BUT A MORE **COMPLEX** PAGE LIKE THIS OTHER (RIGHT) **MIXES** THE BLACK AND THE WHITE. IT IS HIGHLY DRAMATIC AND EFFECTIVE, BUT YOU CAN REALLY SWEAT **BLOOD** TRYING TO BALANCE EVERYTHING OUT – I KNOW **I** DID! THE BIG FACE IN PANEL THREE IS **STILL** AN AWFUL MESS...SIGH...

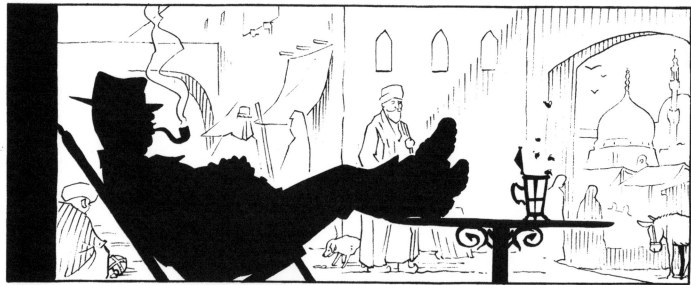

HERE I USE **SILHOUETTES** TO DIFFERENTIATE MY PICTURE PLANES — **FORE**GROUND, **MID**GROUND, AND **BACK**GROUND. ALSO, A NOD TO THE QUALITY OF LIGHT IN THE NORTH AFRICAN SETTING — HARSH BRIGHT LIGHT IN SHARP CONTRAST TO DEEP, BLACK SHADOWS...

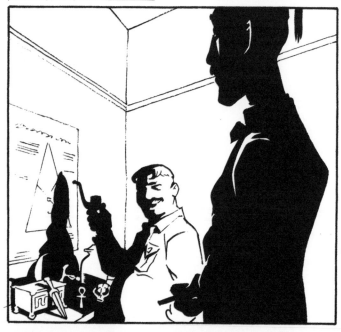

SIMILARLY, TO ESTABLISH MORE OF AN ATMOSPHERE OR **MOOD** OF UNEASE, IF NOT OUTRIGHT **HORROR**, I KEEP LOADING UP MY BRUSH TO ADD IN MORE INK, MORE **BLACK**. IT TAKES A FEW GOES TO GET IT HOW I WANT...

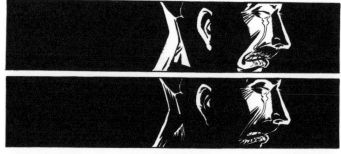

MORE **INK** = MORE **BLACK** = MORE **MOOD**

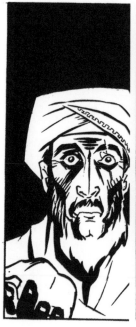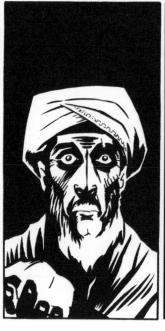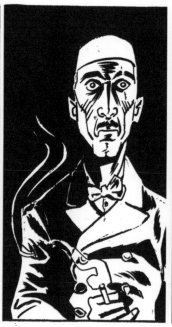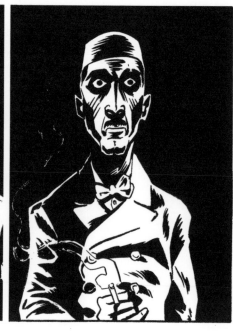

AS LUSCIOUS AS A LOADED BRUSH OR BRUSHPEN LINE CAN BE (LEFT), A USEFUL HALFWAY HOUSE BETWEEN THE ABSOLUTES OF PENCIL AND INK IS THE WAXY BLACK LINE OF THE **CHINAGRAPH PENCIL...**

APPLIED **FIRMLY** IT PRODUCES A HARD BLACK LINE, BUT WITH CHARACTER (RIGHT)

YET IT CAN ALSO BE USED **DELICATELY**, BUILDING UP STROKES FOR MORE ETHEREAL EFFECTS, AS WITH THIS EXPLORER'S **PIPE DREAM...**

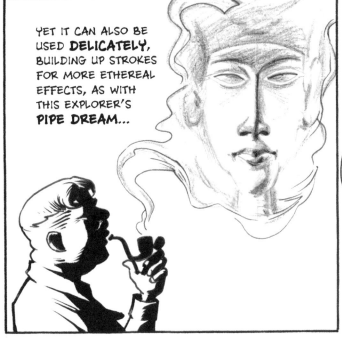

WHEN DRAWING WITH A CHINAGRAPH PENCIL, THE 'TOOTH' OR SURFACE OF THE PAPER BECOMES OF VITAL IMPORTANCE – A SMOOTH FINISH WILL NOT WORK NEARLY SO WELL AS A MORE TEXTURED **WATERCOLOUR** TYPE STOCK, OR **CARTRIDGE.**

YOU CAN USE THE CHINAGRAPH IN ANY NUMBER OF WAYS, FOR ITS OWN PROPERTIES AS A ROUGHER, DARKER SORT OF LINE, SOMETIMES JUST TO ACCENT PARTS OF AN ORDINARY INK DRAWING (ABOVE), OR TO SUGGEST STONE, OR SMOKE, OR...**EXPERIMENT!**

ONE TRICK I'VE DISCOVERED IS IF, FIRST, YOU LAY DOWN AN AREA OF WHITE CORRECTION FLUID, LIKE TIPP-EX, THIS CREATES A ROUGH SURFACE ON WHICH TO CREATE **TEXTURED** EFFECTS, EVEN WHEN THE PAPER THAT YOU ARE USING IS OTHERWISE SMOOTH. THE HARDER YOU PRESS, THE MORE 'GRIT' CREATED.

TRUE GRIT

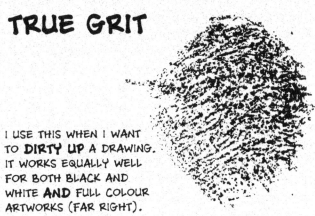

I USE THIS WHEN I WANT TO **DIRTY UP** A DRAWING. IT WORKS EQUALLY WELL FOR BOTH BLACK AND WHITE **AND** FULL COLOUR ARTWORKS (FAR RIGHT).

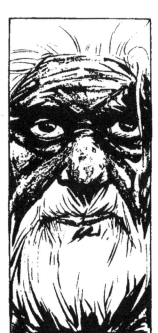

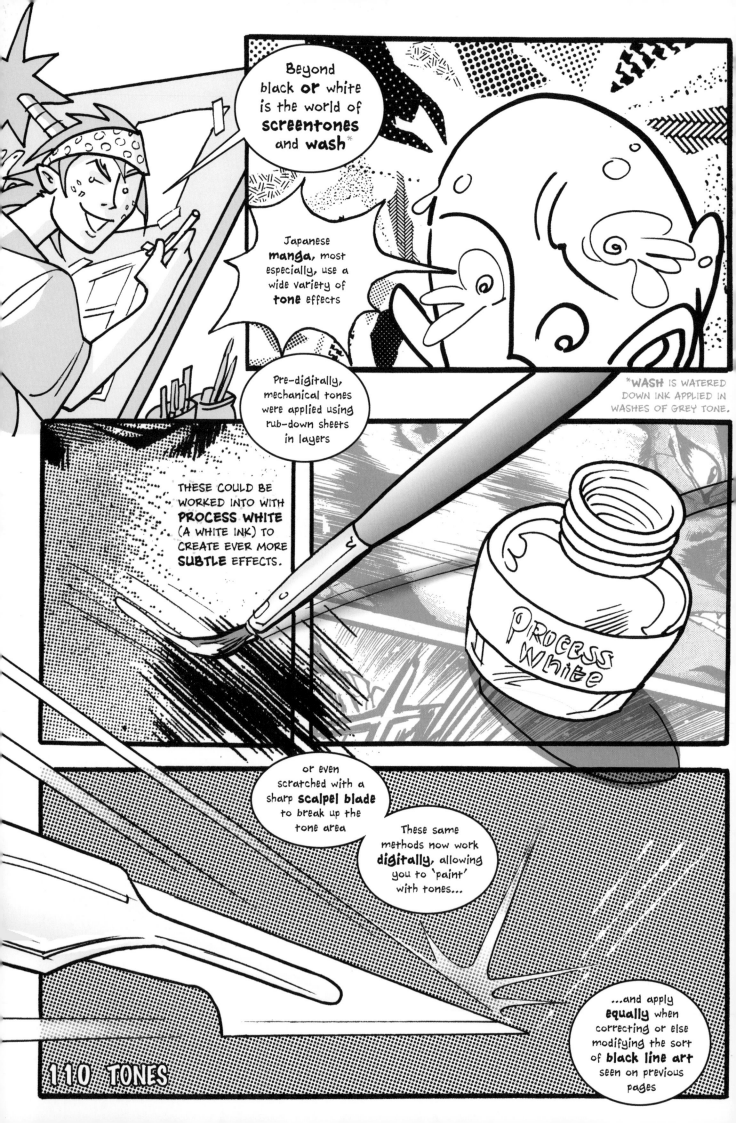

Beyond black **or** white is the world of **screentones** and **wash**[*]

Japanese **manga**, most especially, use a wide variety of **tone** effects

Pre-digitally, mechanical tones were applied using rub-down sheets in layers

THESE COULD BE WORKED INTO WITH **PROCESS WHITE** (A WHITE INK) TO CREATE EVER MORE **SUBTLE** EFFECTS.

[*]**WASH** IS WATERED DOWN INK APPLIED IN WASHES OF GREY TONE.

PROCESS White

or even scratched with a sharp **scalpel blade** to break up the tone area

These same methods now work **digitally**, allowing you to 'paint' with tones...

...and apply **equally** when correcting or else modifying the sort of **black line art** seen on previous pages

110 TONES

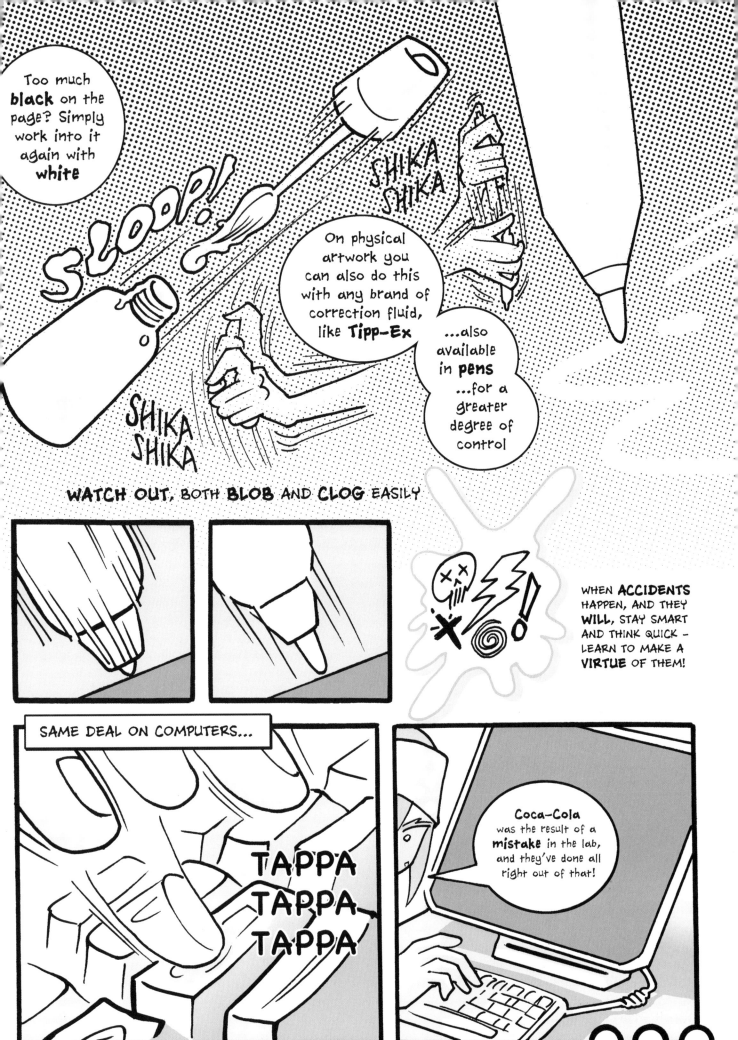

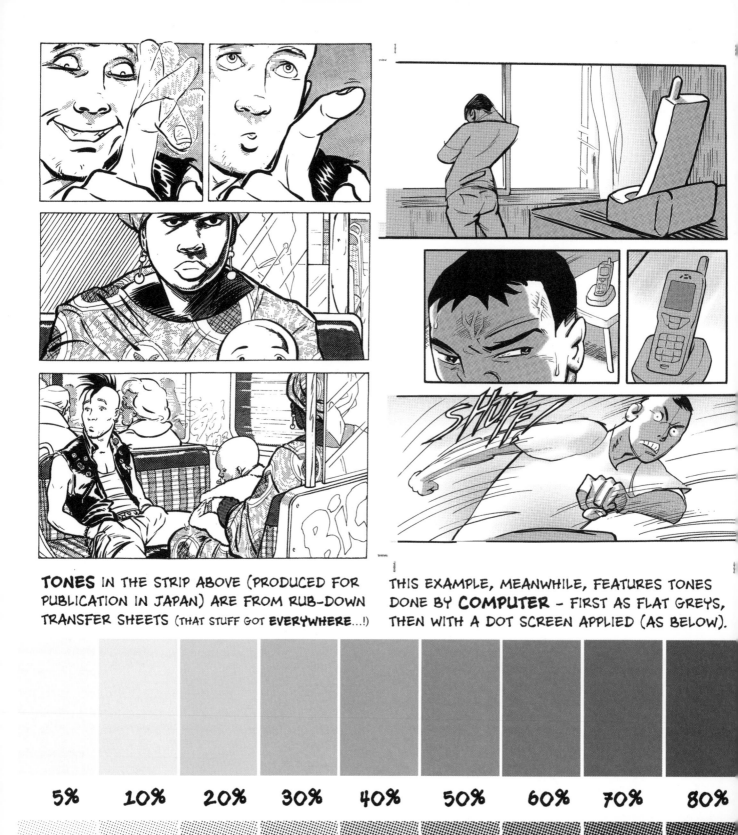

TONES IN THE STRIP ABOVE (PRODUCED FOR PUBLICATION IN JAPAN) ARE FROM RUB-DOWN TRANSFER SHEETS (THAT STUFF GOT **EVERYWHERE**...!)

THIS EXAMPLE, MEANWHILE, FEATURES TONES DONE BY **COMPUTER** - FIRST AS FLAT GREYS, THEN WITH A DOT SCREEN APPLIED (AS BELOW).

| 5% | 10% | 20% | 30% | 40% | 50% | 60% | 70% | 80% |

WHETHER YOU ARE WORKING **ANALOG** OR **DIGITAL**, BEAR IN MIND WHEN PRINTING GREY TONES (DOTSCREENED OR NOT), THAT THEY WILL UNIVERSALLY **DARKEN** BY **10**% - THIS MEANS TONES ABOVE **80**% BLACK WILL COME OUT PRETTY MUCH THE SAME AS IF THEY WERE SOLID BLACK. YOUR IMAGES MAY **FILL IN** AS A RESULT, WITH A **LOSS** OF DETAIL...

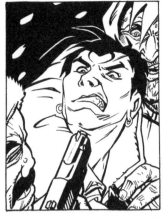
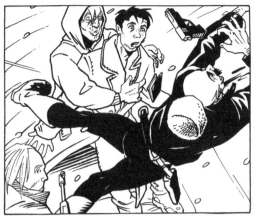

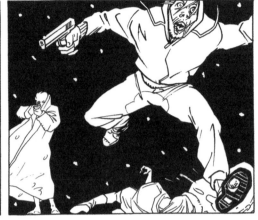

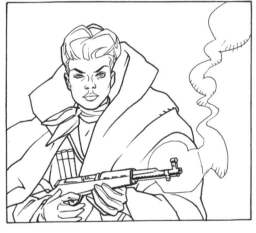

TAKE A LOOK BACK AT PAGE **104**, AND COMPARE THE INKING THERE WITH THE SAMPLE PAGE AT LEFT.

ASIDE FROM BEING IN DIFFERENT GENRES (ON 104, COMEDY; HERE, ACTION THRILLER) THERE'S ABOUT **10 YEARS** BETWEEN THEM.

OVER THE COURSE OF MY CAREER, PRACTISING MY CRAFT, I'VE CHOSEN TO MOSTLY ELIMINATE LINEWORK – LESS AND LESS **CROSSHATCHING**. (TO MAKE THOSE TECHNIQUES WORK TAKES A STEADY, SLOW HAND AND LOTS OF PATIENCE – SO GO AHEAD AND GOOD LUCK IF YOU HAVE THOSE!)

BUSY LINEWORK IS NO SUBSTITUTE FOR WEAKER DRAWINGS, TONES, OR INDEED **COLOUR** (PAGE SEEN LEFT HAS THE ADVANTAGE OF BEING INTENDED FOR A COLOUR COMIC).

MY NATURAL DRAWING STYLE IS **OPEN** AND BOLD, PROPERLY BEST FOR COLOUR TREATMENTS. OFTEN WITHOUT THE OPTION OF COLOUR PRINTING, HOWEVER, I'VE HAD TO **LEARN** HOW TO MAKE MY BLACK AND WHITE INKED IMAGES WORK. (YOU WILL FIND YOUR OWN NATURAL STYLES).

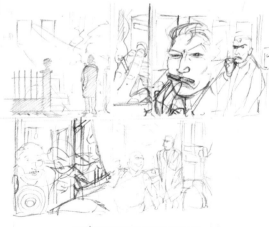
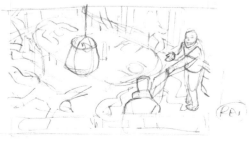

IT IS ALWAYS BEST TO **DEVELOP** YOUR OWN STYLE BY WORKING ON YOUR **OWN** DRAWINGS, FROM START TO FINISH. HOWEVER, AS READYMADE INKING EXERCISES, ON THE FOLLOWING SPREAD YOU WILL FIND PAGES OF **SAMPLE** PENCILS FOR YOU TO PRACTISE WITH. ONE IS QUITE TIGHT AND CONTROLLED, THE OTHER SLIGHTLY LOOSER AND MORE OPEN TO INTERPRETATION. CHANGE ANYTHING YOU WANT TO, THE PENCILS ARE A **GUIDE** ONLY. DARKER AREAS ARE INDICATED: CONSIDER HOW TO ADD **SHADOWS** WHILE RETAINING CLEAR DETAILS...

REFER BACK TO OTHER EXAMPLES THROUGHOUT THIS BOOK IF OR WHEN YOU ARE NOT SURE. PAGE **114** IS OF AN 'OCCULT DETECTIVE' (LET'S CALL HIM **JOE BLOW**), HENCE HOMAGE TO **THE EXORCIST** IN PANEL ONE. YOU WILL WANT TO AIM FOR ATMOSPHERIC MOOD – SUSPENSE, HORROR. **115** IS A WEIRD, INCENSE FILLED RELIGIOUS CEREMONY. **HAVE FUN!**

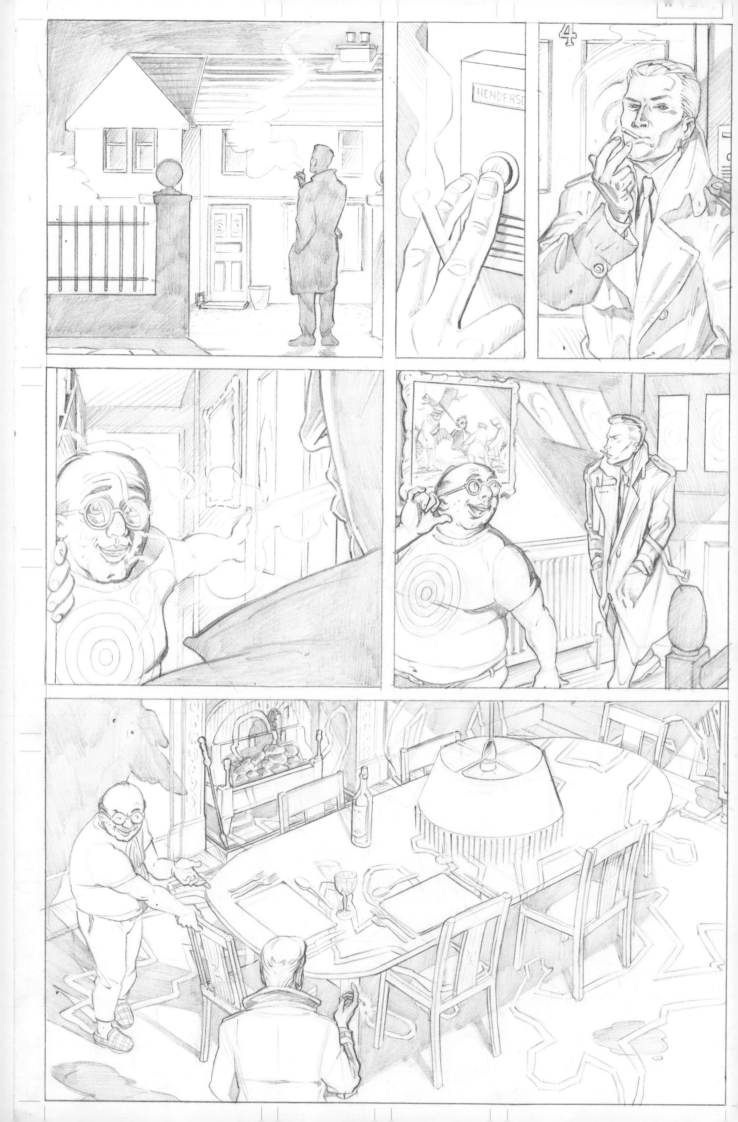

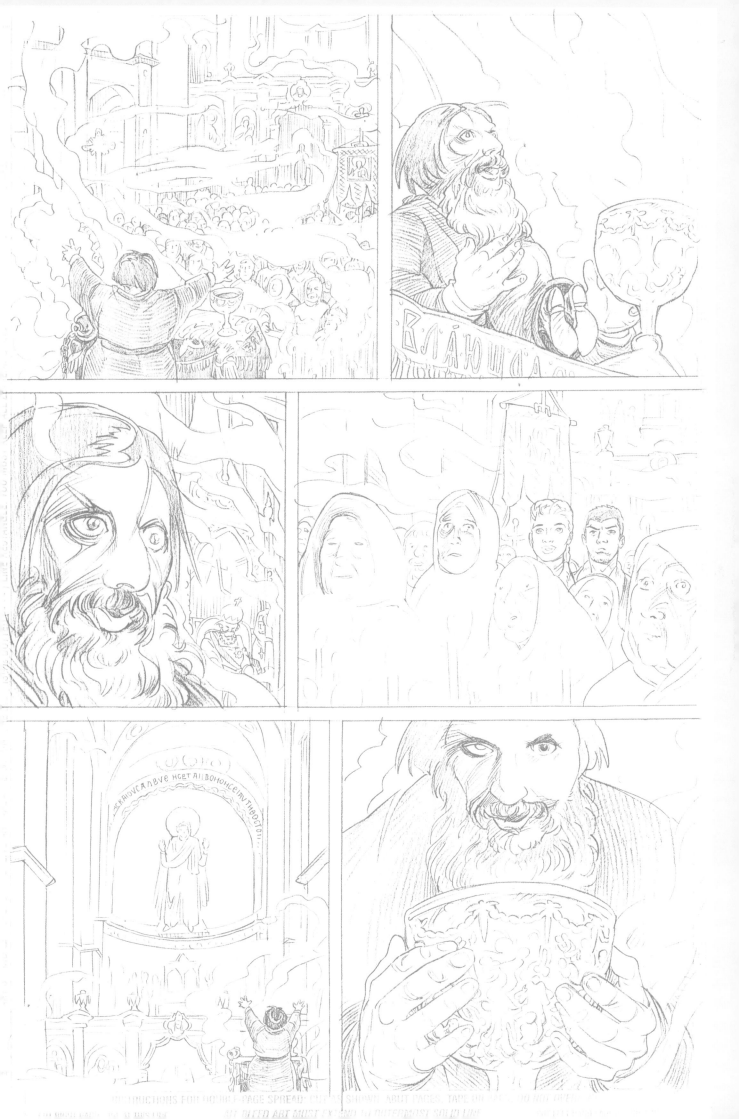

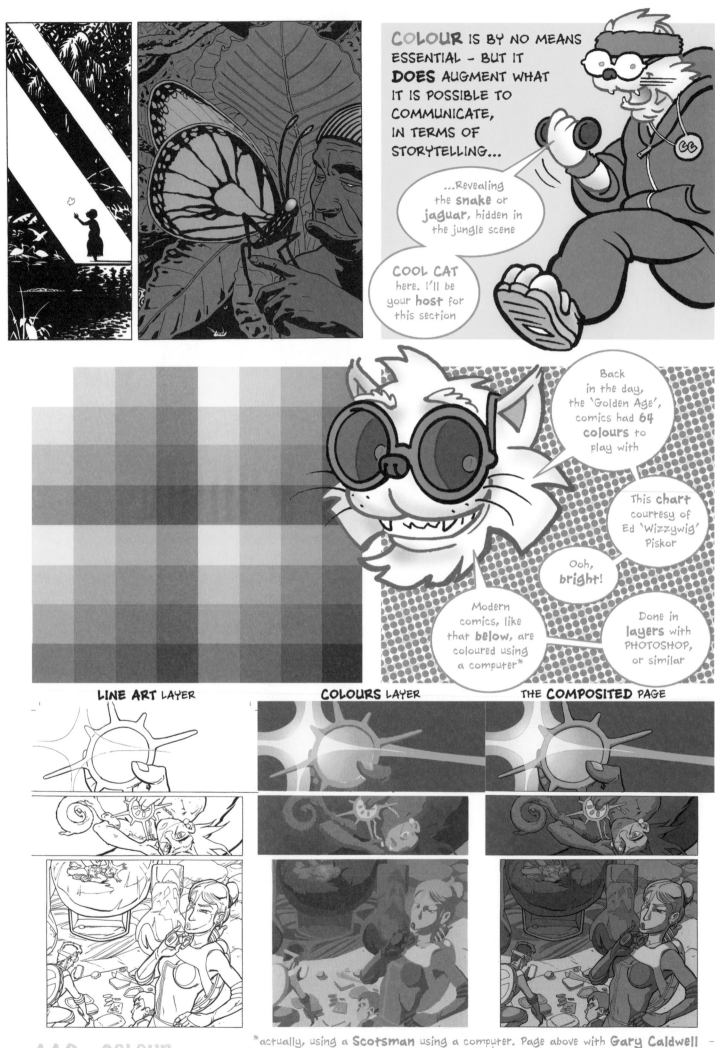

COLOUR IS BY NO MEANS ESSENTIAL - BUT IT **DOES** AUGMENT WHAT IT IS POSSIBLE TO COMMUNICATE, IN TERMS OF STORYTELLING...

...Revealing the **snake** or **jaguar**, hidden in the jungle scene

COOL CAT here. I'll be your **host** for this section

Back in the day, the 'Golden Age', comics had **64 colours** to play with

This **chart** courtesy of Ed 'Wizzywig' Piskor

Ooh, **bright!**

Modern comics, like that **below**, are coloured using a computer*

Done in **layers** with PHOTOSHOP, or similar

LINE ART LAYER

COLOURS LAYER

THE **COMPOSITED** PAGE

*actually, using a **Scotsman** using a computer. Page above with **Gary Caldwell**

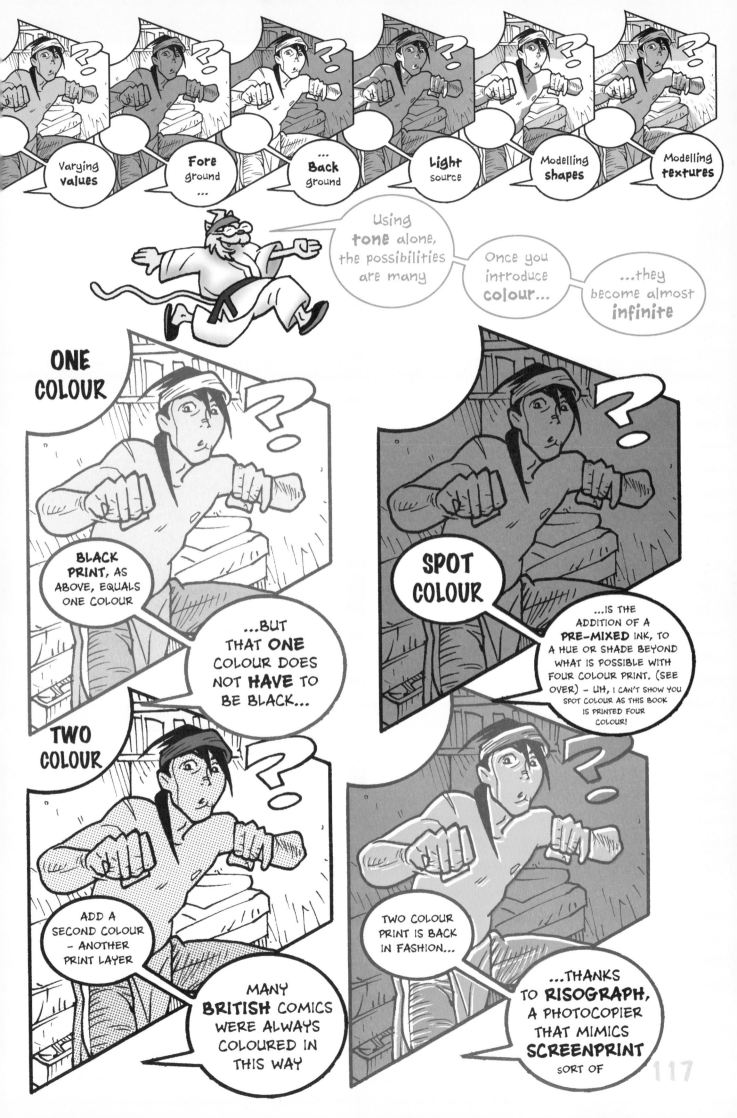

Varying **values**

Fore ground ...

... **Back** ground

Light source

Modelling **shapes**

Modelling **textures**

Using **tone** alone, the possibilities are many

Once you introduce **colour**...

...they become almost **infinite**

ONE COLOUR

BLACK **PRINT**, AS ABOVE, EQUALS ONE COLOUR

...BUT THAT **ONE** COLOUR DOES NOT **HAVE** TO BE BLACK...

SPOT COLOUR

...IS THE ADDITION OF A **PRE-MIXED** INK, TO A HUE OR SHADE BEYOND WHAT IS POSSIBLE WITH FOUR COLOUR PRINT. (SEE OVER) – UH, I CAN'T SHOW YOU SPOT COLOUR AS THIS BOOK IS PRINTED FOUR COLOUR!

TWO COLOUR

ADD A SECOND COLOUR – ANOTHER PRINT LAYER

MANY **BRITISH** COMICS WERE ALWAYS COLOURED IN THIS WAY

TWO COLOUR PRINT IS BACK IN FASHION...

...THANKS TO **RISOGRAPH**, A PHOTOCOPIER THAT MIMICS **SCREENPRINT** SORT OF

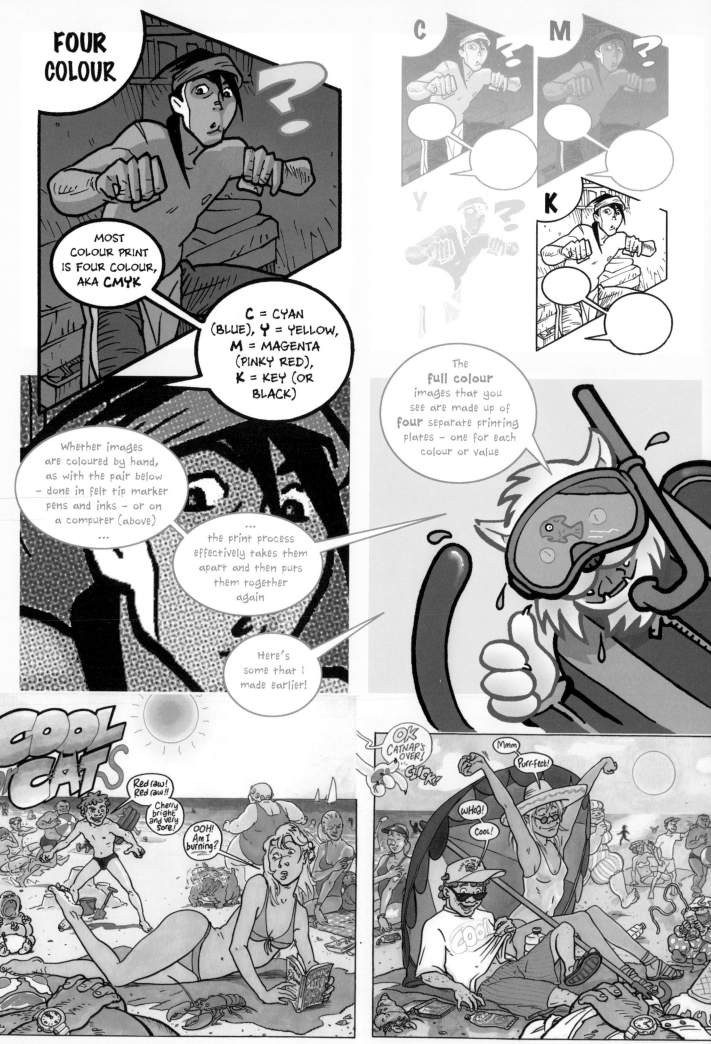

FOUR COLOUR

MOST COLOUR PRINT IS FOUR COLOUR, AKA **CMYK**

C = CYAN (BLUE), Y = YELLOW, M = MAGENTA (PINKY RED), K = KEY (OR BLACK)

Whether images are coloured by hand, as with the pair below – done in felt tip marker pens and inks – or on a computer (above) ...

... the print process effectively takes them apart and then puts them together again

The **full colour** images that you see are made up of **four** separate printing plates – one for each colour or value

Here's some that I made earlier!

C M
Y K

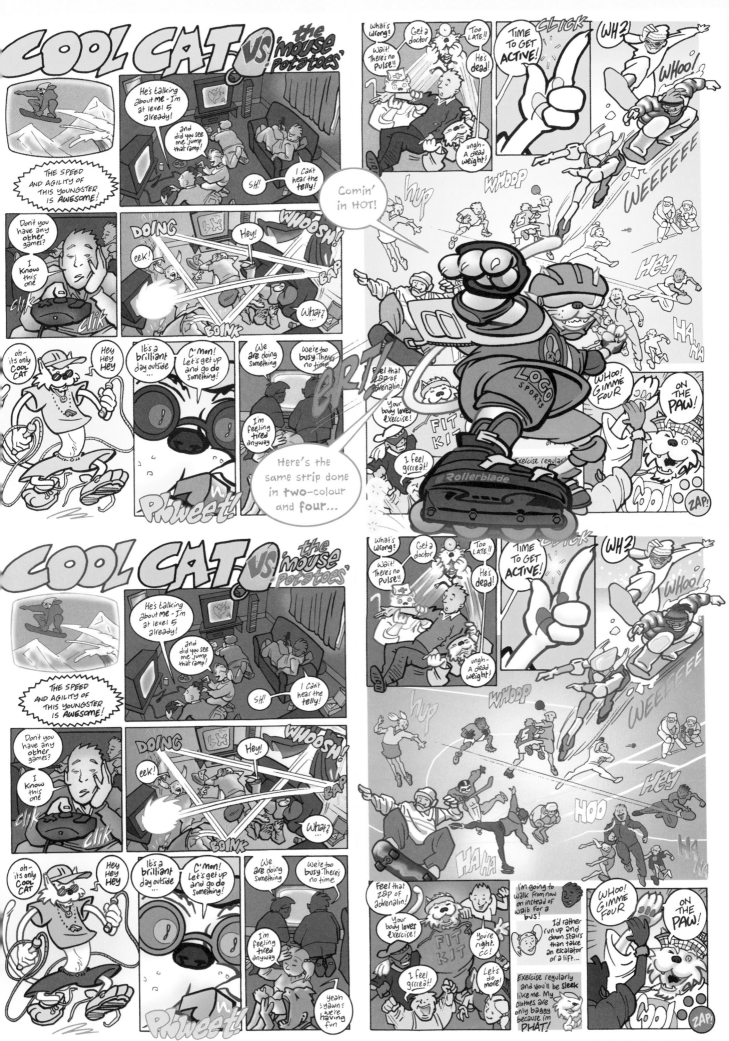

MEWSFLASH! This just in...

Manga also found in colour

COLOUR?! Sacrilege!! Manga are **only** black and white!!!

Pants!

Call yourself a **fan**?!?

DID SOMEBODY SAY 'FAN'?!?

OMG OMG OMG

Me too!

OMG, OMG OMG - I LOVE MANGA!!

CALM DOWN, EVERYONE. YES, THE **CAT** SPEAKS TRUE. ASIDE FROM THEIR COVERS, MANGA WEEKLIES IN JAPAN HAVE ONE OR MORE **FULL COLOUR** SECTIONS BOUND IN - A COVETED SLOT USUALLY GIVEN TO THE DEBUT EPISODE OF ANY **NEW** STRIP SERIAL. (YOU SOMETIMES FIND THESE AT THE START OF ANY BOOK COLLECTION.)

CLEVERLY, **ZASSHI** PUBLISHERS **EMBELLISH** THEIR **SINGLE-COLOUR PRINT** IN A VARIETY OF WAYS...

1) SUBSTITUTE BLACK PRINT WITH A **COLOURED** INK. SOMETIMES **BLUE**, **VIOLET**, OR EVEN **GREEN**...

2) BLACK INK, BUT ON A **COLOUR PAPER STOCK**, INSTEAD OF THE STANDARD OFF-WHITE NEWSPRINT...

3) **COLOUR** INK ON **COLOUR** PAPER STOCK. THIS RESULTS IN ALL SORTS OF **GROOVESOME** COMBOS.

DON'T MISTAKE WHAT LITTLE WE SEE IMPORTED AS THE **BE-ALL/END-ALL** OF MANGA - THERE'S **SO MUCH** MORE TO IT!

Not any single **style**, or any one **genre**...

...an entire **medium**!

グッド・サム (英イギリス)

オレはサム。投げ出した長い足が邪魔って？ そりゃ生でも公衆のルールはわきまえてるぜ！

■ピエールが紹介するヨーロッパ作家による描きおろしシリーズ■

ピエ第

YADDA YADDA, **ONLINE** MANGA NOW WORLDWIDE...MANHUA, MANHWA, ETC.
HIPPOPOTAMUS STRIP IS *Nonbiri Monogatari*, 'Carefree Tales' © *Yasuji Tanioka*, FROM **COMIC MORNING**, pub: KODANSHA

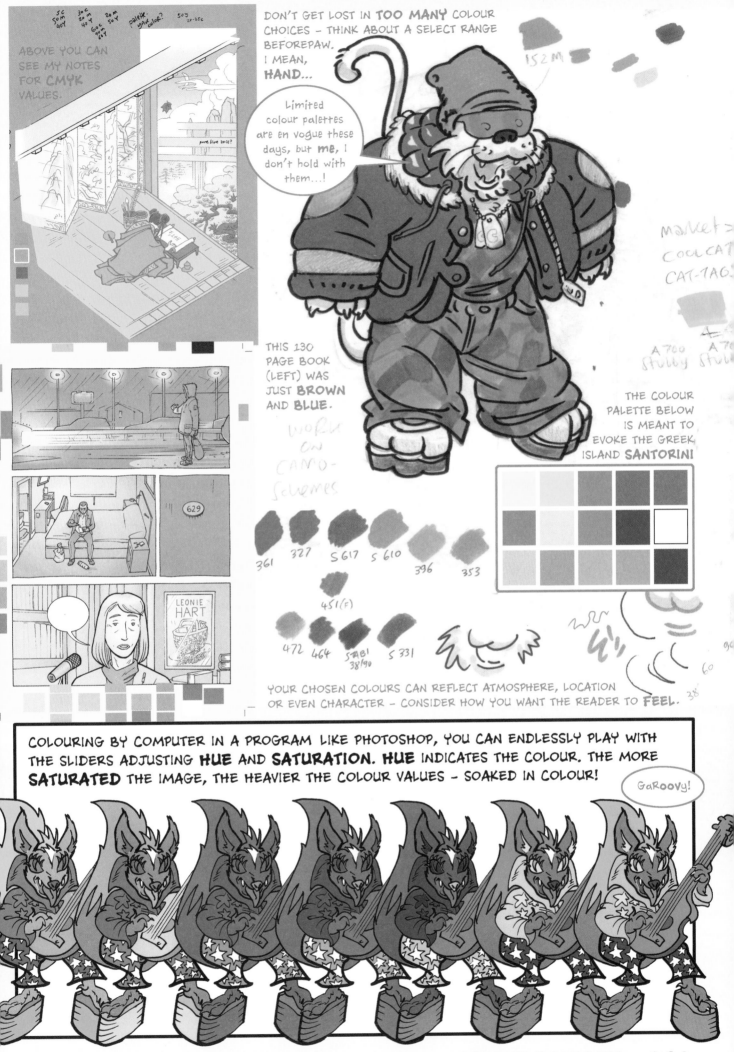

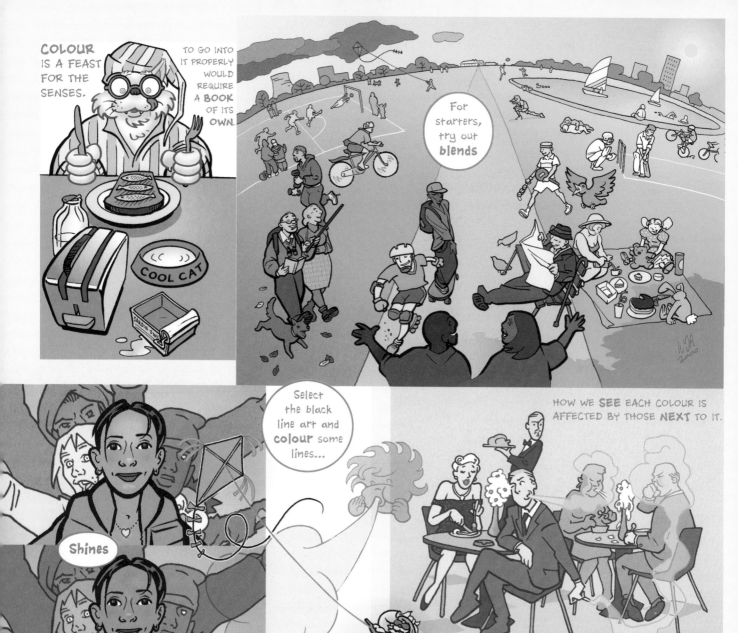

THE MAIN THING TO REMEMBER, WHEN COLOURING BY COMPUTER, IS THAT THE IMAGE YOU SEE ON SCREEN HAS A **LIGHT SHINING** THROUGH IT. SAME AS WITH THE TONAL VALUES, COLOURS WILL **DARKEN** WHEN VIEWED OFFSCREEN - IN PRINT -

BLOBBY WILLIAMS HERE TO SHOW YOU ...

...WHAT YOU **SEE** ISN'T ALWAYS WHAT YOU'LL **GET!**

SCREEN COLOURS ARE MADE UP OF **RGB** VALUES (**RED**, **GREEN** AND **BLUE** LIGHT). IF YOU INTEND FOR YOUR WORK TO BE PRINTED, IT IS SAFEST TO **RECALIBRATE** YOUR SCREEN TO SHOW A MORE ACCURATE RESULT IN **CMYK** - LESS CHOICE, BUT LESS DISAPPOINTMENT TOO!

Given COOL CAT's **Stamp of Approval**... ...Me-out!

SIEGEL AND SHUSTER CREATED SUPERMAN (FIRST PUBLISHED IN 1938); BOB KANE (aka ROBERT KAHN) and BILL (MILTON) FINGER, BATMAN; JOE (HYMIE) SIMON/JACK KIRBY (JACOB KURTZBERG), CAPTAIN AMERICA; KIRBY, WITH STAN LEE (LIEBER), ALMOST THE ENTIRE MARVEL UNIVERSE; WILL EISNER, MAX FLEISCHER, SEGAR TOO - IT'S NO ACCIDENT SO MANY ORIGINATORS OF THE ULTIMATE AMERICAN ARTFORMS WERE JEWISH.

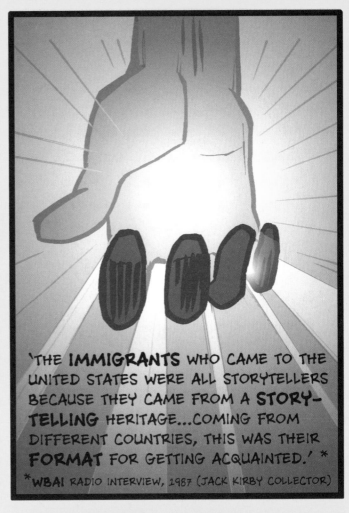

'THE IMMIGRANTS WHO CAME TO THE UNITED STATES WERE ALL STORYTELLERS BECAUSE THEY CAME FROM A STORY-TELLING HERITAGE...COMING FROM DIFFERENT COUNTRIES, THIS WAS THEIR FORMAT FOR GETTING ACQUAINTED.' *
*WBAI RADIO INTERVIEW, 1987 (JACK KIRBY COLLECTOR)

THROUGHOUT HIS WORKING LIFE, KIRBY, VISIONARY KING OF COMICS, NEVER STOPPED EVOLVING, WIELDING HIS GODS OF MYTH AND COSMIC ODYSSEY. READING UP ON SCIENCE, HE DEPICTED VIRTUAL REALITY, GENETICS, PLASTIC SURGERY, ALTERNATE DIMENSIONS, SPACE/TIME TRAVEL, ROBOTICS, HOLOGRAMS, CAMERA PHONES - HELL, EVEN FLYING SHARKS - DECADES BEFORE THEY HAVE BECOME OUR CULTURAL REALITY AND CURRENCY.

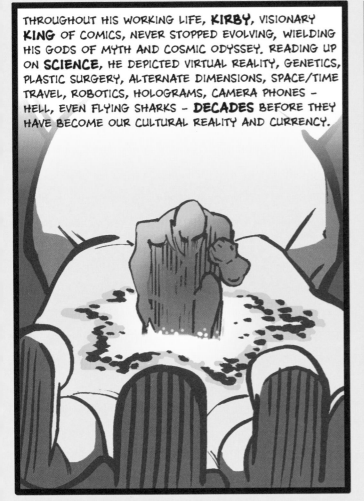

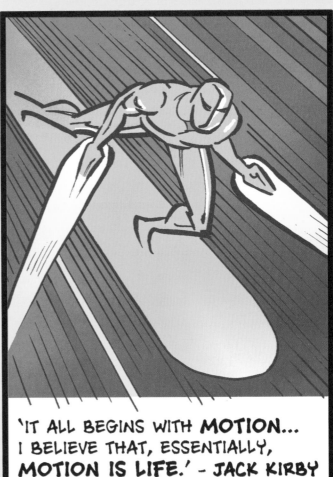

'IT ALL BEGINS WITH MOTION... I BELIEVE THAT, ESSENTIALLY, MOTION IS LIFE.' - JACK KIRBY

A Few Words About CONFIDENCE AND MOTIVATION

ACCEPT THIS NOW – YOU WILL **NEVER** **LIKE** YOUR OWN DRAWINGS...

No artist does

ONE OF THE MOST **MONUMENTAL** WORKS IN ART HISTORY IS THE **SISTINE CHAPEL** CEILING. EVEN WORKING AT BREAKNECK PACE, IT TOOK **MICHELANGELO** (NOT THE TURTLE) FIVE YEARS TO PAINT...HE PROBABLY HATED EVERY MINUTE.

MERDA!*

*Trans: 'Foul I fare and painting is my shame'

DON'T EXPECT YOUR DRAWINGS TO BE **PERFECT**, OR EVEN TO COME OUT **RIGHT**. IT'S NOT ABOUT GETTING IT 'RIGHT' – BETTER THAT YOU SIMPLY GET **ON** WITH IT. JUST (SWOOSH) **DO** IT.

WHEN YOU **DOUBT** YOURSELF OR YOUR ABILITIES, REFLECT ON IT **THIS** WAY – **YOU** ONLY EVER SEE WHAT IS **WRONG** IN ANY DRAWING THAT YOU DO. OTHER PEOPLE WILL SEE FIRST WHAT IS **RIGHT**...

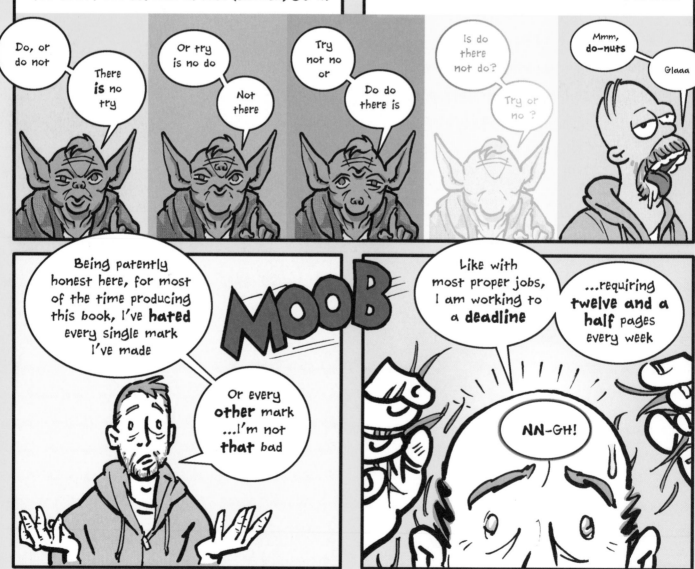

Do, or do not

There **is** no try

Or try is no do

Not there

Try not no or

Do do there is

Is do there not do?

Try or no ?

Mmm, **do-nuts**

Glaaa

Being patently honest here, for most of the time producing this book, I've **hated** every single mark I've made

Or every **other** mark ...I'm not **that** bad

MOOB

Like with most proper jobs, I am working to a **deadline**

...requiring **twelve and a half** pages every week

NN-GH!

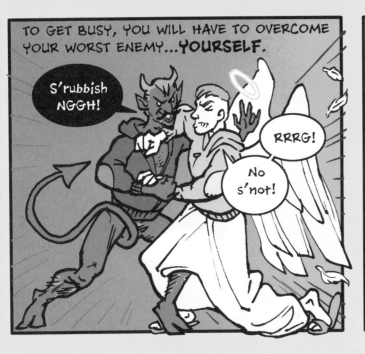

TO GET BUSY, YOU WILL HAVE TO OVERCOME YOUR WORST ENEMY...**YOURSELF**.

S'rubbish NGGH!

RRRG!

No s'not!

LEARN TO IGNORE THAT LITTLE VOICE IN YOUR HEAD. BE PREPARED TO **GET OUT OF YOUR OWN WAY**...

SET YOURSELF GOALS AND PARAMETERS (THE GOALPOSTS). EVEN IF FALSE OR **FAKE**, GIVE YOURSELF A **DEADLINE** AND **KEEP TO IT**. LIMITED TIME FOCUSES YOUR ATTENTION, AND **PROPELS** YOU ACROSS ANY ROUGH PATCHES.

TELL OTHERS AROUND YOU WHAT YOUR GOAL WILL BE, AND ALSO **WHEN** YOUR DEADLINE IS. **PROMISE TO** THEM THAT YOU'LL **FULFIL** IT. THEN **DELIVER** ON YOUR PROMISE - PRESENT WHATEVER YOU'VE ACHIEVED IN THE ALLOTTED TIME, FOR HOPEFULLY **HONEST** FEEDBACK.

HOWEVER SHY YOU FEEL OF IT, **DO** SHOW YOUR COMICS TO OTHERS...

...COMICS WITHOUT ANY READERS ARE LIKE THOSE TREES THAT FALL SILENTLY IN FORESTS, WITH NO ONE TO HEAR THEM...

...YOU'LL NEVER KNOW IF WHAT YOU'VE DONE **WORKS** OR NOT, AS A FORM OF COMMUNICATION. YOU'LL HAVE NO IDEA AS TO WHETHER IT ACTUALLY IS, OR **ISN'T**, ANY GOOD.

IN ETERNAL QUEST OF PERFECTION, WE HOPE FOR WHAT WE CAN SEE IN OUR 'MIND'S EYE'.

IT'S LIKE CHASING A RAINBOW - SHOULD YOU EVER CATCH ONE, IT'S ALL OVER. YOU'D STOP.

I'M SO OVER THE RAINBOW.

BE MORE LIKE THE **SHARK**. BECOME THE SHARK - ALWAYS KEEP **MOVING**...

DUM DUM DUM DUM

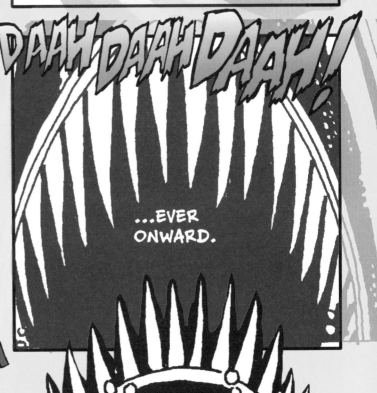

DAAH DAAH DAAH!

...EVER ONWARD.

SHARK BY ROBIN BARNARD AFTER ROMITA AFTER KASTEL

BABUM!

LEARNING FROM THE MASTERS

THERE'S SO MUCH **MORE** TO COMICS THAN WHAT I CAN SHOW YOU HERE - MORE ABOUT THE STRUCTURE, EDITS, STORYTELLING, MANGA, COLOUR, **PERSPECTIVE...**

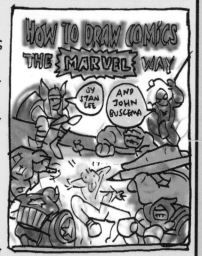

DESPITE THE TITLE, JOHN BUSCEMA'S **HTDC THE MARVEL WAY** REMAINS AMONG THE BEST BOOKS TO TURN TO FOR **OVERALL** POINTERS.

MY **BASIC TRAINING** CAME FROM THAT BOOK, PERSPECTIVE NOT LEAST - IN LATTER YEARS I'VE CHOSEN TO ABANDON MOST, BUT TO BREAK RULES, FIRST YOU HAVE TO **LEARN** THEM...

WHAT ELSE HAVE I LEARNED FROM **OTHERS...?**

IN MY CAREER I'VE BEEN LUCKY TO WORK ALONGSIDE OR IN WORKSHOPS WITH VARIOUS COMICS PROFESSIONALS

EDDIE (FROM HELL, BACCHUS) **CAMPBELL** TAUGHT ME...

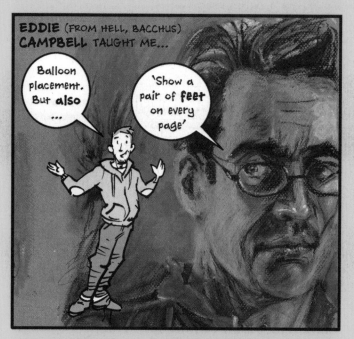

Balloon placement. But **also** ...

'Show a pair of **feet** on every page'

WHAK!

THIS IS HIS LIGHTHEARTED WAY TO SAY THAT IT'S GOOD TO **VARY** UP YOUR SHOTS...TWO PEOPLE IN A ROOM TALKING NEVER **HAS** TO BE BORING, UNLESS YOU SHOULD CHOOSE* TO MAKE IT SO. IT'S NOT JUST **TALKING HEADS. WHAT** ARE THEY DOING WITH THEIR HANDS? **HOW** ARE THEY SITTING? **WHEN** DO THEY MOVE? AND SO ON. CHANGE **P.O.V.** - NOT FOR THE SAKE OF IT: WITH RHYTHM AND REASON.

***DOUG MAHNKE** DARINGLY DID JUST THAT ON **THE MASK.** HE KEPT ORDINARY LIFE SCENES EXTRA STATIC AND LITERAL SO THAT WHENEVER **STANLEY** DONNED THE **MASK** THE CRAZED ANARCHY REALLY **POPPED.** SEARCH OUT HIS SEMINAL SERIES 'MAJOR BUMMER' IN BARGAIN BINS. **LESSON:** WHATEVER WORKS, **WORKS!**

MASTER OF **DARKNESS, DAVID** (V FOR VENDETTA) **LLOYD** TAUGHT ME ARTISTIC LICENCE.

CONSIDERING **LIGHT SOURCES** AND WHERE A **SHADOW** WOULD FALL, HE INSISTED, 'WHERE WOULD IT SERVE **STORY** FOR THE SHADOW TO FALL?' - **DRAMA,** NOT REALITY, IS THE GOAL. CARTOONS ALLOW **YOU** TO CONTROL PHYSICS!

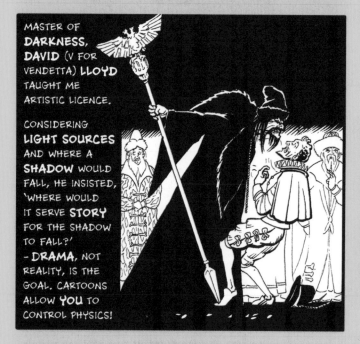

O SENSEI **OSCAR** (A SMALL KILLING) **ZARATE,** ADVISES 'ESTABLISH **INTIMACY'.** YOUR CHARACTER LITERALLY OR METAPHORICALLY LAID **BARE** BEFORE THE READER = A SHARED HUMAN MOMENT, VULNERABILITY/EXPOSURE, = IDENTIFICATION; THEIR CARE AND CONCERN, EARNED.

JOB DONE!

NO WAIT...'JOB'!!

THE FUTURE'S MEDIUM

COMICS IS THE MEDIUM OF THE FUTURE – AN INCREASINGLY **GLOBAL** ART FORM, AND CULTURE, ON IT'S WAY TO BECOMING AN INTERNATIONAL **LANGUAGE**

THINK ABOUT IT – LOOK AT HOW POPULAR COMIC BOOK **ICONOGRAPHY** (SPEECH BALLOONS, THOUGHT BUBBLES, AND THE REST) HAS BECOME IN **ADVERTISING** – A SURE SIGN IT'S UNDERSTOOD BY THE GENERAL POPULACE

LOUD AND PROUD

RELATIVELY CHEAP AND ACCESSIBLE, THE COMICS FORMAT IS TRULY DEMOCRATIC – NOT ONLY CAN ANY PERSON READ THEM, ANYONE CAN ALSO **DRAW** AND **MAKE** THEM, IF THEY WISH

...VOTE WITH YOUR **HANDS!**

IN WHAT'S BEEN CALLED A POST-LITERATE SOCIETY, PEOPLE ARE **LEARNING** FROM COMICS WHAT THEY NO LONGER DO FROM THE LIKES OF **PAINTING** AND **LITERATURE**...WHICH IS NOT THE SAME AS SAYING COMICS ARE ILLITERATE OR FOR THE SIMPLE-MINDED

...UH, **IS IT?**

...SIMPLY THAT THEY HAVE MORE **IMPACT!**

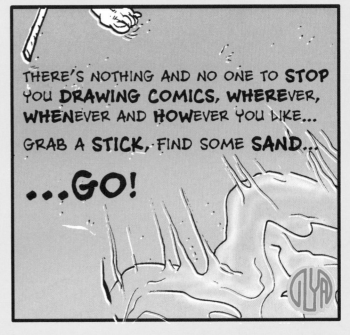

THERE'S NOTHING AND NO ONE TO **STOP** YOU **DRAWING COMICS, WHER**EVER, **WHEN**EVER AND **HOW**EVER YOU LIKE... GRAB A **STICK**, FIND SOME **SAND**...

...**GO!**

ILYA PULLS ON MORE THAN **30** YEARS' EXPERIENCE AS A COMICS WRITER, ARTIST AND EDITOR. HIS WORKS HAVE BEEN PUBLISHED BY **MARVEL**, **DC** AND **IMAGE** IN THE **USA**, **KODANSHA** IN **JAPAN**, AND NUMEROUS BOOK COMPANIES WORLDWIDE. TITLES INCLUDE THE AWARD-WINNING **THE END OF THE CENTURY CLUB**, MANGA SHAKESPEARE'S **KING LEAR**, **ROOM FOR LOVE**, AND FOR 2016 – **KID SAVAGE**, CO-CREATED WITH **JOE** (Ben 10, DEADPOOL) **KELLY**. YAY!

BUK... BUK...BUK... BUK. KARK...

HEH... ...HEH